Sketching Your Favorite Subjects in
Pen & Ink

About the Author

Claudia Nice was born in Shelton, Washington, and spent her childhood years in Portland, Oregon. It was the call of the nearby Cascade mountain range and her family's numerous camping trips that developed her love of nature.

Claudia began experimenting with art materials at a young age, sketching anything that would hold still. She gained basic art skills and encouragement from grade school and high school art classes. She won a scholarship for summer art classes at the University of Kansas, where she began sketching in pen and ink.

Claudia and her husband Jim presently reside in the scenic Columbia River Gorge on the Oregon border. She travels as an art consultant for Koh-I-Noor Rapidograph, teaching workshops across the nation and Canada. She has authored nine books, numerous magazine articles and has exhibited her work extensively.

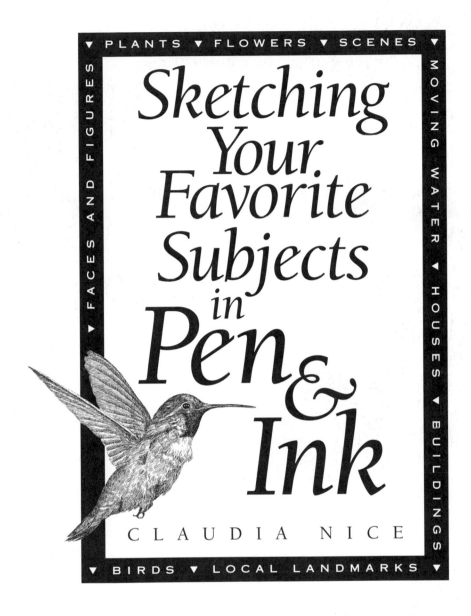

▼ PLANTS ▼ FLOWERS ▼ SCENES ▼

▲ FACES AND FIGURES

MOVING WATER ▼ HOUSES ▼ BUILDINGS

Sketching Your Favorite Subjects in Pen & Ink

CLAUDIA NICE

▼ BIRDS ▼ LOCAL LANDMARKS ▼

NORTH LIGHT BOOKS

CINCINNATI, OHIO

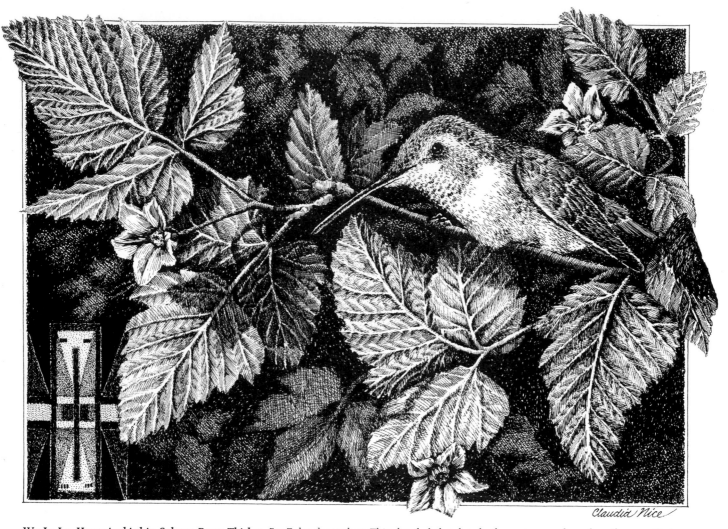

Wa Le La, Hummingbird in Salmon Berry Thicket, 5 × 7, by the author. This detailed sketch is both a nature study and a tribute to Native American art. Note the hummingbird symbol in the lower left corner. Rapidograph pen sizes 6 × 0, 4 × 0 and 3 × 0 were used.

Sketching Your Favorite Subjects in Pen & Ink. Copyright © 1993 by Claudia Nice. Printed and bound in the United States of America. All rights reserved. No part of this book may be reproduced in any form or by any electronic or mechanical means including information storage and retrieval systems without permission in writing from the publisher, except by a reviewer, who may quote brief passages in a review. Published by North Light Books, an imprint of F&W Publications, Inc., 1507 Dana Avenue, Cincinnati, Ohio 45207. 1-800-289-0963. First edition.

This hardcover edition of *Sketching Your Favorite Subjects in Pen & Ink* features a "self-jacket" that eliminates the need for a separate dust jacket. It provides sturdy protection for your book while it saves paper, trees and energy.

97 96 95 94 93 5 4 3 2

95B4076

Library of Congress Cataloging in Publication Data

Nice, Claudia
 Sketching your favorite subjects in pen and ink / Claudia Nice.
 p. cm.
 Includes index.
 ISBN 0-89134-472-1
 1. Pen drawing—Technique. I. Title.
NC905.N53 1992
741.2'6—dc20 92-25610
 CIP

Edited by Kathy Kipp
Designed by Sandy Conopeotis

I dedicate this book to the Master Creator, whose handiwork I acknowledge, study with admiration and try to depict with the point of my pen.

Second, I dedicate these pages to my husband Jim, who encouraged me to "climb mountains" and then walked beside me.

I also thank my family and friends for their love and support.

Table of Contents

Introduction, 1

Materials

Find out the professional way to use and care for your technical pen, inks and paper.

2

Strokes & Marks

Learn the seven simple strokes used to create just about every texture in pen and ink work.

6

Creating Value & Contrast

See why the use of contrast and properly placed ink washes can be the key to better ink drawings.

22

Design & Composition

Learn to use ink to create value, texture and shape for a great design.

30

Selecting & Drawing the Subject

Start your drawings off right by selecting the right subject and creating an accurate pencil drawing.

36

Sketching the Plant Kingdom

Step-by-step instruction shows you how to sketch plants, flowers, leaves and trees.

52

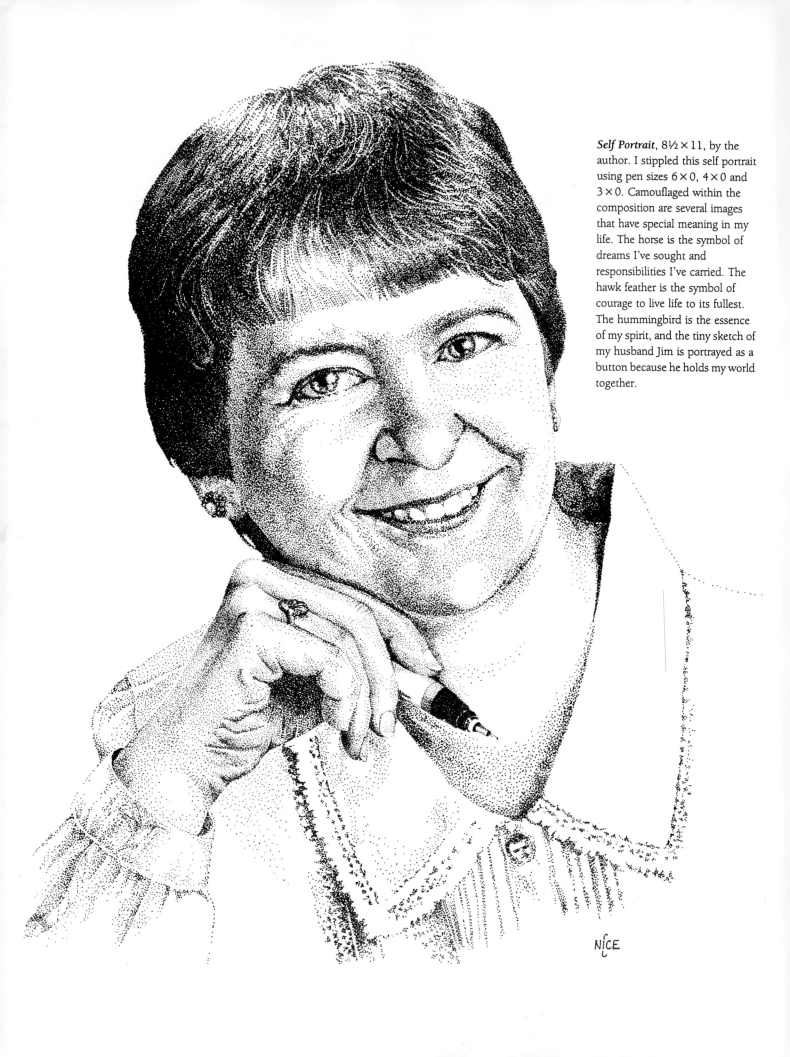

Self Portrait, 8½ × 11, by the author. I stippled this self portrait using pen sizes 6 × 0, 4 × 0 and 3 × 0. Camouflaged within the composition are several images that have special meaning in my life. The horse is the symbol of dreams I've sought and responsibilities I've carried. The hawk feather is the symbol of courage to live life to its fullest. The hummingbird is the essence of my spirit, and the tiny sketch of my husband Jim is portrayed as a button because he holds my world together.

INTRODUCTION

I am fascinated by the tapestry of nature, each woven thread vibrant with the Master's touch. All the colors, textures, forms and designs you could imagine are entwined within nature's mantle; to find them, you need only to open your "artist's eye" and observe. The more I see, the more I am inspired to take my pen and set down yet another lovely scene or intriguing image, lest I forget it. I may change it some to fit my mood or whimsy, or strive to capture it just the way it is. It makes no difference, for if a part of me also flows through the pen and remains behind on the paper, this to me is art.

My favorite subjects are most often found out of doors, sometimes at the end of a meandering country road, along a high mountain trail, or over a barnyard fence. I travel light, with a camera around my neck, a sketchbook tucked under my arm, and a pocketful of sketching tools. Although I work in many mediums, I like the sharp contrast and intricate detail of a pen stroke.

The ink techniques in this book have been developed mainly by trial and error. The failures have been given to experience and the successes have been repeated, improved and committed to memory. This is how to build a personal style, for everyone judges success by a different yardstick, holding fast to those things that please.

So take the pen in hand, learn to observe, feel free to experiment and above all, relax and enjoy what you do. And if this book can help or encourage, then it has accomplished its purpose, and I am pleased.

Happy Sketching,

Claudia Nice

Chapter One

MATERIALS

One of the advantages of pen and ink as an artistic medium is the convenience of the materials, which are few in number and small enough to tuck into a pocket. One needs ink, a tool with which to apply the ink, and a surface to work on.

The Pen

I have used fountain pens, felt-tip markers, fiber-tip pens, art pens, ballpoint pens, reeds, sticks and feather quills for my inking tools, with varying degrees of success. Though interesting, each of the aforementioned writing tools was limited in usage. The characteristics I look for in an ideal pen are a steady, reliable, leak-free flow, and a nib that is precise and can be stroked in all directions.

Originally, bird feathers (quills) were used as writing tools. Generally duck quills were used, but when a finer line was desired, crow quills were selected. The ends of the quills were sharpened to a point with a "pen knife." The quill tip was dipped into the ink, and the hollow feather shaft held enough ink for several strokes.

The *crow quill dip pen* is an adaptation of the early feather quill dip pens. It consists of a plastic or wooden holder and a removable steel nib. With Hunt nibs no. 102 (medium) and no. 104 (fine), the crow quill will provide a good ink line. The tool cleans up easily and is inexpensive. It's useful for applying colored inks when you want many color changes. However, crow quills are limited in stroke direction, with a tendency to drip and

splatter, and the redipping process interrupts the stroking rhythm.

The *technical pen* is an advanced drawing instrument consisting of a hollow nib, a self-contained ink supply (either a prefilled cartridge or a refillable cartridge) and a plastic holder. Within the hollow nib is a delicate wire and weight, which shifts back and forth during use, bringing the ink supply forward. This wire *should not be removed* from the nib.

The nibs are made out of steel and are quite durable on paper surfaces. More expensive jewel point nibs (the writing surface is sapphire) and tungsten points are available for use on more abrasive surfaces. Because the hollow technical pen nibs are circular in design, they can be stroked in any direction. The resulting line is precise, allowing you to achieve engraver's perfection, a loose sketchy style, or a finely detailed pointillistic technique. When properly maintained, the technical pen is reliable and provides a consistent, leak-free ink flow. I consider it the best inking instrument available.

Of all the styles and brands of technical pens available, my favorite is the Koh-I-Noor Rapidograph. I have found it dependable, and the refillable cartridge allows me to choose my own ink. Most of the illustrations in this book were drawn using a Rapidograph pen.

Note: The following information on use, care and maintenance of a technical pen refers directly to the Koh-I-Noor Rapidograph, but will be useful for other brands of technical pens as well, many of which are similar in design.

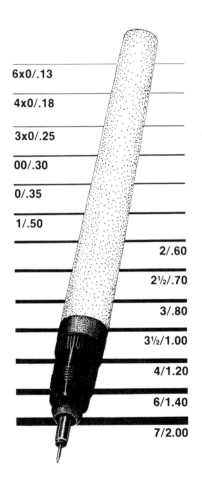

| 6x0/.13 |
| 4x0/.18 |
| 3x0/.25 |
| 00/.30 |
| 0/.35 |
| 1/.50 |
| 2/.60 |
| 2½/.70 |
| 3/.80 |
| 3½/1.00 |
| 4/1.20 |
| 6/1.40 |
| 7/2.00 |

Nib Sizes

Technical pens come in various nib sizes, ranging from very fine to extra broad. The line width chart above shows both the Rapidograph nib sizes and the equivalent metric line widths.

Nib sizes from 6 × 0/.13 to 3 × 0/.25 provide a delicate to fine line, good for detail work. Nib sizes 00/.30 and 0/.35 provide a medium line that's nice for making quick sketches, creating texture and detailing larger drawings. Nib size 1/.50 provides a heavy line that is good for bolder techniques and fill-in work. Nib sizes 2/.60 and larger can be useful for very large, bold illustrations and for

filling in large areas. For a first pen, I recommend nib size 3×0/.25. It's fine enough for detail work, yet can produce nice texture and value changes.

In this book, I have indicated the sizes of the Rapidograph pens I used on many of the projects by placing the numbers in parentheses beside the sketches.

Ink

India inks are composed of water, carbon black particles for rich, dark color, and shellac or latex for a binder. Different blends of these ingredients determine the ink's opacity, open pen time, surface drying time, adhesion and permanence.

Very black, opaque inks have a higher ratio of pigment in the mixture. Such inks give the greatest amount of contrast, and create lines that reproduce well. Keep in mind that heavily pigmented inks may not flow as well in the finer nibbed pen sizes.

Open pen time is an important factor when selecting the proper ink. It refers to the amount of time the ink will remain fluid in an open, inactive nib. (Pens should be capped when not in use.) If you use a 4×0 or 6×0 pen nib or work in a very dry climate, choose a free-flowing ink with a longer open pen time. They are less apt to clog.

India inks labeled "permanent" should hold up under high humidity situations, adhering well to the drawing surface when touched. However, even "waterproof" inks may smear or lose pigment when overlaid with brush-applied washes of watercolor, acrylic, diluted ink or oil paint. Test the ink before applying any type of wash to your sketch.

My favorite India inks are Koh-I-Noor's Universal Black India (3080), a versatile, high-opacity black ink that is free flowing, fast drying, and that withstands being brushed with colored

washes; and Koh-I-Noor's Ultradraw (3085), a very black, easy flowing ink that is ideal for finer nibs.

Dye-based colored inks have a tendency to fade over a period of time. For a brown (sepia) tone or colored ink I recommend Rotring's ArtistColor. It is a finely pigmented, transparent, permanent acrylic that can be used in technical pens.

Liquid Paper for Pen and Ink is useful for correcting small mistakes, or making corrections on art pieces that are to be used for reproduction only. To avoid clogging nibs, let the correction fluid dry several minutes before inking over it.

I have not found an effective way of masking or removing large mistakes from pen-and-ink drawings meant for direct viewing. In most cases, a large mistake means starting over. However, with luck, you might be able to disguise a mistake underneath additional ink lines.

Filling and Starting the Pen

Since technical pen designs vary, carefully read the directions on filling or inserting the prefilled cartridges for each individual pen type.

Unless otherwise stated, start the ink flow by rocking the pen gently in a horizontal position. The best way to start a Rapidograph pen is to hold the newly filled pen, cap off, with the nib pointing up. Tap the side of the pen several times, allowing excess air to escape out the nib. Turn the pen, nib pointing downward, and tap the end of the holder. The ink will drop into the nib and in most cases be ready to write. This eliminates the air bubbles that form when the pen is shaken.

Using the Technical Pen

Hold the pen as you would a pencil, keeping the angle rather upright. Use a steady, *light* pressure, maintaining good contact with the drawing surface. Too much pres-sure will inhibit the ink flow. As the pen travels across the paper, you'll be able to feel the wire within the tubular nib. This is normal.

Do not shake the technical pen. Most clogging problems occur when pens are shaken, thus flooding the air channel with ink. The blocked air channel creates a vacuum that prevents the ink flow. Flooded pens must be cleaned. Keep the cap on when not in use.

Cleaning the Pen

Clean the technical pen at least once a month for maintenance and before storing it unused for more than a month or when it's clogged.

Cleaning methods vary with the style of pen. To clean the Rapidograph and similar pens, disassemble the pen and re-move the nib from the body of the pen. *Do not remove the wire from the nib.* Rinse the nib, pen body and cartridge under running water. You may need a pen-cleaning solution to remove dried ink and shellac. Several commercial varieties are available. A pressure-cleaning syringe, threaded to accept the pen nib, is very helpful in flushing out the old ink and cleaning solutions. Ultrasonic cleaning machines work well but are expensive.

Troubleshooting

Ink flow stops suddenly — usually caused by air bubbles trapped in the nib. With the nib pointing up, *tap* the end of the pen holder vertically against the table.

Pen skips — not enough hand pressure; nib is dirty; or pen is low on ink.

Pen bleeds — caused by temperature change, altitude change, low amount of ink in the cartridge, or dirty nib.

No ink flow — pen is clogged, wire is damaged, or pen is out of ink.

Nib snags — caused by worn nib or in-appropriate drawing surface.

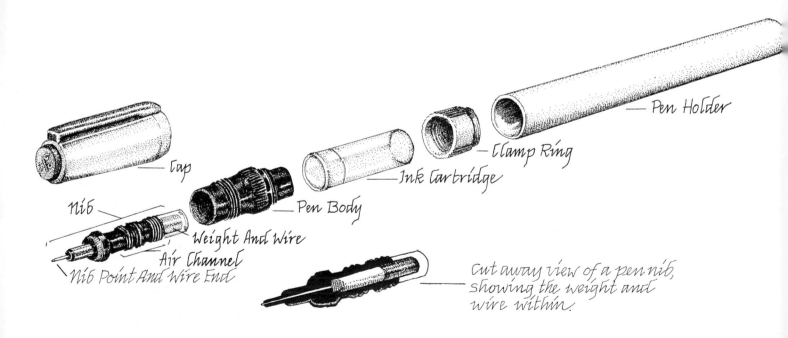

Cap

Pen Holder

Clamp Ring

Ink Cartridge

Nib

Pen Body

Weight And Wire

Air Channel

Nib Point And Wire End

Cut away view of a pen nib, showing the weight and wire within.

Inking Surfaces

When choosing a drawing surface, I look for a paper or illustration board with a firm, polished finish. The pen should glide over its surface without snagging, picking up lint or clogging. The ink should neither bleed nor bead up as it's applied. The resulting line should be sharp-edged and precise in appearance.

• *Hot-press illustration board* was used for most of the drawings in this book. It is an ideal background for detailed ink work: The surface is very smooth and polished, yet highly absorbent. Ink lines applied on this surface may be lightened by gently scraping them with a new razor blade.

• *Cold-press illustration board* has a less polished surface texture that allows the ink lines to lose some of their sharpness. The result is a softer appearance, which complements some subjects and techniques.

• *Mylar* or *acetate* is often chosen as a work surface when the artist needs very precise lines for reproduction. However, these surfaces, both clear and frosted, tend to be abrasive; they can wear out steel-nibbed pens rather quickly. Jewel point or tungsten nibs are recommended for use on these surfaces. Protect ink work on Mylar or acetate from abrasion with a sheet of wax paper on top.

• *Bristol boards* and various *drawing papers* can provide an adequate sketching surface. There are so many grades and varieties that you must experiment to see which of the available papers are compatible with your choice of pen sizes, ink and technique. A frayed ink line is a good indication that the paper is too soft for ink work. Index card stock, parchments and vellums usually hold an ink line quite well. For quick studies and field work, I prefer to work in hardcover, bound sketchbooks. These books usually contain a good quality of paper, and the binding helps preserve the sketches.

• *Watercolor paper* is a good choice if you wish to experiment with a combination of ink line work and washes of transparent acrylic, watercolor or diluted ink.

The more textured the paper, the rougher the line work will appear. Hot-press paper is the most compatible with pen-and-ink lines; however, washes are sometimes easier to apply to the more absorbent, textured surfaces of the cold-press papers. Decide if the emphasis of the art piece will be on the ink work or the painted portion of the composition, and choose the surface accordingly.

My favorite watercolor paper is Lanaquarelle by Lana. The 140-lb. cold press is lightly textured and readily accepts a fine ink line. The 140-lb. hot press has good absorption for washes and has such a nice inking surface that you may choose to use it even when washes aren't involved.

• *Textured surfaces* can add an interesting quality to an ink drawing. I have inked successfully on mat board, glass, portrait-grade stretched canvas, film, sealed wood, leather and polished rock. Almost any smooth surface is fair game for experimentation, keeping in mind that pens tend to wear and clog when abused.

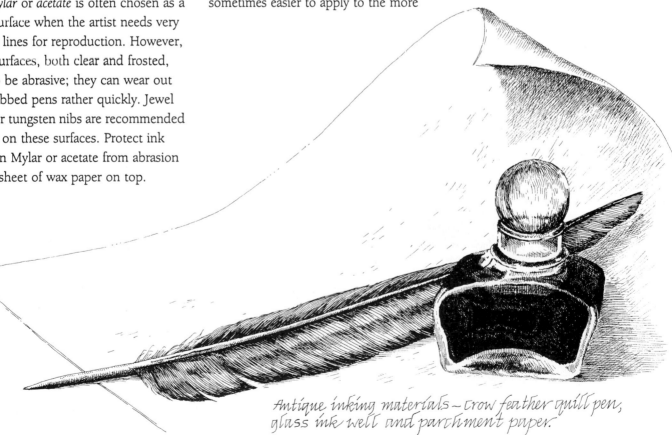

Antique inking materials — crow feather quill pen, glass ink well and parchment paper.

STROKES & MARKS

Pen-and-ink art consists of a series of marks set down on the paper to create a pleasing composition. There are basically two types of marks that can be applied to the paper: dots or lines. Both dots and lines can be varied in size, volume and arrangement. Lines also can be varied in form. By changing the size, volume and arrangement of the marks — and in the case of lines, their form — you can create the appearance of texture.

There are seven distinct texturing techniques: contour lines, parallel lines, crosshatching, dots or stippling, scribble lines, wavy grain lines and crisscross lines. Each of these texture groups and their many variations will be dealt with separately in this chapter. In addition, there is the line drawing technique that is a form of scribble line, but is distinct in that it deals mostly with the outline of shapes rather than inner contours and shading.

The pen-and-ink artist has the choice of using only one texturing technique in her work or using several or all of them in one composition. Textures can be layered one over another to produce countless effects. The ink marks each artist chooses to use and the way in which he arranges and combines them will constitute that artist's style. As in other mediums, the ink artist can develop his inking style to the point that his work becomes quite distinct and recognizable.

Line Drawings

Line drawings consist of free-flowing outlines that define the general shape of the subject. While texture, highlights and shadows are sometimes suggested by an additional scribble of the pen, the main emphasis of a line drawing is simplicity of form.

Line drawings in their simplified form are the fastest way to sketch. They're great for capturing a subject on the move. Many an artist's sketchbook is filled with hastily rendered line drawings that record some idea or intriguing shape to be referred to at a later time.

Neighborhood Kids (right) was first lightly sketched in pencil, then loosely inked using a 3 × 0 Rapidograph pen. However, it's not always necessary to precede a line drawing with pencil work. A line drawing set down directly in ink often has a special freedom to it that offsets inaccuracies of form.

Neighborhood Kids is a line drawing of several children at a birthday party. As in all line drawings, simplicity of form is important in this sketch, with just enough detail added to hint at interior shapes, children's identities and their moods.

Contour Lines

Contour lines are those lines that precisely follow the curves and planes of an object. They should flow over the surface contours like a thin sheet of water over glass, producing a very smooth appearance. Not only is this technique useful for portraying solid objects with polished finishes, but contour lines also can be utilized to give fluid subjects, such as ocean waves, the appearance of motion.

Contour lines may be straight or curved, long, or short enough to be considered dashes. The marks should be aligned side by side but uneven in length, so that when they are applied they will not line up in uniform rows across the surface of the object, producing a distracting design. (See example A below.)

If the pen is not lifted carefully at the end of each stroke, little hooks are formed at the top or bottom of the line, spoiling the look of smoothness (example B). Eliminate the hook problem by slowing down and concentrating a little more on each individual stroke. On the other hand, you can sometimes correct the tendency to produce wiggly lines by speeding up the stroking procedure and developing a rhythm.

Seashells and Marbles is a contour line drawing that took approximately twelve hours to complete. I used Rapidograph pen sizes 4×0 and 6×0. When working in contour lines, keep in mind that lines that wrap around the subject horizontally will give the feeling of solidness and weight to the object they depict. Note the seashells within the glass vase. Contour lines that are applied vertically will lend the appearance of height and grace to the subjects they depict. Note the glass vase and the seashell on the right.

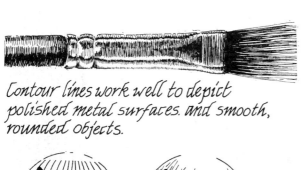

Contour lines work well to depict polished metal surfaces and smooth, rounded objects.

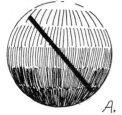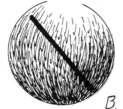

A. B.

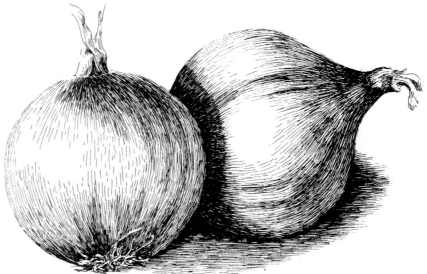

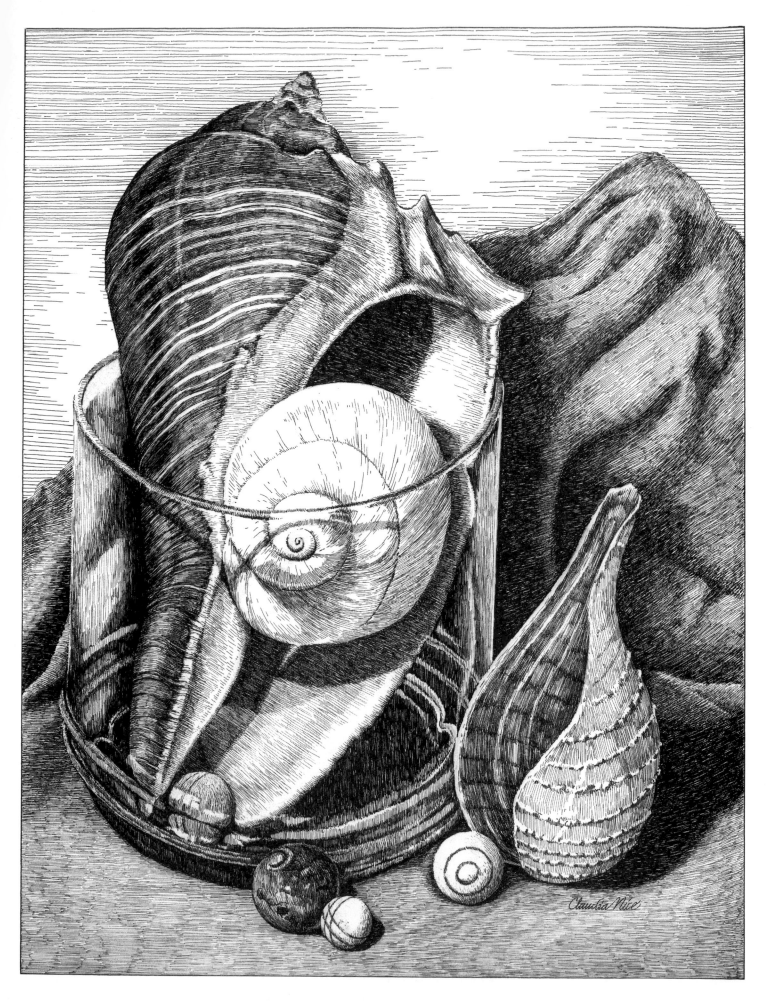

Parallel Lines

Parallel lines, drawn freehand as a sketching technique, should be as straight as the human hand can draw them, extending in the same direction and stopping short of actually crossing over one another. They may be drawn horizontally, vertically or diagonally.

Parallel lines give a subject a flat, smooth appearance. When used without an outline, these lines portray a faded, hazy or distant look, making them perfect for depicting background objects. When drawn over flat surfaces, they look the same as contour lines, except that contour lines curve over rounded surfaces

and parallel lines *always* remain straight.

The human wrist bends in an arch when it moves, which makes drawing a long, straight line difficult. I prefer to break long lines into sections, leaving tiny spaces between marks. These spaces are staggered to present a natural, random appearance, as in example A below.

During the preliminary pencil sketch stage of a drawing, you may wish to use a ruler and put a straight pencil mark about every inch for a visual guide. However, I seldom use a ruler to make ink marks. One perfect line will make all freehand lines look off.

Draft Horse Team was sketched using vertical parallel lines. I used pen sizes 4×0, 3×0 and 00. The drawing took eight hours to complete. I chose the parallel line technique because its hazy quality added the look of shimmering heat to the composition, suggesting that the team was working on a warm summer afternoon.

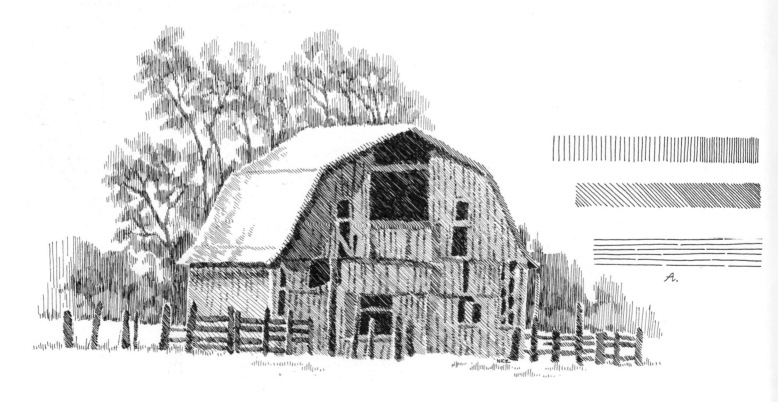

A.

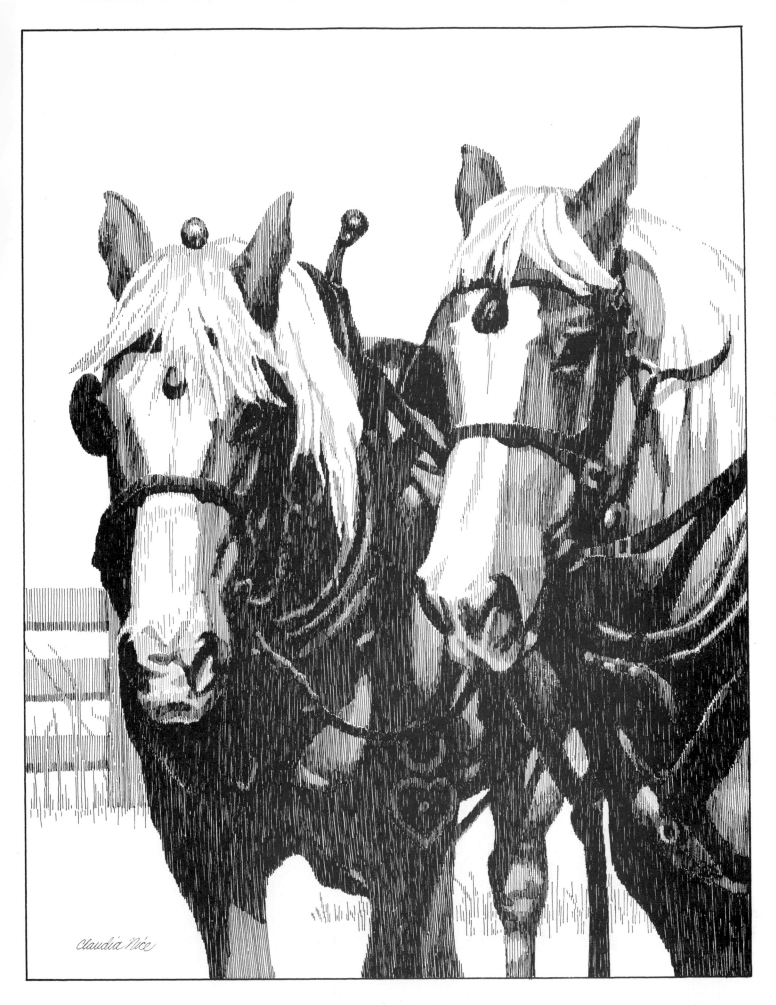

Crosshatching

Crosshatching uses two or more sets of contour or parallel lines that are stroked in different directions and intersect. You can use crosshatching to add roughened texture or to deepen tonal value. Contour crosshatching will depict curved objects, while parallel-line crosshatching suggests flat planes.

If you use a very loose, sketchy crosshatch, with the lines changing direction at whim, the result can be a rugged, heavily textured look (see example A at bottom). This is useful in depicting coarsely woven fabric, craggy rocks, weathered shingles, tree bark, etc.

If you use a finer-sized pen nib and crosshatch in a precise, even manner, the result is a semismooth, lightly textured appearance. This finer crosshatch technique is so versatile and so easy to control in value and form that many artists choose to work with it exclusively. Fine crosshatching is especially nice to portray the shadowed contours of the human body.

If you use three or more sets of lines, intersecting from different directions in a precise manner, you form geometric shapes. I refer to this type of crosshatching as "honeycombing" (see example B at bottom right).

Elephant Portrait is an example of fine crosshatching work. I used pen sizes 6 × 0, 4 × 0 and 3 × 0. It took close to sixteen hours to complete. The use of contour crosshatching allowed me to follow the folds of the elephant's wrinkled skin. Crosshatch lines that intersect at right angles suggest a look of stability. Lines that cross diagonally may have a shimmery or fluid appearance.

Above are examples of fine crosshatching done with a 4x0 pen nib.

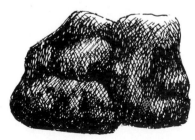

A. Examples of bold, sketchy crosshatching drawn with a size 0 nib.

B. Honeycomb Crosshatch

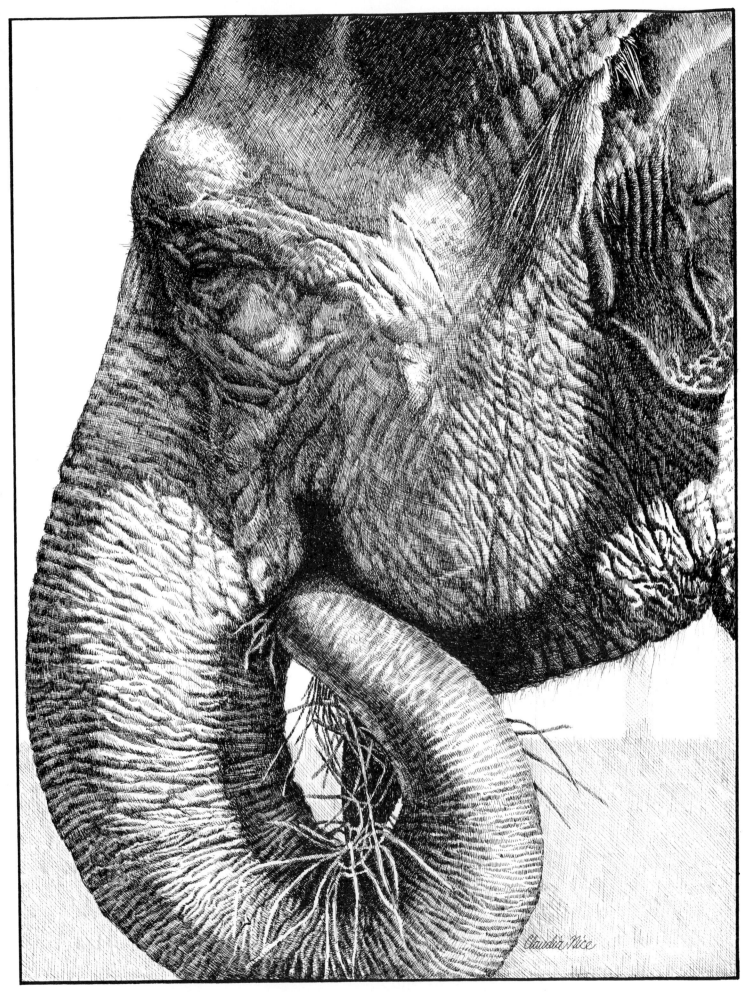

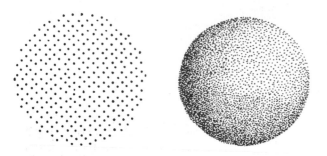

Dots or Stippling

A dot is produced by holding the pen nib perpendicular to the paper, touching the pen to the surface, and raising it without dragging. The result is a round black mark. Texturing an area with a grouping of dots will give it a dusty, gritty or velvety appearance. Dots are also useful for depicting subjects consisting of a lot of little particles, like water spray, clouds or sand. When an entire composition is rendered in dots, it takes on the look of antiquity, as if it were sprinkled with the dust of ages.

Stippling is both the most tedious and forgiving of techniques. It takes a while to shade an area, dot by dot. On the other hand, a few dots out of place are seldom noticed.

Many artists favor stippling technique because of the subtlety of value changes that they can achieve simply by changing the density of the dots. The smaller the nib size used, the more delicate and well blended the dot work will appear (see example A, below right). I seldom use a pen nib size greater than 00.

Chair by the Cottage Window is a stippled drawing. The composition took approximately twenty hours to complete, using pen sizes 4 × 0, 3 × 0, 00 and 0. A drawing rendered entirely in dots takes on an aged quality, making it perfect for depicting antique subjects.

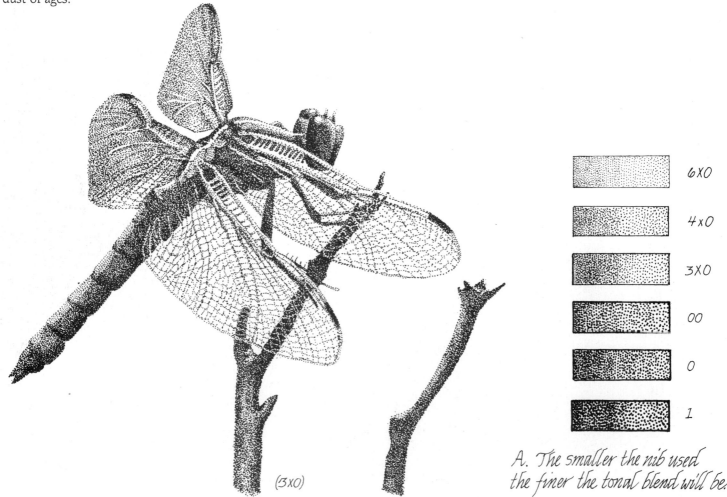

(3X0)

6X0

4x0

3X0

00

0

1

A. The smaller the nib used the finer the tonal blend will be.

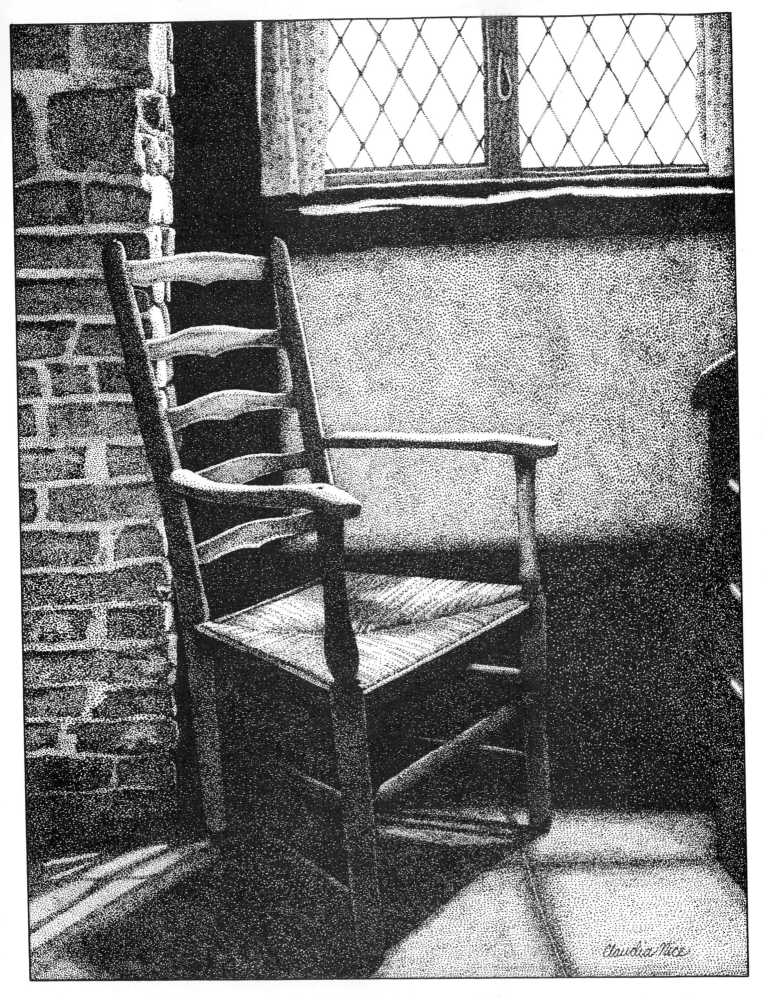

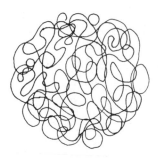

Scribble Lines

A scribble line is a mark that loops and twists about in a loose, whimsical manner. It may move in any direction and be as long or as short as desired. Scribble lines are popular for making quick field sketches because they produce images quickly and are loose enough to allow some room for correction.

When used as a texturing technique, scribble lines create a thick, matted look. Rounded loops give a soft appearance that is great for depicting background trees and shrubs, tangled undergrowth areas and curly hair (see example A, below center). If the scribble lines bend back on themselves at sharp angles, they achieve a wiry look (see example B).

Some artists use scribble lines in a more stylized manner, producing small curlicue shapes of similar design or a continuous pattern of loops (example C, below right). Stylized scribble lines can be used to duplicate designs such as those often found in printed fabric or to produce images with a contemporary or fantasy quality.

Contemplation Under the Maple Tree is a sketchy, scribble-line drawing. It took ten hours to complete using pen sizes 4×0, 3×0 and 1. Scribble-line technique is a favorite of mine for depicting thick, tangled foliage areas and rough, mossy tree bark. Because of its busy appearance, scribble-line areas should be contrasted against open, uninked or lightly inked areas.

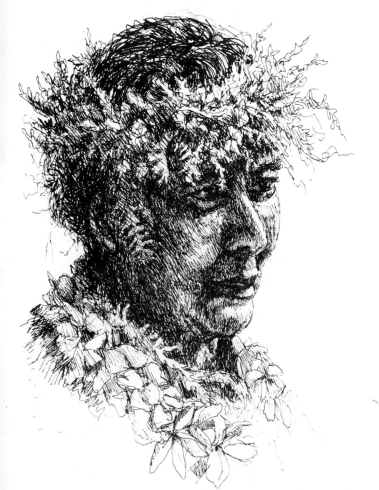

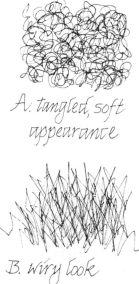

A. tangled, soft appearance

B. wiry look

C. Above are examples of stylized scribbling.

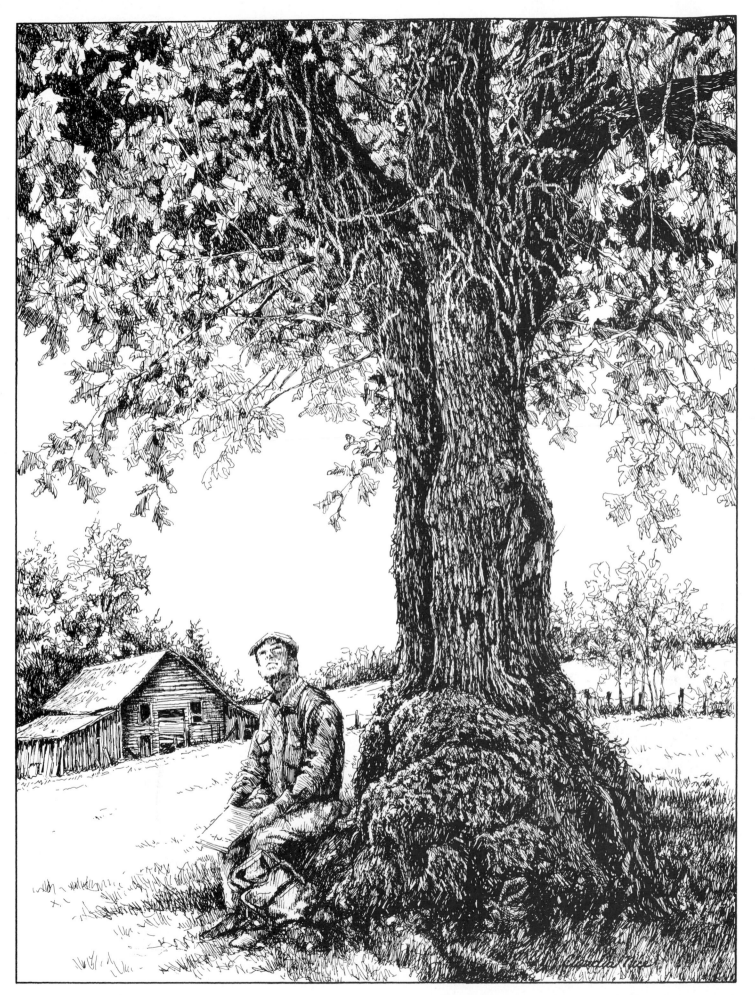

Wavy Lines

Wavy lines are drawn side by side in such a manner as to form a rippling pattern. Wavy lines are useful for depicting the repetitive patterns found in marble, woodgrain, water rings, feather barbs and the veins of some leaves.

When depicting wood grain, first pencil in the elements that determine the pattern of the wood, such as knotholes and cracks. Ink in these areas. Then draw the first wavy line in the direction of the woodgrain, passing near to and wrapping around one of the cracks or knotholes like a hand in a glove. Each wavy grain line that you add must conform to the developing design, incorporating new knotholes and cracks as you encounter them. For coarser wood grains, use larger-sized pen nibs, and spread the wavy grain lines farther apart.

Marble is depicted like woodgrain, but some of the spaces between the wavy lines are textured and shaded using contour lines, parallel lines, crosshatching, dots or scribble lines — or a combination of several (see below right). These textured stripes represent color changes and mineral deposits within the marble.

When using wavy lines to suggest a grain pattern, add shadows by using a second layer of contour or parallel lines. If the shading lines run in the same direction as the grain lines, the wood or marble will look smooth. When the shading lines crosshatch across the grain lines, the result will be a rough, abraded appearance.

Bunk House Window was sketched using the wavy-line technique to depict the various woodgrains. It took eight hours to complete. I used pen sizes 4×0, 3×0 and 4. Then I used the large no. 4 pen to fill in the background, which was applied in four layers, the pen work in each layer stroked in a different direction. I added a final fifth layer, using a pen size 0 to add stroking texture to the black surface and to fill in small areas at the edges and around the chicken wire.

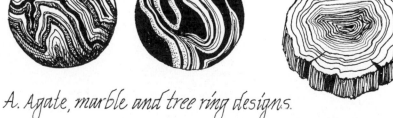

A. Agate, marble and tree ring designs.

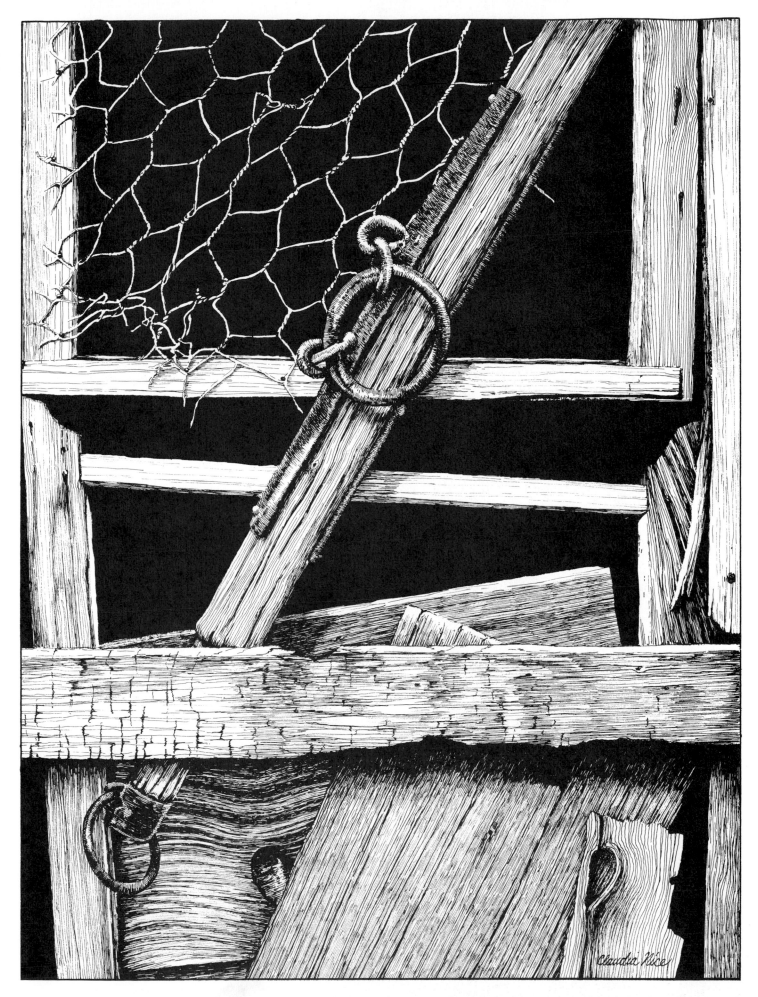

Crisscross Lines

Crisscross lines are similar to both contour and crosshatch lines in that they generally flow with the contour of the object they're sketched on. However, instead of being placed side by side as contour lines are, the crisscross lines are free to cross over each other at random.

Crisscross lines do not end abruptly at the edge of an object but hang unevenly over the edge, creating a hairlike or furry texture. (Animal fur is discussed in detail in chapter ten.)

When crisscross lines are stroked upward, they can be used to represent blades of grass or weed stocks. In this technique, each line represents one hair or grass stem. The lines should be as long or short, as straight or curved, as the fur or blade of grass they represent. I find I have more control over the stroking of the lines if I draw the pen toward my body. For this reason I often turn my working surface sideways or upside down in order to stroke in a comfortable direction.

Timber Wolf is a crisscross stroke composition that took eight hours to complete. I used pen sizes 4×0 and 3×0. When using crisscross lines to depict fur, each line represents a hair in the animal's coat. Therefore, pay special attention to the length of each line and the direction in which it's stroked.

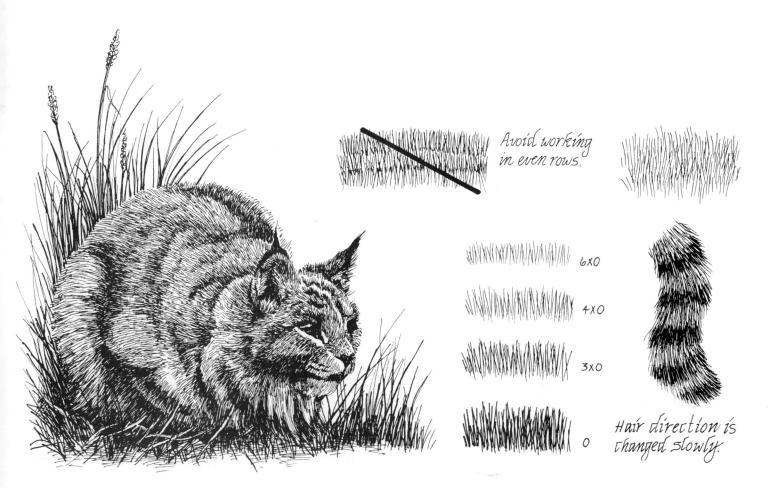

Avoid working in even rows.

6×0
4×0
3×0
0

Hair direction is changed slowly.

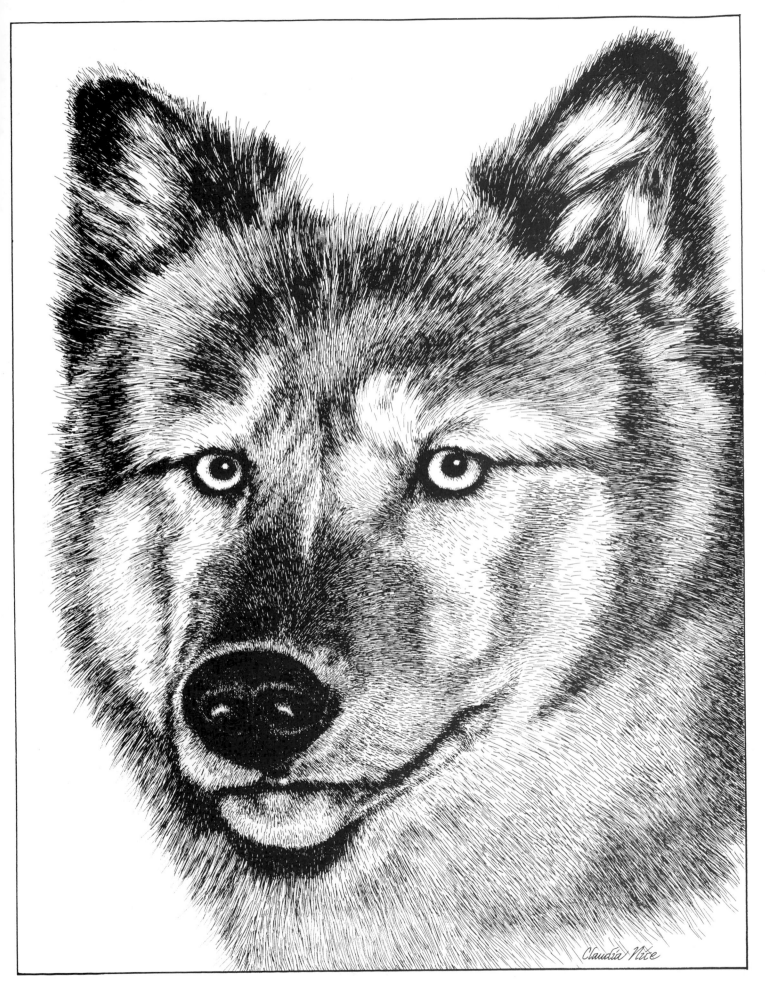

Chapter Three

CREATING VALUE & CONTRAST

Value is the degree of lightness or darkness in a color. Artists working in India ink deal with a limited color range: white, grays and black. White is achieved by the absence of black marks on a white surface. When white areas are intermixed with black marks, gray values are formed. If white prevails in the mixture, the gray values will be light. As more marks are added, the degree of darkness in the gray value area will be greater. When the marks are so close together that the white surface no longer shows, black is achieved.

Value changes in pen-and-ink work may be accomplished in two ways: by layering sets of black marks one over another to deepen the value (see example A below), or by moving the marks closer together as they are set down (example B).

The use of value in pen-and-ink work is important. Too much white in a drawing can give the composition a flat or sun-bleached appearance. Overuse of mid-value grays can cause a sketch to appear overworked. When so many marks have been added that the entire composition turns near black, it's time to start over.

Weyerhaeuser Pinecones, 8 × 14, sketched by Gary Simmons of Hot Springs, Arkansas, is a superb example of the use of value in pen-and-ink work. Gary's work is characterized by intricate crosshatching, creative use of negative space, and attention to detail. © 1987 by Gary Simmons.

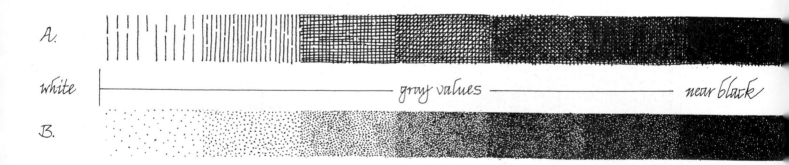

A.

white ———————————— *gray values* ———————————— *near black*

B.

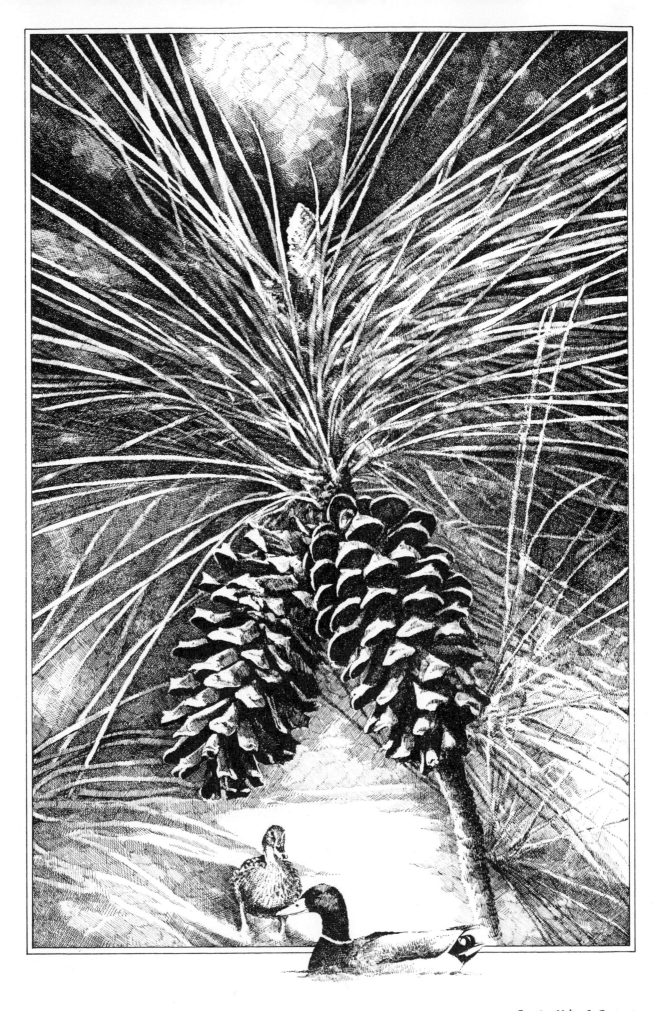

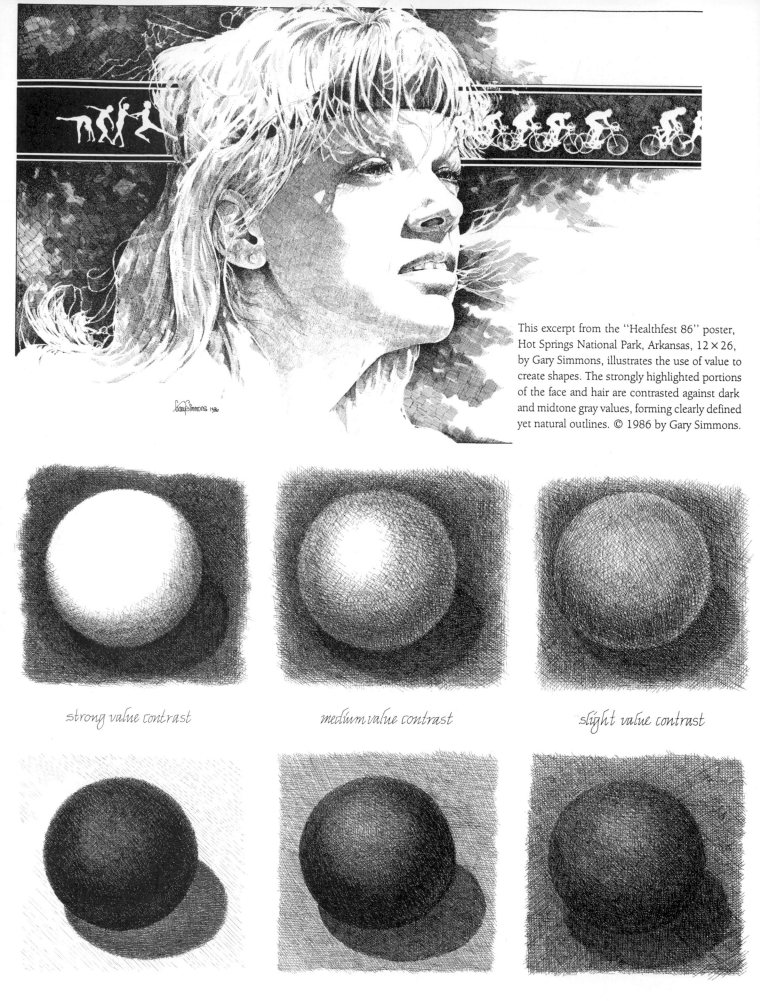

This excerpt from the "Healthfest 86" poster, Hot Springs National Park, Arkansas, 12 × 26, by Gary Simmons, illustrates the use of value to create shapes. The strongly highlighted portions of the face and hair are contrasted against dark and midtone gray values, forming clearly defined yet natural outlines. © 1986 by Gary Simmons.

strong value contrast *medium value contrast* *slight value contrast*

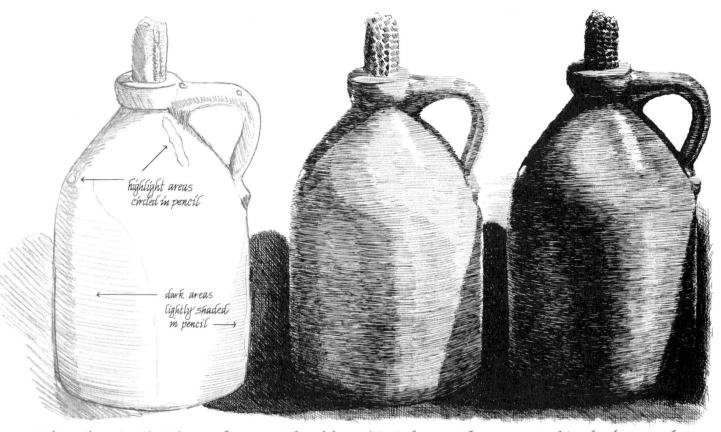

Light pencil sketch with highlights and shadows marked.

Ink work begun with shadows stroked slightly darker.

Completed ink drawing with values ranging from white to black.

The pen-and-ink artist need not draw an outline around subjects to give them form. He may do this subtly by the use of *value*. Placing dark objects against lighter backgrounds and vice versa provides a natural edge where the two values meet. The greater the contrast between the two values, the more distinct the edges of the objects will become, and the more the object being depicted will stand out in the composition.

Value contrasts that are less dramatic, such as light gray against dark gray, can be used to create objects that blend somewhat into their surroundings. However, keep in mind that some contrast must exist to give definition to the shapes in the drawing.

Before beginning the actual work, decide how light your lightest value will be — white or light gray — and how dark your darkest value will be — dark gray, near black or black. Circle the white highlight areas with a pencil to remind yourself to take caution. White areas, once marked with ink, cannot be recovered easily.

The actual ink stroke work is begun in one of the light gray sections, deepening the value only slightly to mark the location of a darker area. Continue to deepen all darker value areas gradually. It's easy to stroke a section of the drawing heavier than first intended, causing you to compensate by darkening the values of the whole composition.

Contrast is the key to a well-defined drawing. While contrast of value and the skillful use of highlights and shadows will go a long way in forming distinct shapes, there are other factors to consider. Texture, line direction and nib size are subtle tools that can all add to the contrast of a composition.

Texture is created by the use of the various stroking techniques. Open white areas are devoid of texture. Contour- and parallel-line work provides a simple, smooth texture. Dots, crisscross lines and crosshatching create patterns that are more complicated. Wavy-line and scribble-line patterns can be very busy textures.

When two areas of similar value are placed side by side, you can use texture to help distinguish one area from another. For example, both the crisscross blades of grass and the dotted, sandy soil they're growing from may be depicted in midgray values, but the grass will be distinguishable from the soil because of a contrast in texture. Placing simple textures next to complicated ones will provide the most dramatic contrasts. You can achieve subtle contrasts in texture by placing one texture over another in a gradual blend.

Line-direction variation is another way of creating contrast. This technique is es-pecially useful in a composition where only one stroking texture is used. For example, in a drawing created entirely of parallel lines, changing the line direction from a vertical slant to a horizontal direction could be quite distinctive, calling attention to certain areas of a drawing.

Switching line direction from background to foreground can help move the foreground subjects forward, providing more of a three-dimensional illustration. Keep in mind that line direction can also be detected in black, solidly marked areas.

You also can create contrast by simply switching pen sizes. Not only does the width of the line differ, but also the amount of ink being laid down. Marks created by larger nibs have a thicker concentration of ink and therefore better coverage. (In other words, an area filled in solidly with a fine nib would be lighter in value than an area filled in solidly with a heavier nib.)

By combining variations of value, texture, line direction and nib size, you can create countless contrasts. The artist is limited only by his imagination.

Contrast of texture

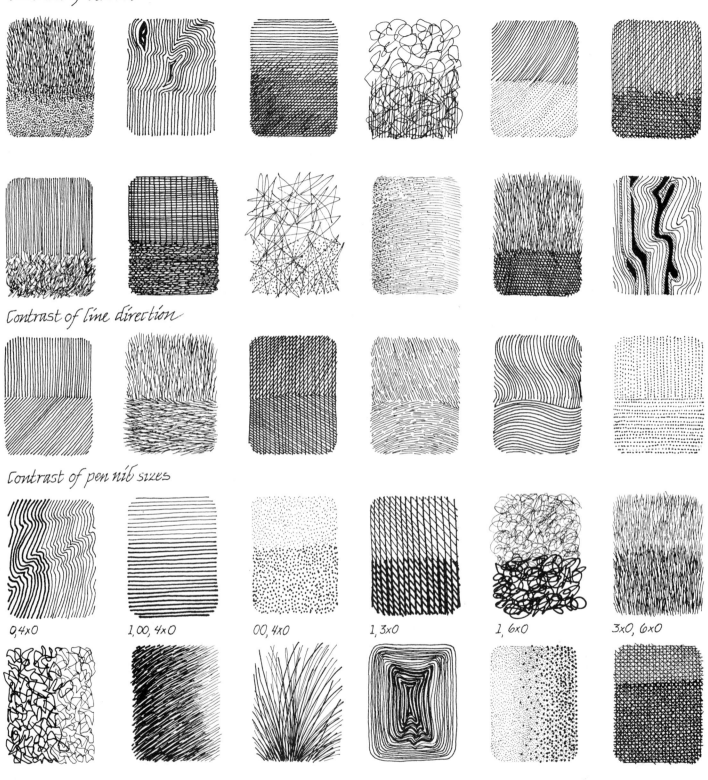

Contrast of line direction

Contrast of pen nib sizes

0,4x0 1,00,4x0 00,4x0 1,3x0 1,6x0 3x0,6x0

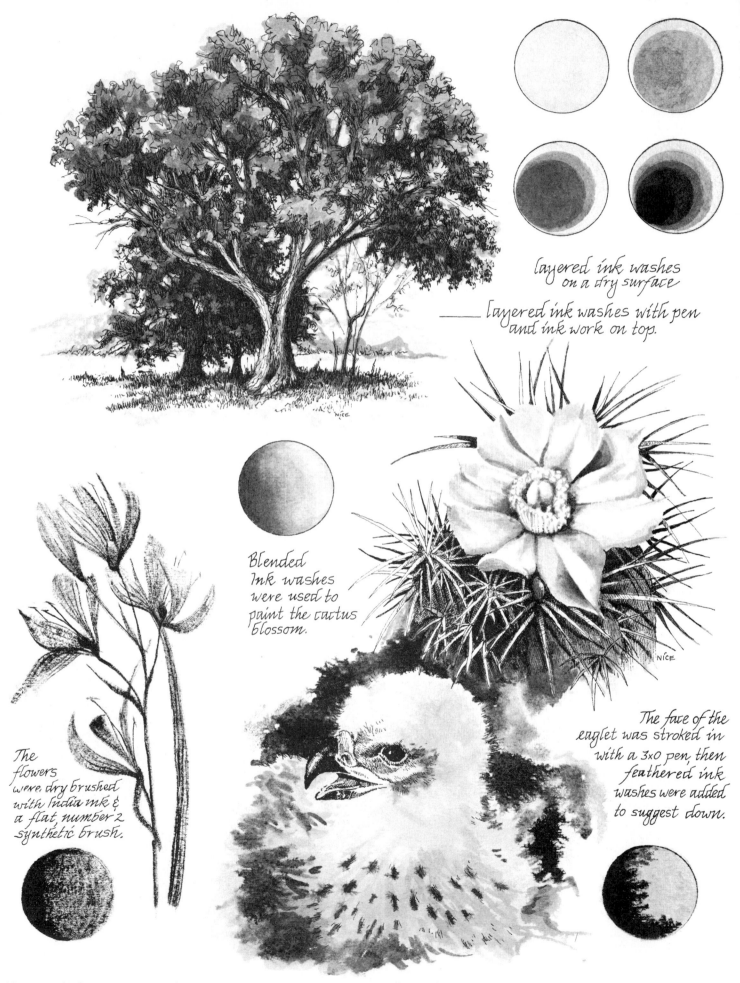

layered ink washes
on a dry surface

_____ layered ink washes with pen
and ink work on top.

Blended
Ink washes
were used to
paint the cactus
blossom.

The face of the
eaglet was stroked in
with a 3x0 pen, then
feathered ink
washes were added
to suggest down.

The
flowers
were dry brushed
with India ink &
a flat number 2
synthetic brush.

Ink Washes

Unusual contrasts in texture and value can be achieved by combining pen and ink, and ink-and-brush painting. This procedure requires a water-absorbent surface such as watercolor paper and one or two old watercolor brushes. India ink, fountain pen ink or black watercolor may be used for the washes. (A wash is simply an ink or paint diluted with water.) Washes may be applied over ink drawings if a permanent, brushable ink was used in the pen.

Applying the washes to a dry or almost-dry surface will result in painted areas with sharp, controlled edges. Layers of different wash values may be built up by letting each wash dry before the next darker wash is added.

For a softer, blended look, work on a damp surface. Blend a lighter wash into a darker one by stroking them with a clean, damp brush where they meet. As the brush picks up pigment, rinse and blot it to prevent the darker wash from spreading too far. Work in small areas so that the blending may be accomplished before the washes dry.

Feathered washes are achieved by working on a surface that is wet, but not runny. As you stroke on the wash, the water on the surface will pull the pigment into random, feathery designs.

Dry-Brush

The dry-brush technique is so named because no water is used on the brush; it is dipped directly into the ink. The freshly dipped brush leaves heavy ink coverage, but if it's blotted on a paper towel it leaves a softer gray tone that can be used for lighter value areas. I use an old, flat synthetic brush that is stiff enough to stand up to scrubbing, but soft enough to produce good lines. Dry-brush ink work has a sketchy, primitive quality.

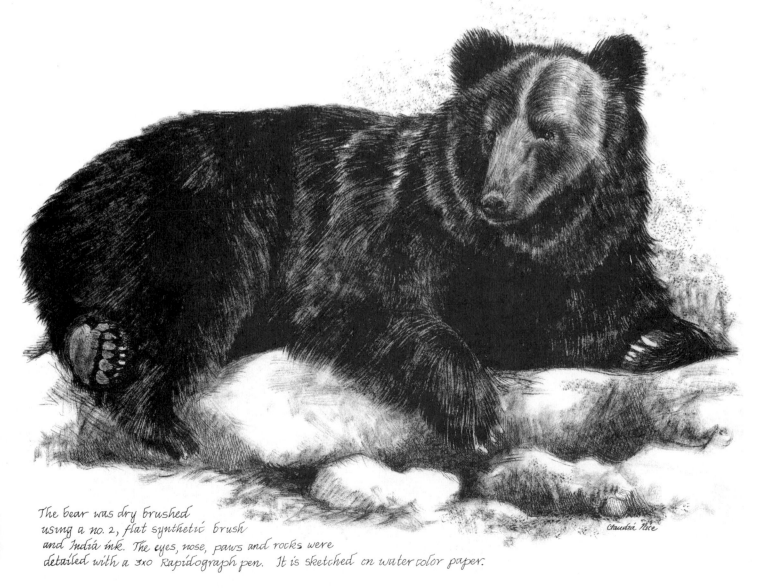

The bear was dry brushed using a no. 2, flat synthetic brush and India ink. The eyes, nose, paws and rocks were detailed with a 3x0 Rapidograph pen. It is sketched on watercolor paper.

Claudia Nice

Chapter Four
DESIGN & COMPOSITION

Composition is the way in which the various elements that make up an art piece are arranged. These elements include color, value, texture, and the size, shape and direction of the subjects being portrayed. Design is the blueprint or plan behind the composition.

In a well-planned composition, the viewer's eye is first attracted to the piece by a striking shape or color; then by skillful use of design, the eye is guided on a continuous pathway throughout the work, finding new subtle points of interest. When any one part of the composition becomes overpowering, the eye will focus exclusively on that one area, and the overall harmony of the composition is spoiled. The master designer considers all aspects of the composition, striving for harmonious balance throughout.

Balance in an artistic sense is not the creation of mirror-image perfection, but rather the random, imperfect balance found in nature. This natural balance can best be achieved by thinking in odd numbers — one, three, five, etc.

If you planned a landscape consisting of two equal-sized trees, either the trees could be placed on each side of the composition — making the drawing uniform but boring — or both the trees could be placed on one side of the drawing, which would threaten to make the composition one-sided. By working instead with three trees of varying sizes, two could be placed together on one side and the third could be placed on the opposite side, creating an interesting *imperfect balance*. This is sometimes called the "triangle theory of composition," because a design element in one area of the artwork is repeated again in at least two other places within the piece, thus forming a continuous triangular path for the eye to follow.

perfect balance

unbalanced

imperfect balance

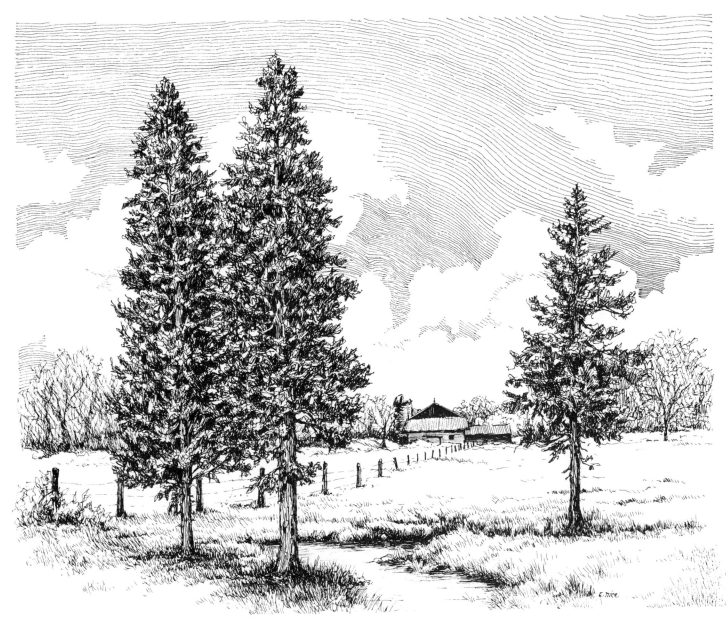

Value and texture take on a special importance when you work exclusively with black India ink. Not only do these two design elements define shape and depth as described in chapter two, but value and texture can be used to create pathways and stepping-stones for the eye to follow.

In most compositions, the eye tends to go to the black or near-black areas first. Then the more complicated gray, textured areas are examined. Last of all the eye rests in the quiet, unworked white areas. You can use this knowledge in your design plans to allow strong shadow areas to act as roadways, leading the viewer to important subjects and points of interest. Take care that none of the values or textures overwhelmingly dominates the composition.

Color is not usually an element that concerns the pen-and-ink artist; however, you may wish to experiment with colored inks or washes. Following the triangle theory of composition, if a color is used in one area of the drawing, then that color or a tint or shade of that hue should be repeated in at least two other spots.

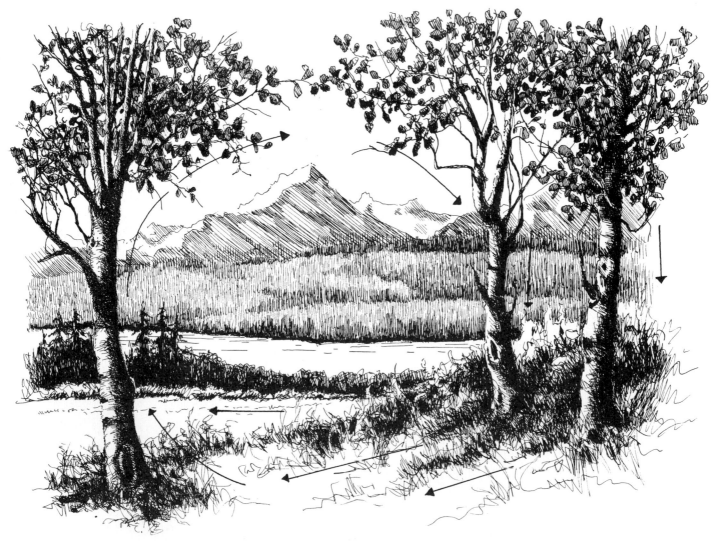

In this sketch the eye follows the pathways created by the dark value areas.

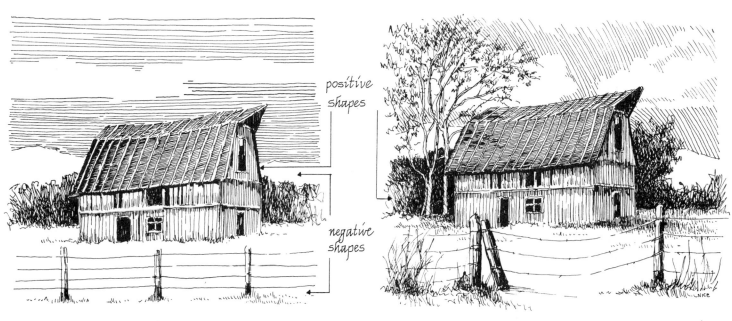

positive shapes

negative shapes

Too many horizontal lines and shapes stretch across this drawing, leading the eye out of the composition

This is a better composition with both vertical and horizontal lines, as well as curves.

Shapes represent the building blocks of the composition. Positive shapes represent objects and the shadows they cast. Negative shapes are the spaces surrounding the objects. Both positive and negative shapes are in all art pieces, and each is important to the composition.

Shapes vary in size and form, creating interest within a work of art. Each composition should have an imperfect balance of the following: objects that stretch up-ward vertically, objects that spread across the surface horizontally, and shapes that are centered masses such as circles or squares. You should also find a good mixture of straight lines and curves within an art piece. Straight lines direct the eye with authority, while curves invite the eye to move along at a slower, meandering pace.

Avoid strong, unbroken lines or shapes that disappear off the edge of the work surface; they will lead the eye out of the composition. Soften their outward direction by crossing them with lines or shapes that lead back into the drawing.

When a main subject needs to be placed near the center of the composition, either off-set it slightly to one side, or combine it with a couple of other objects that are set off to the side of it. This arrangement will keep the subject from dividing the composition in half.

vertical center of interest

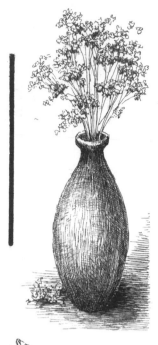

Horizontal center of interest

The focal point of a composition is called the "center of interest." The arrangement of the center of interest, and the placement of the secondary lines and forms that lead the eye and provide contrast and balance, determine the design of the composition. Some of the basic compositional structures are shown here.

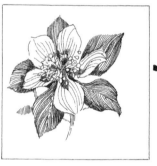

Diagonal center of interest

Centered focal point (avoid placing the center of interest in the exact middle of the composition.)

Converging lines leading to the focus point

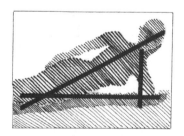

A few of many possible design combinations.

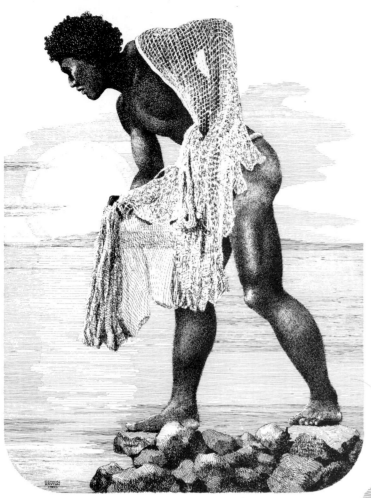

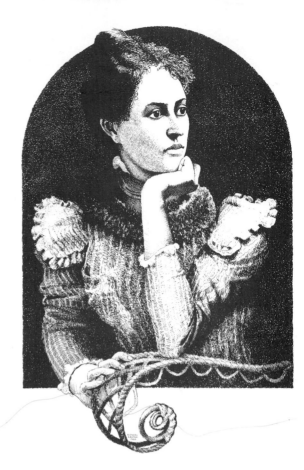

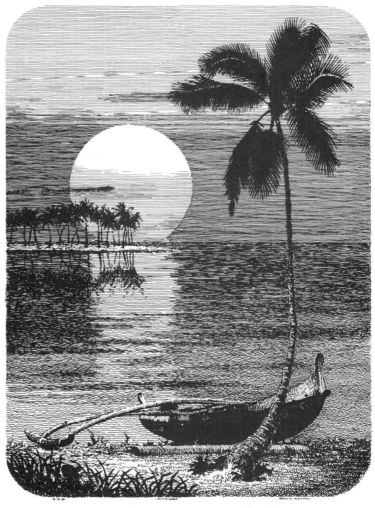

These Polynesian sketches, penned by Hawaiian artist Edwin Kayton, depict the ethnic lore and cultural heritage of the islands.

Net Thrower (above) is a diagonal design depicting the ancient Hawaiian art of net fishing.

Ka'iulani (above right) has a centered focal point (the face) with the arms, shoulders and wicker chair arm providing strong lines that lead back to the face. This drawing of Princess Ka'iulani is a composite of several photos taken of the late-nineteenth-century heir to Hawaii's throne.

Outrigger (right). In this composition, Kayton combined the horizontal design of the canoe with the vertical design of the palm tree. Then he added the supporting shapes of the moon, horizon and distant palms to provide contrast and balance.

SELECTING & DRAWING THE SUBJECT

When choosing a subject for a pen-and-ink drawing, consider three things: appeal, adaptability, and your skill as an artist.

Appeal — The subject must have enough appeal to hold your interest long enough to finish the sketch, and enough appeal to capture the eye of the viewer.

If you wish simply to render a "subject study" sketch, look for an interesting example to draw from. The most appealing study sketches are those that show fine details, that depict action, or that are a little bit out of the ordinary in form or design.

Subjects that appeal to the viewer on both a visual and emotional level are the ultimate choice for artistic renderings. Therefore, consider not only the subject you wish to portray, but how that subject makes you feel. A landscape that is simply pretty will not have the same impact as a landscape that moves the viewer to feel majestic inspiration, stormy unrest, nostalgic yearnings or peaceful tranquility.

Adaptability — The chosen subject must lend itself to be adapted into good compositional material. Study the subject to see if the objects will fit well onto the sketching surface. If not, could they be easily altered to do so? Will the subject shapes allow you to achieve unequal balance in size, form and direction within the composed drawing? If the subject does not naturally have these qualities, can it be changed without destroying its appeal?

Mentally strip the color from the proposed subject and consider it in terms of the values and textures that are crucial to a good pen-and-ink art piece. If color is the main appeal, it probably would not adapt well to pen and ink.

Skill — Last of all, be honest with yourself in considering your level of artistic skill. Can you arrange, draw and ink the proposed subject with some degree of proficiency? And should the venture fail, will the experience gained be worth the effort?

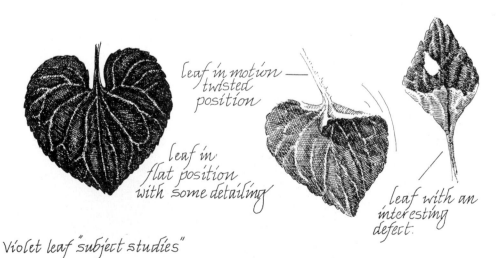

leaf in motion — twisted position

leaf in flat position with some detailing

leaf with an interesting defect.

Violet leaf "subject studies"

leaf with unusal shape

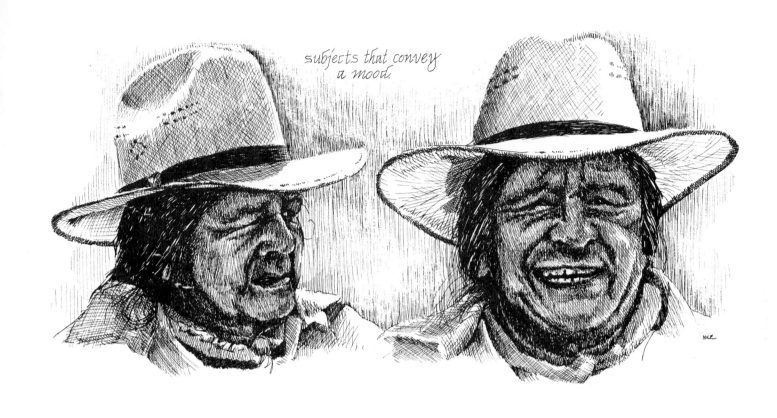

subjects that convey a mood.

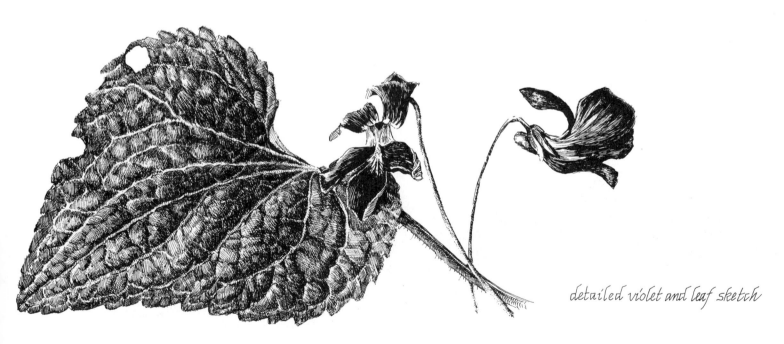

detailed violet and leaf sketch

From Pencil Drawing to Ink Work

I begin my drawings by studying the subject, visually locating the various geometric shapes that make up the object and the negative shapes that surround the subject. Then I set these shapes down on paper in a light, sketchy manner, using a no. 2 pencil. I try to forget what I am drawing and concentrate on the geometric shapes and how they are placed in relation to each other. The result is a rough framework on which to build a more accurate drawing (see step 1, below).

Next, I refine the drawing, making corrections and erasing lines that are no longer needed. I keep pencil work light to prevent etching lines into the surface of the paper. At this time I use a ruler to pencil in any lines that need to be straight. These will serve as a visual guide when I ink (step 2, top right).

When I am satisfied with the overall appearance of the basic drawing, I pencil in a *few* of the finer details, and suggest where important highlights and shadows belong (step 3, center right).

Finally, I stroke on the ink work over the pencil lines, beginning in the foreground. It's easier to shade around foreground objects than it is to get rid of background lines that are in the way. I try to resist the use of a ruler during the pen-and-ink portion of my work. Lines that are too straight and perfect tend to transform the sketch into an architectural drawing. When the ink work is finished and dry, any noticeable pencil lines can be erased (step 4, bottom right).

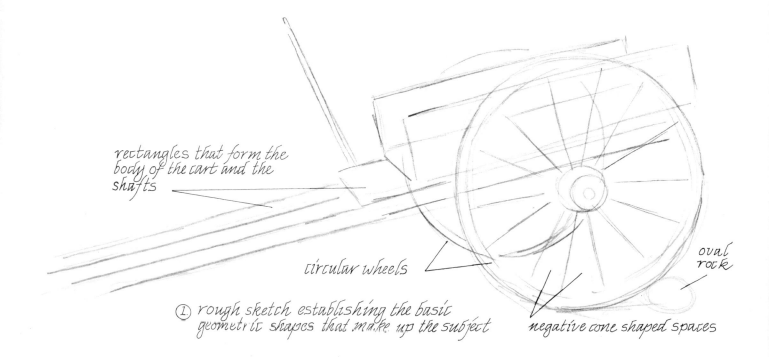

rectangles that form the body of the cart and the shafts

circular wheels

oval rock

① rough sketch establishing the basic geometric shapes that make up the subject

negative cone shaped spaces

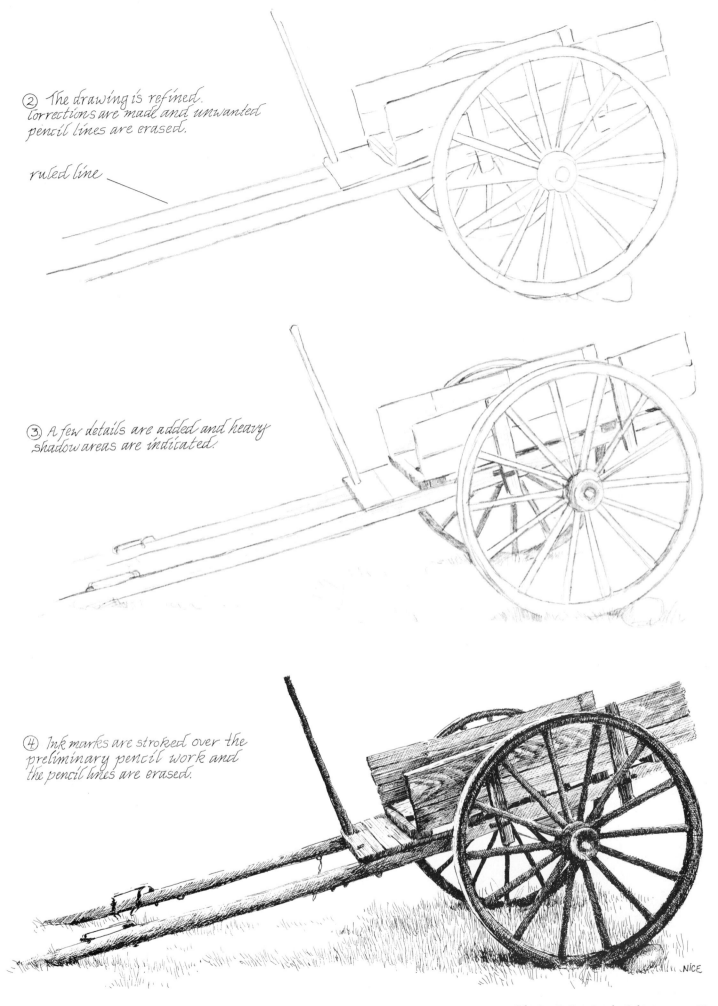

② The drawing is refined.
Corrections are made and unwanted
pencil lines are erased.

ruled line

③ A few details are added and heavy
shadow areas are indicated.

④ Ink marks are stroked over the
preliminary pencil work and
the pencil lines are erased.

NICE

Correcting Inaccuracies in Preliminary Drawings

As I begin to change the pencil drawings from rough geometric shapes into a more refined version, I check my work for accuracy of form. If I am working from a photo, I may lay a clear piece of acetate, with a grid of vertical and horizontal lines inked on the surface, over the photo. I then study the grid to see which parts of the subject fall along each of the lines. Then I lay a second, identical grid over my drawing and see if the elements line up in the same manner. Where the eye may fail to determine a problem, the straight edges of the grid will more readily reveal mistakes, which you'll need to correct. This technique is especially helpful when sketching the tricky perspectives found in buildings, and for obtaining the accuracy required when portraying living subjects. Keep in mind that this procedure will produce a drawing only as accurate as the photo you work from. Distorted photos produce distorted sketches.

If a clear grid isn't available, you can substitute a clear ruler or straight edge. It must be held absolutely horizontal or vertical across the photo, then placed on the sketch in the exact same position to make comparisons.

I can use a similar check system when sketching from life. In the field, I make my visual comparisons by holding a ruler, stick or pencil up in the air, making sure that it's straight, and sighting the subject in behind it.

As you become more experienced in freehand drawing, comparing the relationship of subject to sketch will become part of the mental process, and you'll make fewer mistakes.

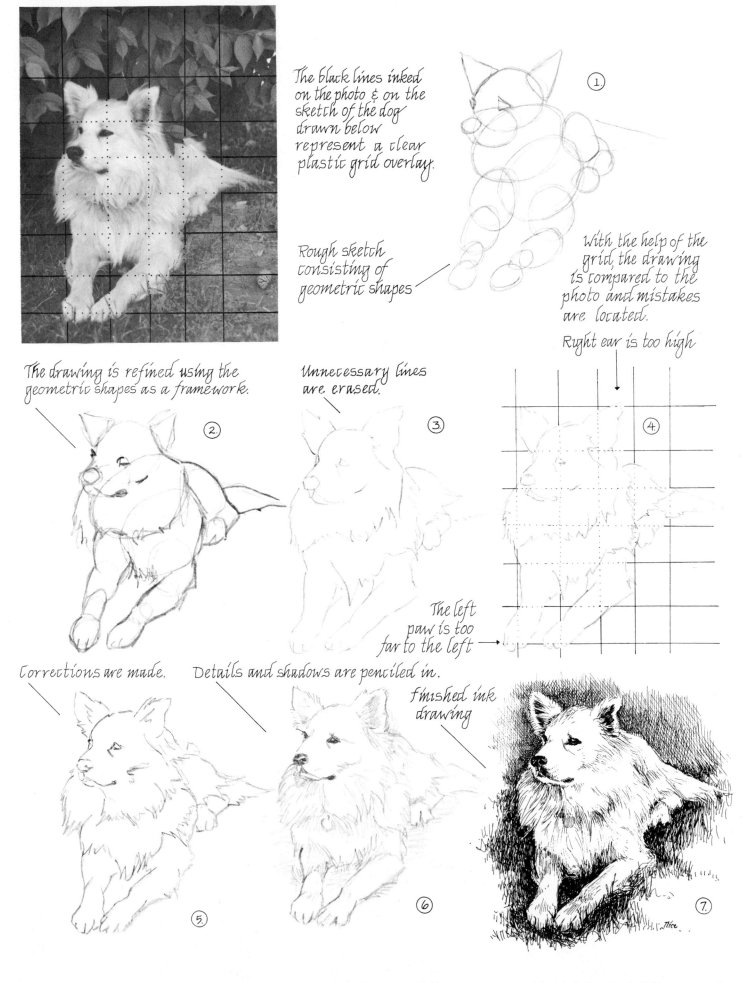

The black lines inked on the photo & on the sketch of the dog drawn below represent a clear plastic grid overlay.

①

Rough sketch consisting of geometric shapes

With the help of the grid, the drawing is compared to the photo and mistakes are located.

Right ear is too high

The drawing is refined using the geometric shapes as a framework.

Unnecessary lines are erased.

②

③

④

The left paw is too far to the left →

Corrections are made.

Details and shadows are penciled in.

Finished ink drawing

⑤

⑥

⑦

Achieving Perspective

Perspective is the technique of portraying three-dimensional objects on a flat surface. The first step in establishing a three-dimensional look is determining where the horizon, or eye-level, line will be in the drawing. If the horizon line is in the upper portion of the drawing, the viewer will look down on the objects in the composition. If the horizon line is near the middle, the view is straight on. And if the horizon line is low in the sketch, the viewer will look up to the objects. There should be only one horizon line or "point of view" within a single, realistic compo-

sition, and all the objects in the composition should relate to it.

The second factor to consider when drawing in perspective is that objects appear to grow smaller as they recede into the distance, and seem to disappear altogether as they reach the horizon. This is called the "vanishing point." The difference between a short object and a distant object is that the short object is merely lowered in height, while the distant object is shrunk inward in all directions.

Lines that run parallel to one another, like the two sides of a railroad track, will appear to grow closer together as they re-

cede further into the distance, meeting eventually at the vanishing point somewhere along the horizon line. This concept is useful when you sketch buildings where the roofline, foundation, and the bottoms and tops of windows and doors on one side of the structure are all parallel to each other. Lay a ruler along one of these lines and extend it to the horizon line. This establishes where the vanishing point is. If the lines don't meet at the same vanishing point when they are extended, they are out of perspective.

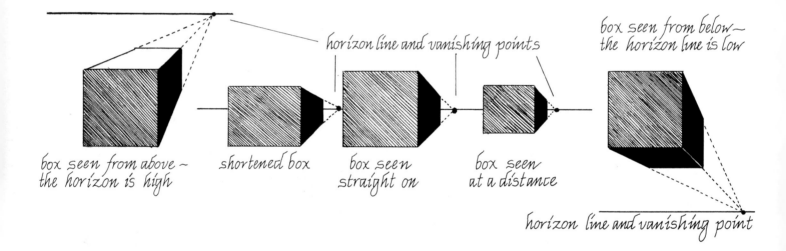

box seen from above — the horizon is high

shortened box

horizon line and vanishing points

box seen straight on

box seen at a distance

box seen from below — the horizon line is low

horizon line and vanishing point

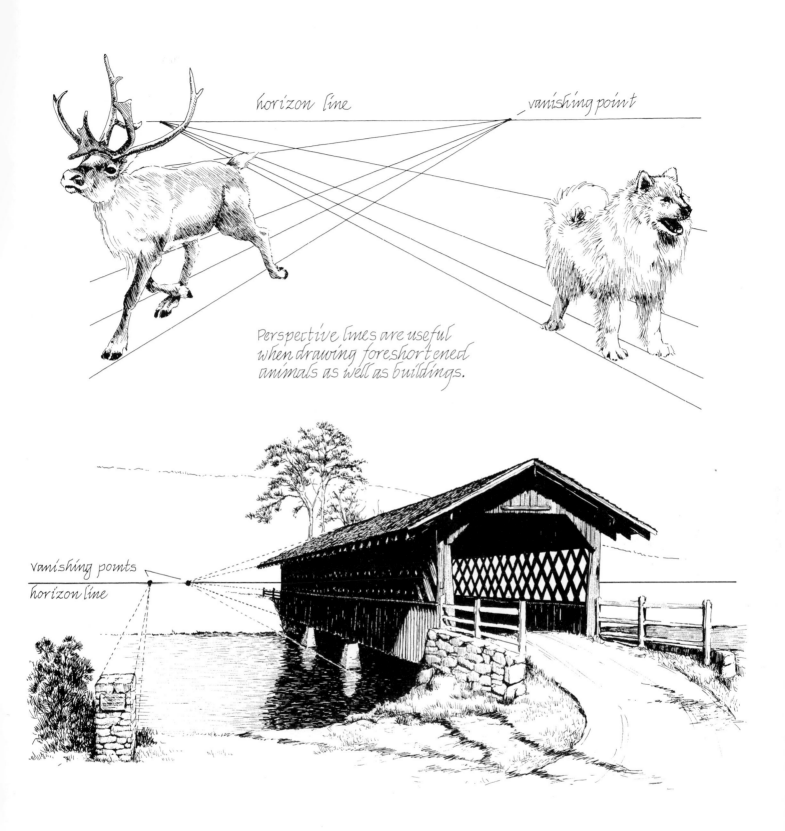

horizon line vanishing point

Perspective lines are useful
when drawing foreshortened
animals as well as buildings.

vanishing points
horizon line

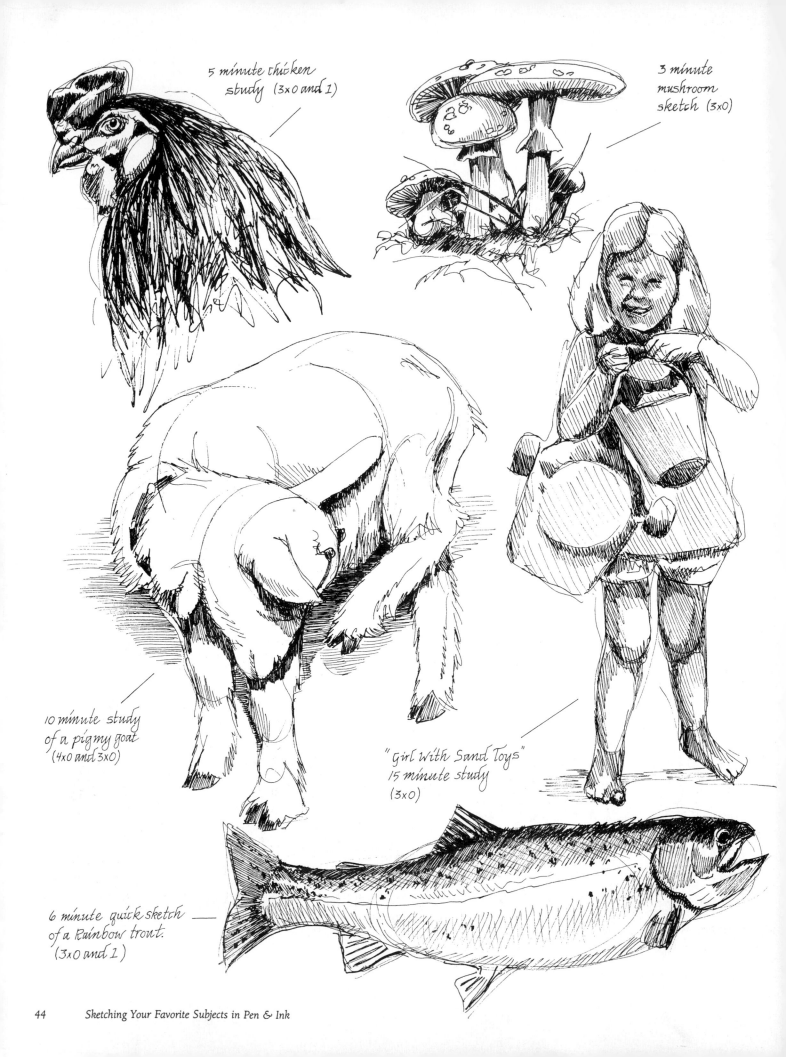

5 minute chicken
study (3x0 and 1)

3 minute
mushroom
sketch (3x0)

10 minute study
of a pigmy goat
(4x0 and 3x0)

"Girl With Sand Toys"
15 minute study
(3x0)

6 minute quick sketch
of a Rainbow trout.
(3x0 and 1)

Quick Ink Sketches

When sketching from life, particularly outdoors, there's not always enough time to carefully go through all the preliminary pencil stages, perfecting the drawing as it proceeds. The weather changes, time may be limited, or in the case of wildlife, the subject may be on the move. In such cases, it's best to go directly to pen and ink, working in fast, loose, scribbly strokes, trying merely to capture the essence of the subject. Mistakes are corrected by overlaying them with new lines, all of which become part of the "flow" of the drawing. Even with their inaccuracies, quick sketches can be very appealing in their simplicity and spontaneity. A notebook of quick sketches can act as a "visual" journal and provide valuable resource material for later drawings.

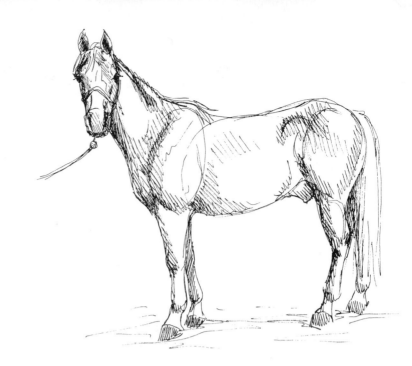

5 minute horse study
(4x0)

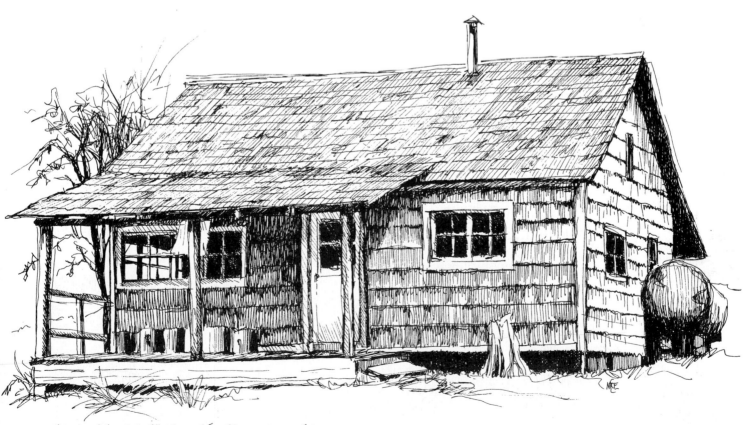

One hour "quick sketch" of an old cabin. (3x0 and 0)

Creating a Field Sketch Kit

When sketching far afield, I travel lightly taking only those art supplies that have proved necessary in the past.

- One 3 × 0 (.25) technical pen — for detail and finer lines
- One size 1 (.50) technical pen — for heavy lines and fill-in work
- Any other favorite pen sizes
- One bottle of India ink (brush-proof if you plan to use washes)
- Extra refill cartridges if your pen is the prefilled cartridge type
- One no. 4 round watercolor brush (for ink washes)
- One no. 2 pencil with sharpener or a lead holder and lead
- One soft, white vinyl eraser
- One pen-cleaning kit and lint-free rag
- A small plastic container for water (for washes and clean-up)
- One sketchpad or bound book, suitable for pen and ink
- One bottle of correction fluid for pen and ink
- One clear plastic ruler
- One small bag to put your supplies in (an old camera bag or a small fanny pack are good choices)
- A camera to record material for later reference

For your own comfort, don't forget a sun hat, a small first-aid kit, a folding chair or waterproof ground cushion, drinking water, bug repellent, and clothing appropriate for the weather and for the chosen sketching site. Consider taking along a sketching companion. Nature is twice as beautiful when shared with a friend.

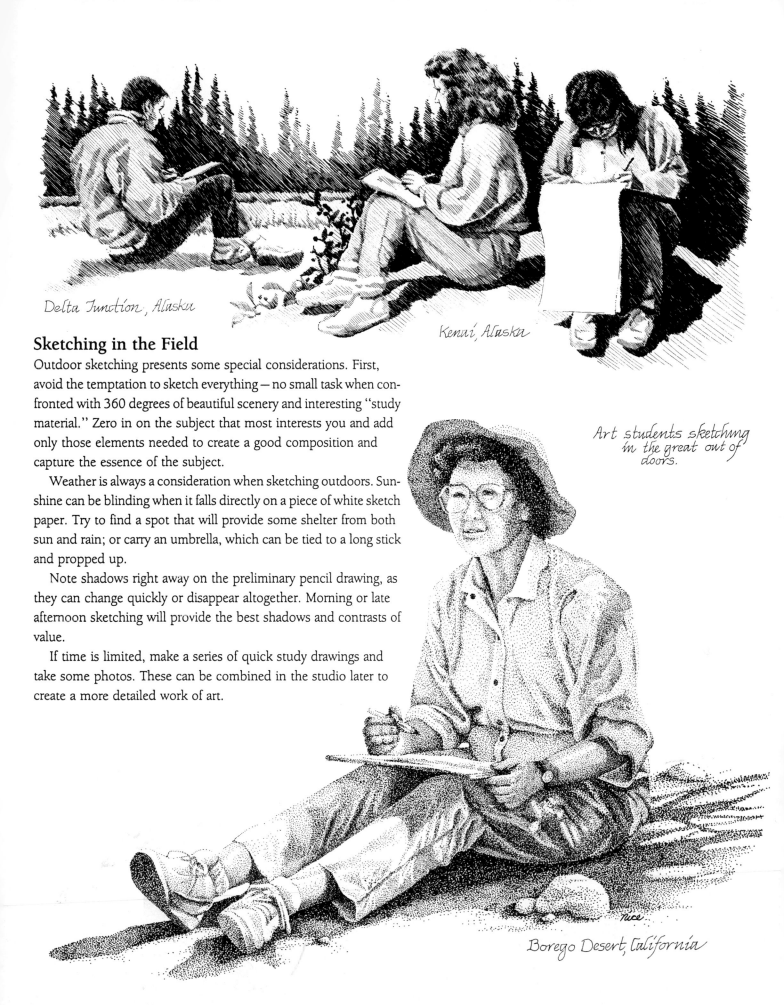

Delta Junction, Alaska

Kenai, Alaska

Sketching in the Field

Outdoor sketching presents some special considerations. First, avoid the temptation to sketch everything—no small task when confronted with 360 degrees of beautiful scenery and interesting "study material." Zero in on the subject that most interests you and add only those elements needed to create a good composition and capture the essence of the subject.

Weather is always a consideration when sketching outdoors. Sunshine can be blinding when it falls directly on a piece of white sketch paper. Try to find a spot that will provide some shelter from both sun and rain; or carry an umbrella, which can be tied to a long stick and propped up.

Note shadows right away on the preliminary pencil drawing, as they can change quickly or disappear altogether. Morning or late afternoon sketching will provide the best shadows and contrasts of value.

If time is limited, make a series of quick study drawings and take some photos. These can be combined in the studio later to create a more detailed work of art.

Art students sketching in the great out of doors.

Borego Desert, California

Working From Slides and Photos

If you cannot work on location, sketching from the actual subject, the next best thing is having several photos or slides from which to sketch the subject.

I prefer to work from slides, because the size of the pictures can be adjusted to the exact size I wish to draw, making enlargements easier to envision. Animals and objects can be flip-flopped to change the direction they face. After I sketch the main subjects, I can project backgrounds onto the paper to see how they might look. When absolute accuracy is needed, I can project the image directly onto the work surface and trace on light guide lines. By projecting the image into a dark corner of the room or into a medium-sized cardboard box, the work area can remain well lit.

Black-and-white photos with good contrast are great to ink from because the values are clearly defined. When possible, take your own photos so that you can arrange the subjects and choose the views that will form the best artistic compositions. And an artist who works from her or his own photos will not have to worry about infringing on someone else's copyrighted material.

For a photo to be used as the basis of a pen-and-ink subject study, the image must be well defined. Close-up shots are important for determining the contours of a beak or the lay of the feathers, none of which show in the distant, full body view of the ostrich shown below.

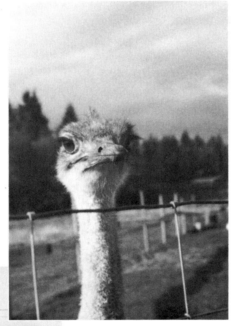

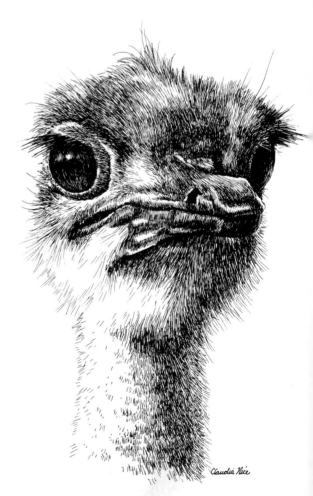

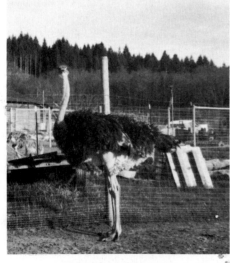

The camera does not always record images with the accuracy of the human eye. The curvature of the lens or the angle at which the camera is held can cause the image to appear distorted. This is especially important to remember when you sketch architecture. The walls of both these houses seem to lean inward and must be straightened when drawn.

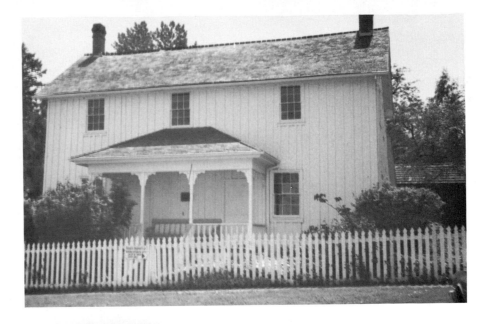

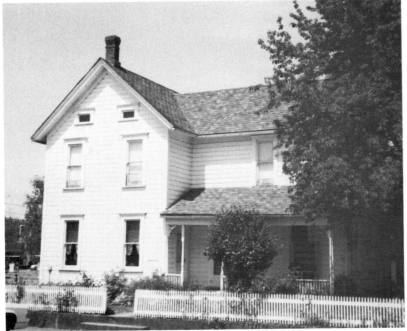

The artist is able to improve or personalize the photographic image by removing the undesirable parts of the scene and adding to or rearranging the subject matter.

A smaller, light valued tree was added to the original scene to provide contrast in an area of heavy shadow.

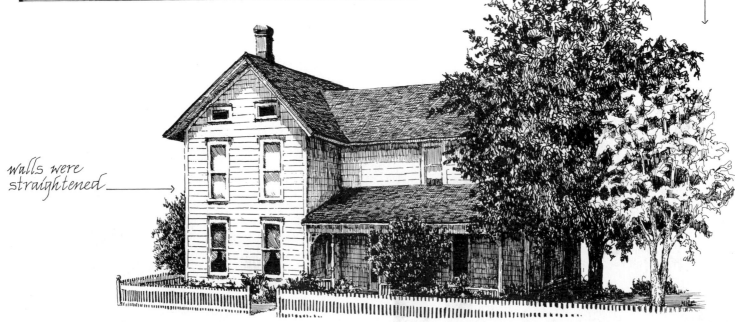

walls were straightened ⟶

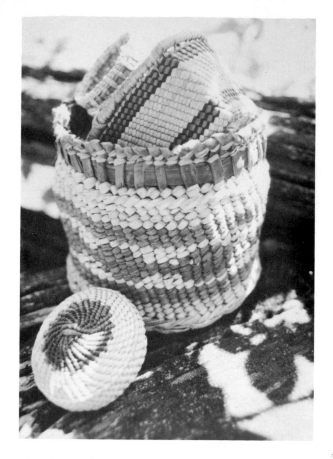

In the photo of the Makah baskets (far left), the light falls on the right side. In the photo of the Mayan carving (left), the light source is from the left. To make them compatible in one composition, I changed the lighting on the stone face (below).

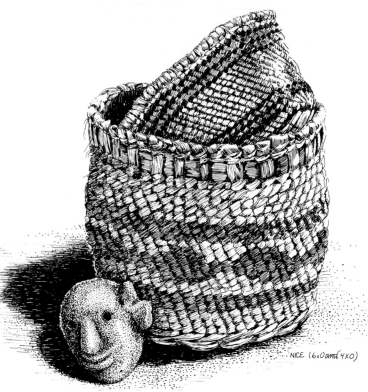

NICE (6x0 and 4x0)

When combining objects from different photos one must be aware of perspective as well as lighting.

The best subjects to sketch are those with which the artist is most familiar. The photo at left is of my grandson, Cameron.

When a small photo is used as the basis of a large drawing, transparent grids may help to keep the drawing in proportion. Lay a small grid over the photo and a grid with proportionally larger squares over the drawing to check for accuracy. In the sketch of Cameron, I doubled the size of the grid squares and penciled them on the paper.

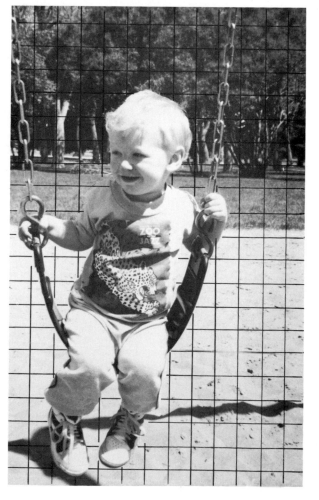

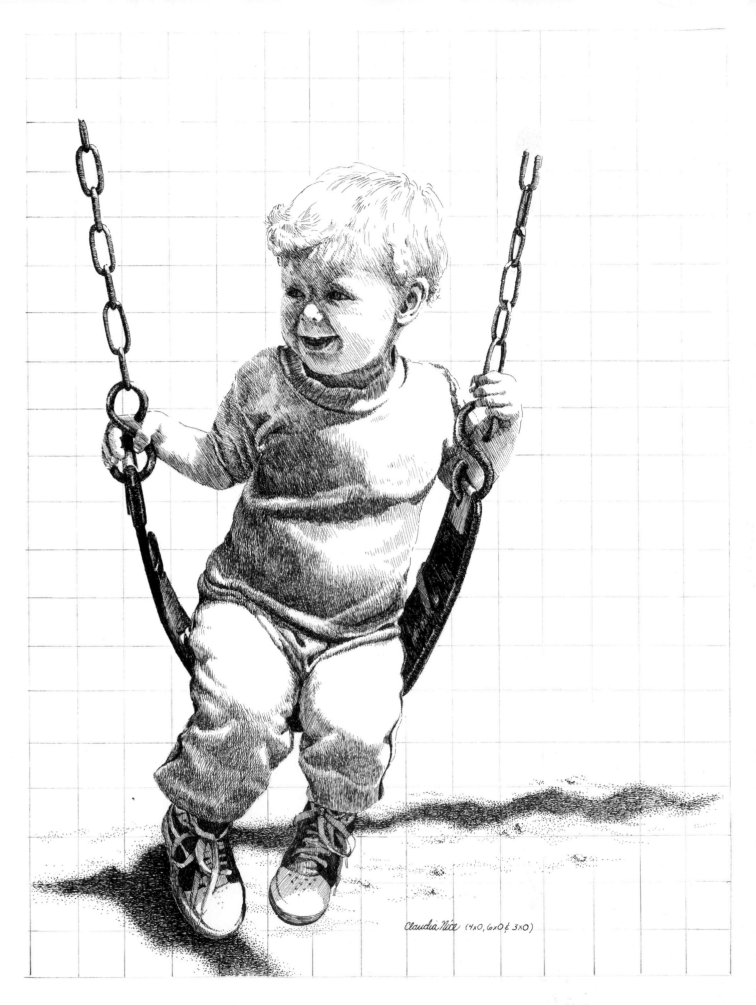

Claudia Nice (4x0, 6x0 & 3x0)

Chapter Six

SKETCHING THE PLANT KINGDOM

Flowers

Flowers, with their delicate, sometimes translucent quality, are one of the most challenging subjects for the pen-and-ink artist to sketch.

As with other subjects, begin floral drawings by studying the plant to be drawn, then making a simple, basic shape pencil sketch. I usually begin sketching each blossom in the center and work my way out, petal by petal, to the outer edge. In this way the flower can be expanded outward so I won't run out of space before I run out of petals. I add stems and leaves last, arranged in a natural manner to complement the blossom. I often include interesting deformities and blemished spots in my floral sketches to give them a natural look, especially if the subject is a wildflower.

The ink work on flowers should be as light and delicate as possible, utilizing the smallest pen nibs (sizes 6×0, 4×0 and 3×0). Take care to avoid heavy outlines. Use light, broken lines if outline work is absolutely necessary for definition of the flower. Whenever possible, use contrast of value, texture, or line direction to define the edges of the petals.

In the sketch of the rose at right, I used contrast of value, texture and line direction to form the image. Contour lines were used for the petals, the leaves were crosshatched, and the background was inked using parallel lines.

I sketched the sunflower using a combination of crosshatch and scribble lines. A row of crisscross lines at the outer edge of the stem and leaves represents the fine hairs that protrude from the foliage of the sunflower.

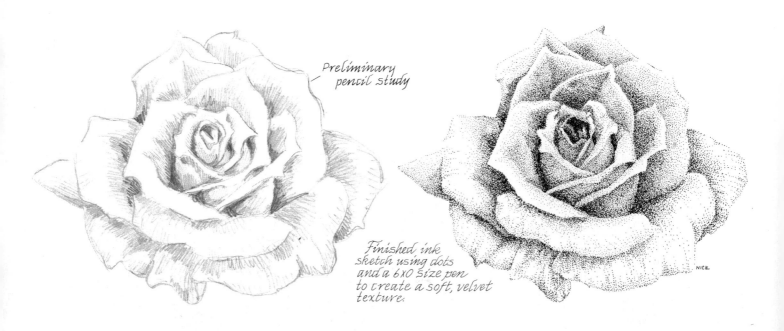

Preliminary pencil study

Finished ink sketch using dots and a 6x0 size pen to create a soft, velvet texture.

NICE

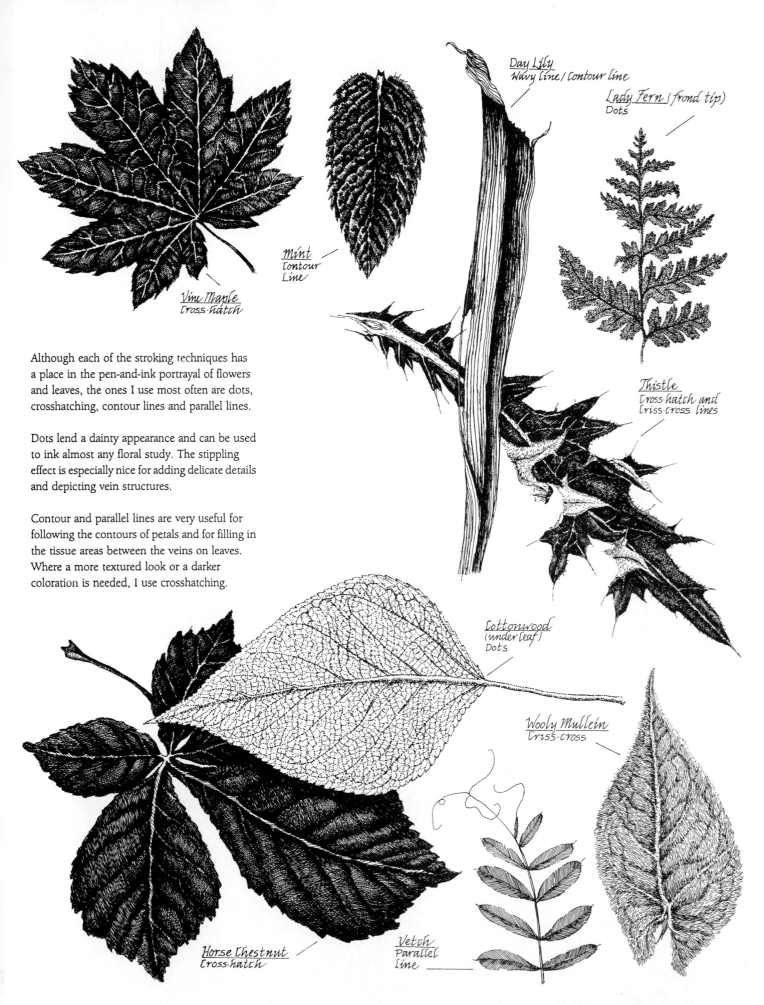

Day Lily
Wavy Line / Contour Line

Lady Fern (frond tip)
Dots

Vine Maple
Cross-hatch

Mint
Contour Line

Thistle
Cross-hatch and
Criss-cross lines

Although each of the stroking techniques has a place in the pen-and-ink portrayal of flowers and leaves, the ones I use most often are dots, crosshatching, contour lines and parallel lines.

Dots lend a dainty appearance and can be used to ink almost any floral study. The stippling effect is especially nice for adding delicate details and depicting vein structures.

Contour and parallel lines are very useful for following the contours of petals and for filling in the tissue areas between the veins on leaves. Where a more textured look or a darker coloration is needed, I use crosshatching.

Cottonwood
(under leaf)
Dots

Wooly Mullein
Criss-cross

Horse Chestnut
Cross-hatch

Vetch
Parallel Line

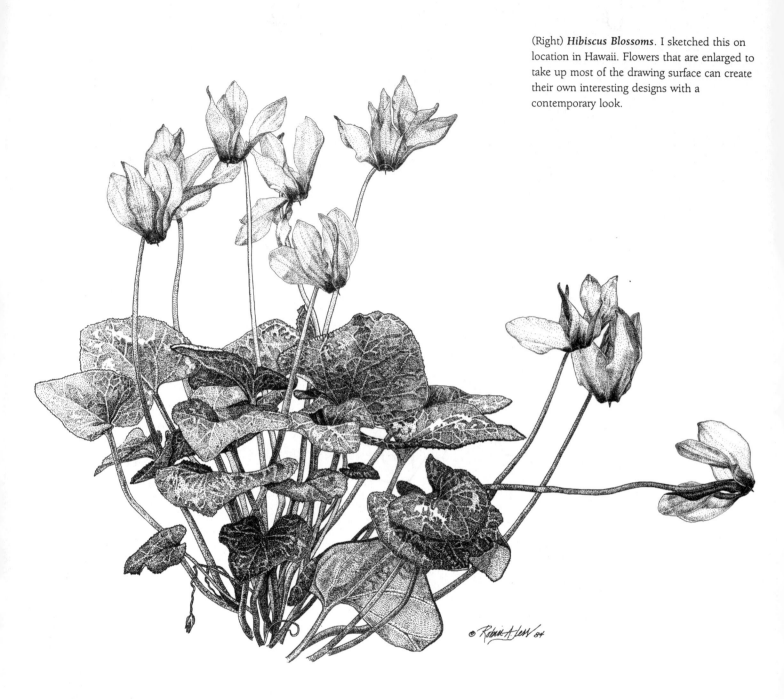

(Right) *Hibiscus Blossoms*. I sketched this on location in Hawaii. Flowers that are enlarged to take up most of the drawing surface can create their own interesting designs with a contemporary look.

Cyclamen, 14 × 11½, by Robin A. Jess. Robin uses a finely detailed stippling technique that produces plant studies reminiscent of eighteenth- and early nineteenth-century engravings. © 1988, courtesy of Hunt Institute for Botanical Documentation, Carnegie Mellon University, Pittsburgh, Pennsylvania. All rights reserved.

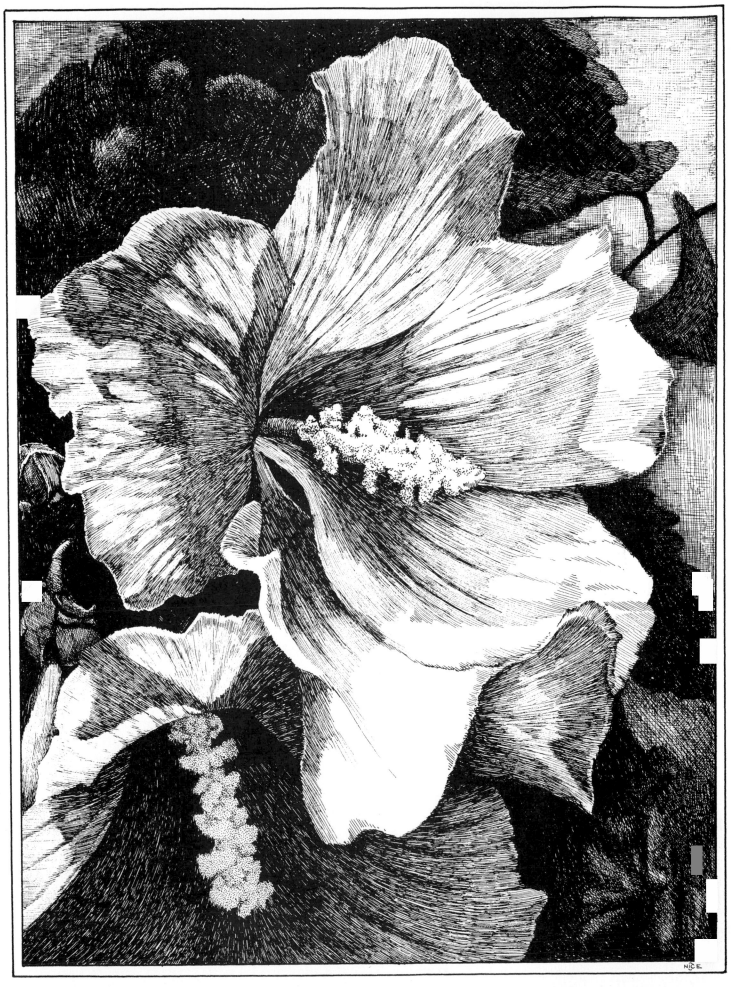

NICE

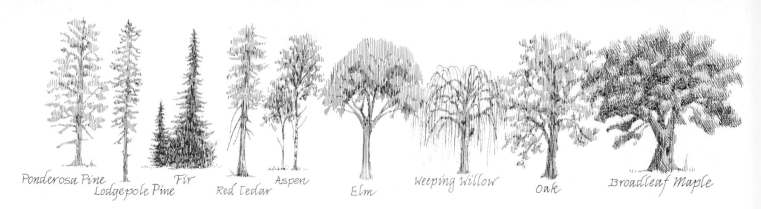

Ponderosa Pine Lodgepole Pine Fir Red Cedar Aspen Elm Weeping Willow Oak Broadleaf Maple

Trees

Only God can create a tree, and He created them big. To sketch a whole tree, you must sketch it at a distance. Trees that are far away can be represented with parallel lines or a combination of contour and crosshatch lines. Shape and shadow are depicted, but little detail. As you move closer, you see clumps of foliage and more tree structure. A combination of scribble lines and parallel lines works well to sketch these trees. Looped scribble lines represent clumps of deciduous foliage; wiry scribble lines work well to depict conifer branches. Remember that thick foliage areas will cast heavy shadows on the leaves and branches beneath them, as shown in the drawing of the spruce, below left. Darken the values in these areas accordingly. Foliage on the back side of the tree can be represented with parallel lines to give the tree depth, and still keep the foreground foliage clumps well defined, as you can see in the dogwood sketch, below center.

When you undertake a close-up study of tree bark, branches and leaves, all of the seven strokes become useful.

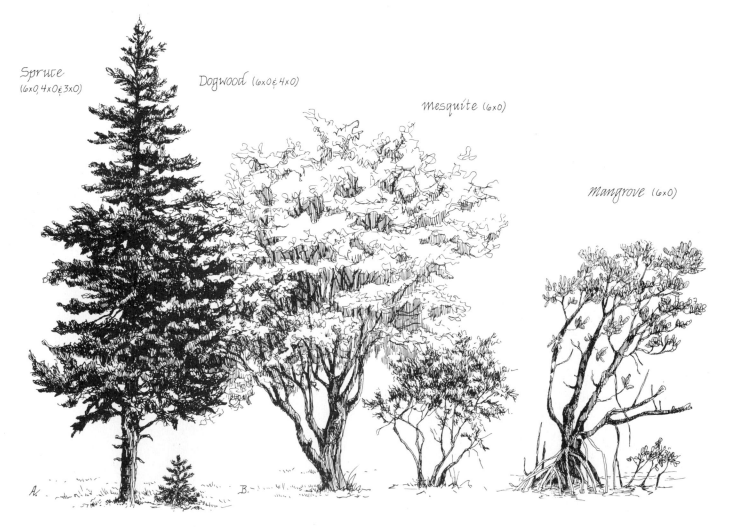

Spruce (6x0, 4x0 & 3x0)

Dogwood (6x0 & 4x0)

Mesquite (6x0)

Mangrove (6x0)

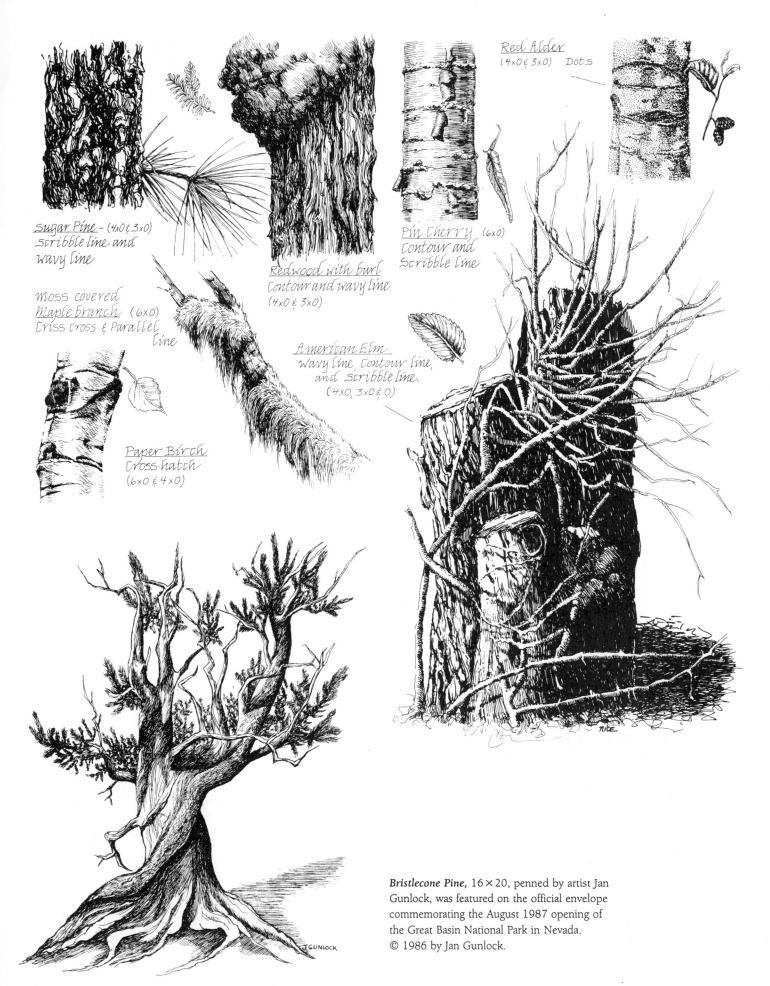

Sugar Pine - (4x0 & 3x0)
scribble line and
wavy line

Moss covered
Maple branch (6x0)
Criss-Cross & Parallel
line

Paper Birch
Cross-hatch
(6x0 & 4x0)

Redwood with burl
Contour and wavy line
(4x0 & 3x0)

American Elm
Wavy line, Contour line,
and Scribble line.
(4x0, 3x0 & 0)

Red Alder
(4x0 & 3x0) Dots

Pin Cherry (6x0)
Contour and
Scribble Line

Bristlecone Pine, 16 × 20, penned by artist Jan
Gunlock, was featured on the official envelope
commemorating the August 1987 opening of
the Great Basin National Park in Nevada.
© 1986 by Jan Gunlock.

The date palms at right were sketched on hot-press illustration board. I used watercolor masking fluid to block out and protect the white areas of the trunks while scribbling in the textured parts. Then I erased the fluid and added the final details.

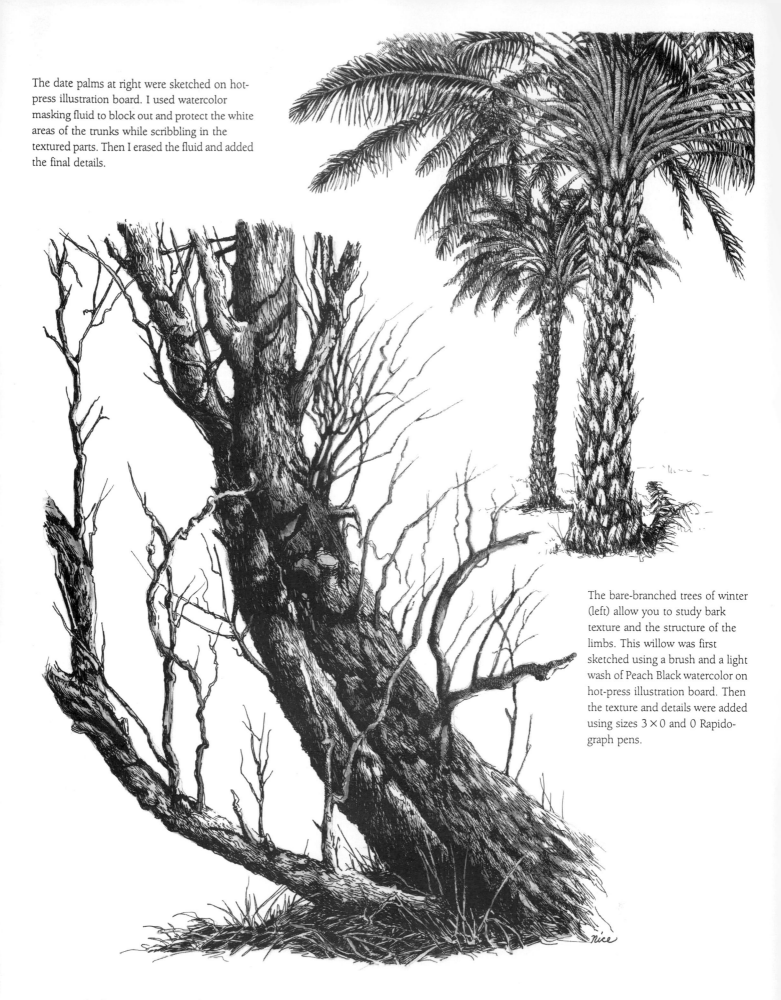

The bare-branched trees of winter (left) allow you to study bark texture and the structure of the limbs. This willow was first sketched using a brush and a light wash of Peach Black watercolor on hot-press illustration board. Then the texture and details were added using sizes 3 × 0 and 0 Rapidograph pens.

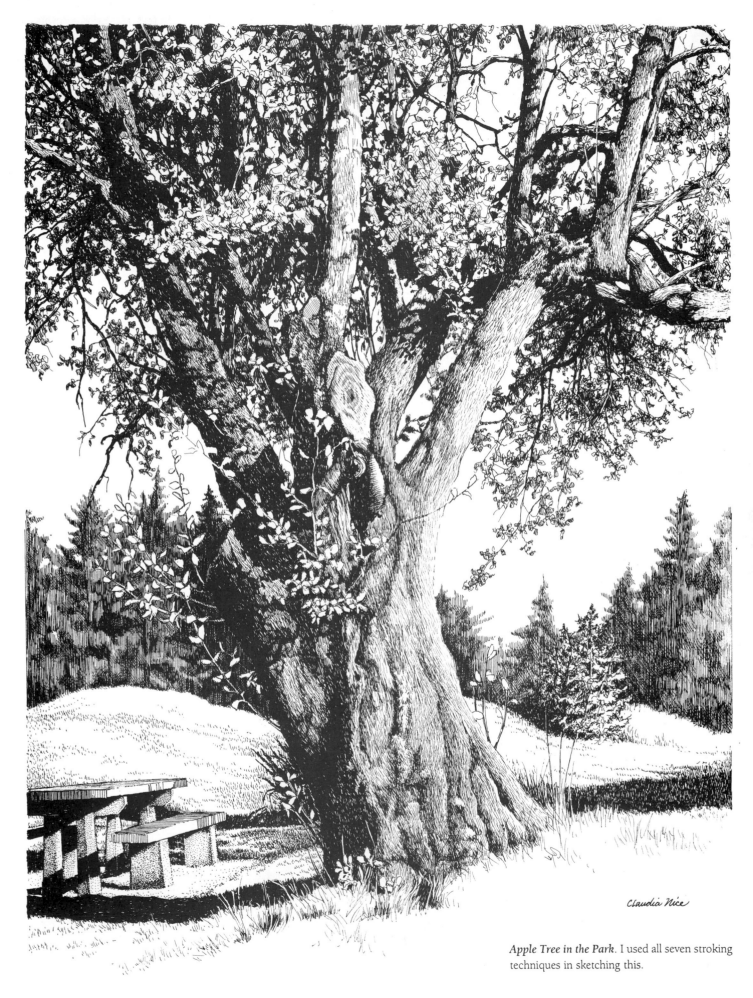

Apple Tree in the Park. I used all seven stroking techniques in sketching this.

The dense undergrowth in this sketch of rural mailboxes began as a loosely rendered pencil sketch (see area A below). Clumps of amoeba shapes were scribbled in the upper portion of the composition to represent maple leaves. Oval shapes and long, curved lines were penciled in, below, to depict grass and underbrush.

Next, I outlined the penciled shapes with a fine ink pen and a loose scribbly stroke (area B). Last of all, I inked in the areas behind the foliage, beginning in the foreground and working back. Some areas were lightly shaded with parallel and scribble lines. The majority of the background was scribbled in solidly. This

"popped" the leaves and grasses forward, giving them both definition and dimension (area C).

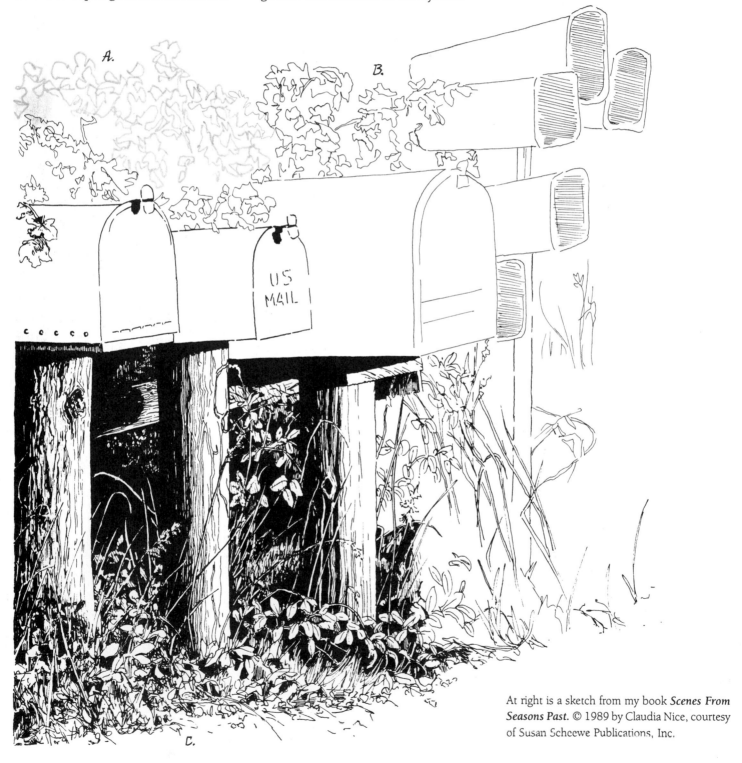

At right is a sketch from my book *Scenes From Seasons Past.* © 1989 by Claudia Nice, courtesy of Susan Scheewe Publications, Inc.

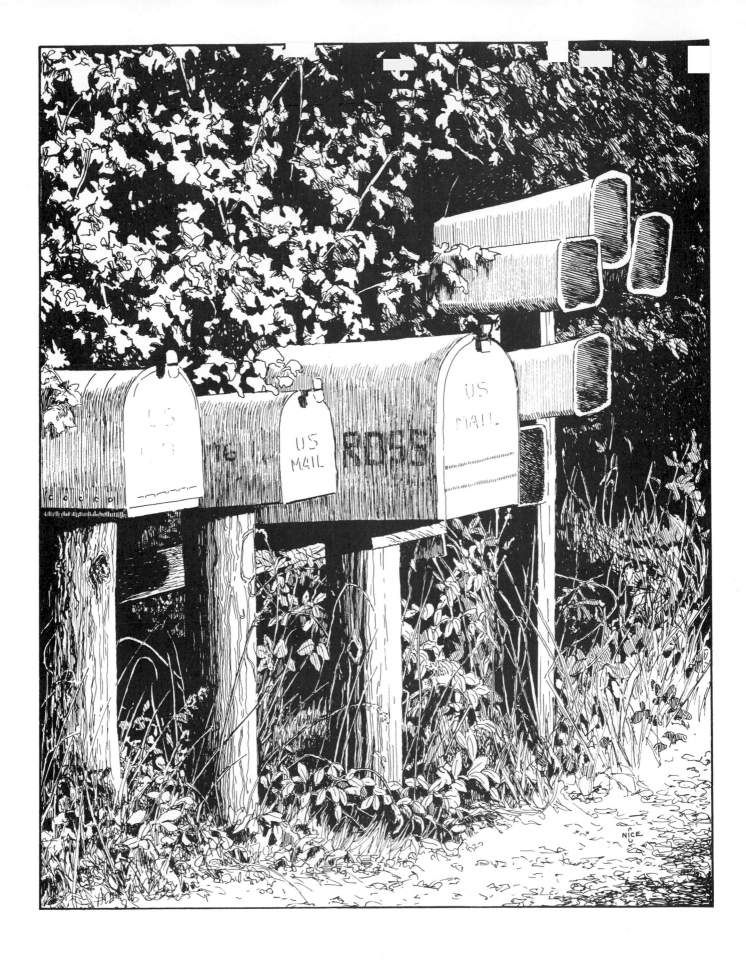

Chapter Seven

EARTH & SKY

Rocks

Sand, the smallest of nature's rocks, can best be depicted using dots. As you move farther away, the individual particles of sand blend together, taking on a smoother appearance that can be sketched using contour lines, parallel lines or fine crosshatching. These same techniques work well to sketch the sandblasted desert rocks, as seen in this sketch of Red Rock Canyon, Nevada.

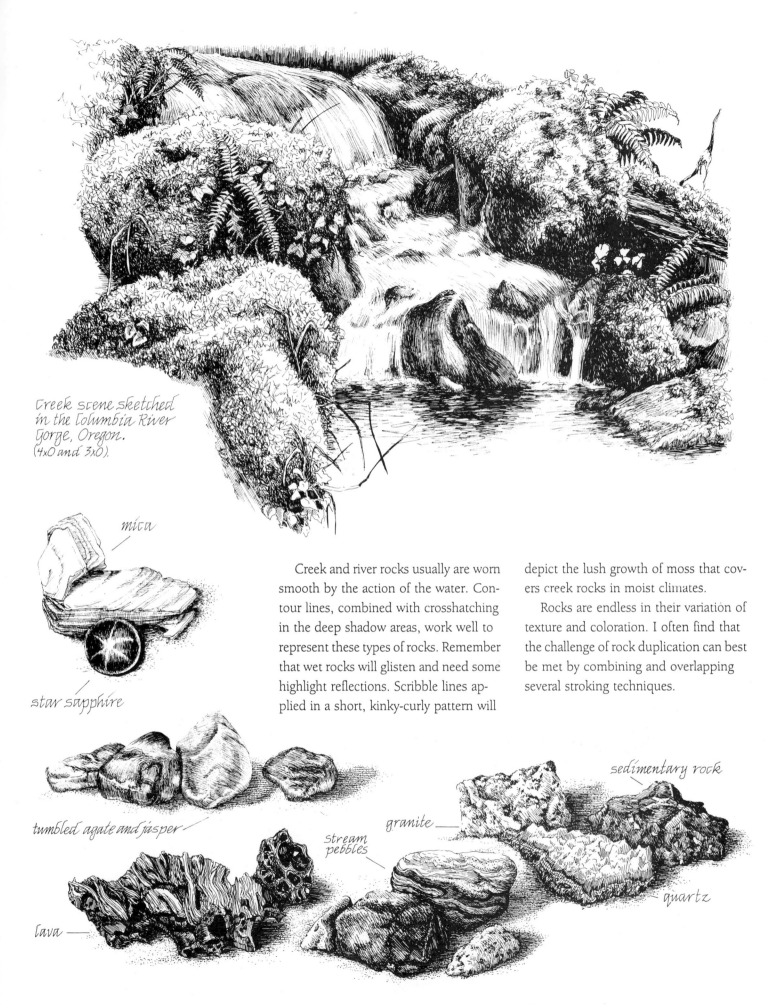

Creek scene sketched
in the Columbia River
Gorge, Oregon.
(4x0 and 3x0).

mica

star sapphire

tumbled agate and jasper

lava

stream pebbles

granite

sedimentary rock

quartz

Creek and river rocks usually are worn smooth by the action of the water. Contour lines, combined with crosshatching in the deep shadow areas, work well to represent these types of rocks. Remember that wet rocks will glisten and need some highlight reflections. Scribble lines applied in a short, kinky-curly pattern will depict the lush growth of moss that covers creek rocks in moist climates.

Rocks are endless in their variation of texture and coloration. I often find that the challenge of rock duplication can best be met by combining and overlapping several stroking techniques.

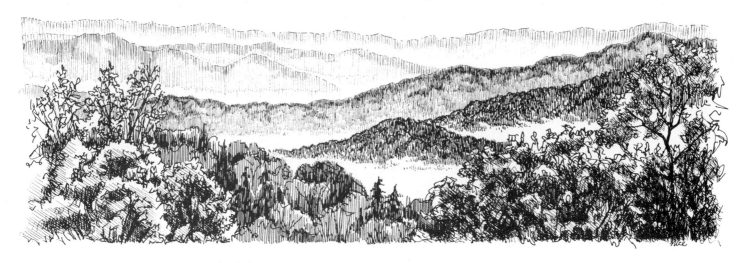

morning mist in the Great Smokies, Appalachian Mountain range. (6x0 and 3x0) Parallel and Scribble line.

Mountains and Hills

Mountains usually are drawn as part of a landscape background; therefore, rather than a lot of detail, they tend to show just a suggestion of the general shape, rock structures, glaciers and stands of timber. Eastern mountains are the oldest and have a worn, rounded appearance; their surrounding forests primarily are pine and deciduous trees.

The Rockies and the western ranges have a rugged, often craggy appearance, the peaks reaching above the timber line. The forests below these mountains are mostly coniferous.

Hills vary in appearance and in the techniques used to depict them, according to vegetation that grows on them and the distance from which they are viewed. In general, use parallel lines to represent forests seen at a great distance. When the forested hills are closer, you can add scribble lines, contour lines and cross-hatching to suggest individual tree shapes. Barren bluffs, snow-covered slopes, and rolling, grass-covered hills can be represented with contour lines.

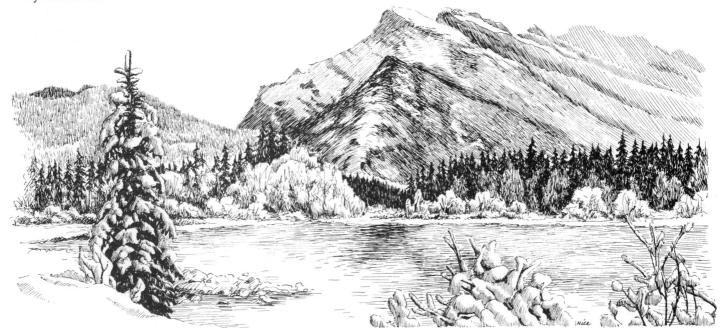

Early spring in the Rockies, Mount Rundle. (4x0). A combination of Parallel and contour lines were used for the mountains.

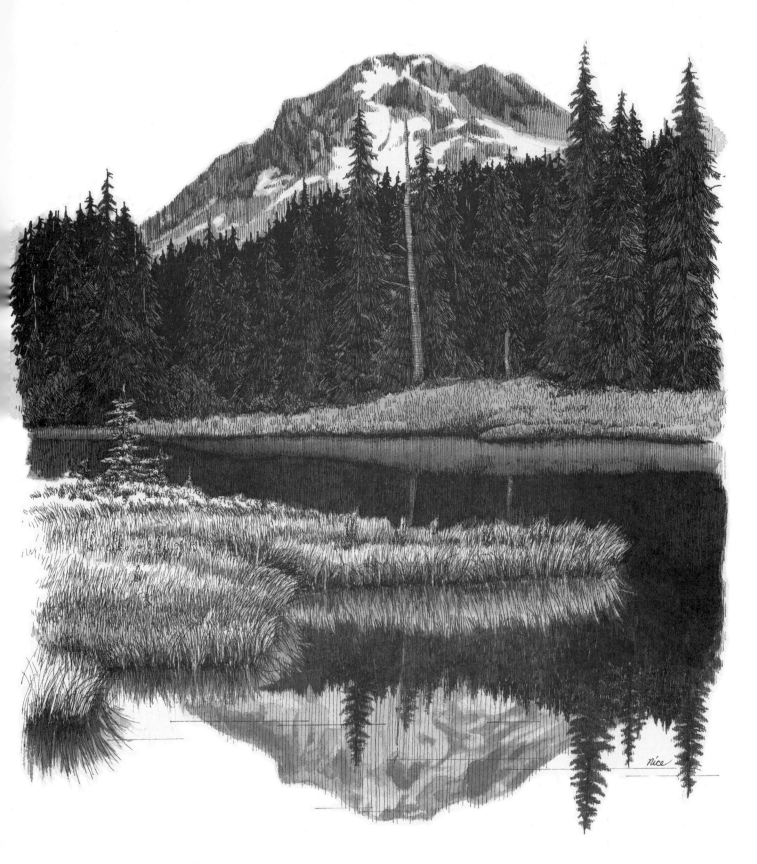

Summer Reflection of Mount Hood is a sketch
of a mountain in the Cascade Range of Oregon.
I drew this on cold-press illustration board. I
used a wash of ink and water, applied with a
no. 4 round watercolor brush, for the prelim-
inary sketch. Then I added pen work for texture
and detail. Pen sizes 3×0 and 4×0 were used.

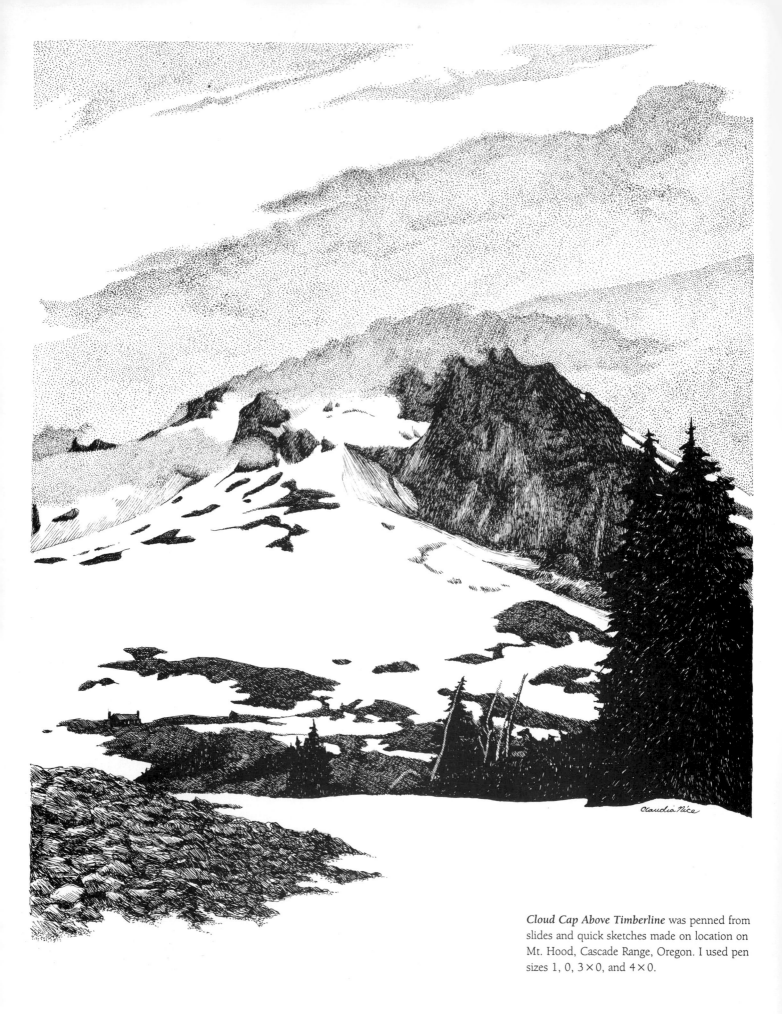

Cloud Cap Above Timberline was penned from slides and quick sketches made on location on Mt. Hood, Cascade Range, Oregon. I used pen sizes 1, 0, 3×0, and 4×0.

Sketching Your Favorite Subjects in Pen & Ink

Clouds and Sky Texture

Cloud formations are a great way to add line direction, texture and interest to an area of the composition that is often neglected: the sky.

The basic stroking techniques I use for sketching clouds are dots, parallel lines and contour lines. Dots or broken outlines are good for depicting fluffy cumulus clouds. You can form rain clouds with the use of slanted parallel lines, built up in layers. Use contour lines to form wispy, cirrus clouds (mare's tails) and to show wind direction in the sky.

A wavy-line pattern is a good way to create an interesting directional sky, devoid of clouds.

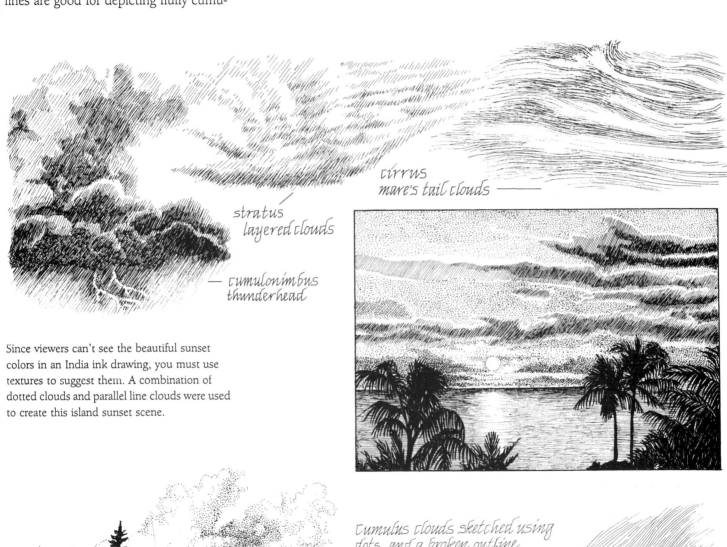

cirrus
mare's tail clouds ———

stratus
layered clouds

— cumulonimbus
thunderhead

Since viewers can't see the beautiful sunset colors in an India ink drawing, you must use textures to suggest them. A combination of dotted clouds and parallel line clouds were used to create this island sunset scene.

Cumulus clouds sketched using dots, and a broken outline with a wavy line sky.

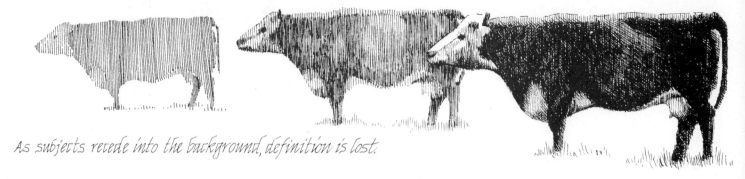

As subjects recede into the background, definition is lost.

Backgrounds

Backgrounds set off the main subject. They should complement, but not compete with, the foreground. Distant background shapes, textures and values should be merely suggested.

I usually use either broken outlines or parallel lines, or a combination of the two to portray objects whose value and detail are muted by distance. As objects approach the foreground, values intensify (lines are moved closer together) and de-tail increases (definition and texture are added).

Contrast is very important. If the foreground consists of busy gray tones, the background should be darker or lighter in value, and the shapes simple. Light-valued main subjects call for a gray-to-black background, while dark subjects need lighter backgrounds. To design an effective background, you must first establish the foreground.

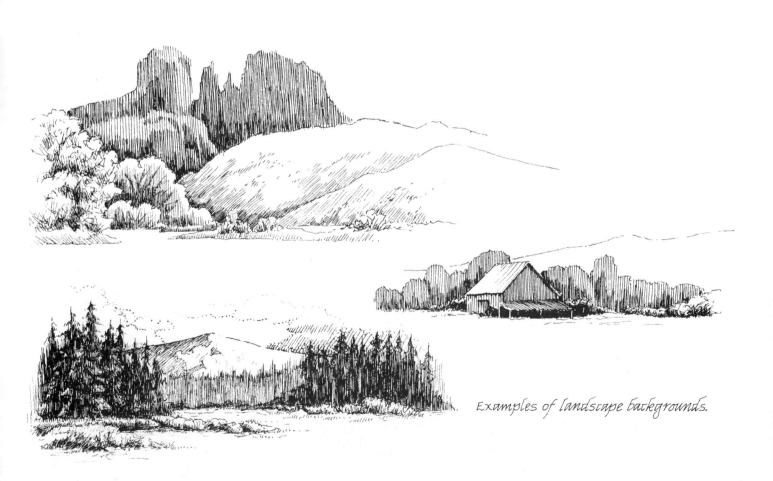

Examples of landscape backgrounds.

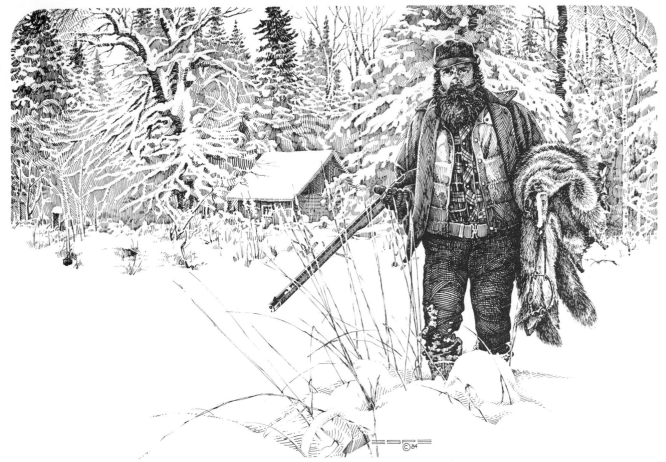

Huntin' n Trappin' (top) and *Cuttin' Cedar* (bottom), 14 × 20, by Marv Espe, part of a visual documentary series titled *Man's Hand in the Northland*. (Collection of Citizens State Bank, Roseau, Minnesota.)

These illustrations are a good example of how a complicated background can be effectively worked behind busy subject areas with the careful use of value, texture and spacing.

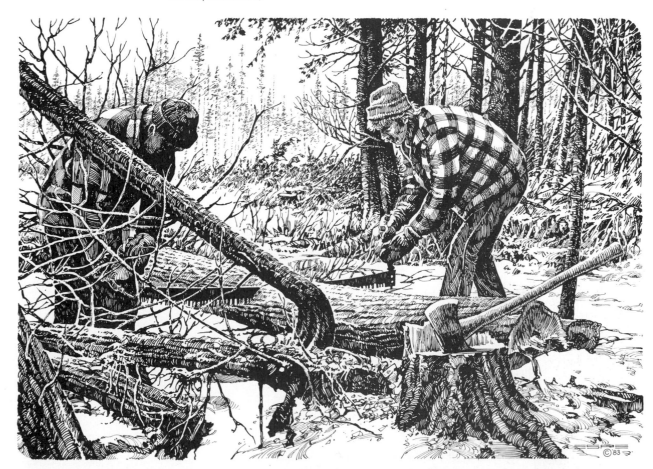

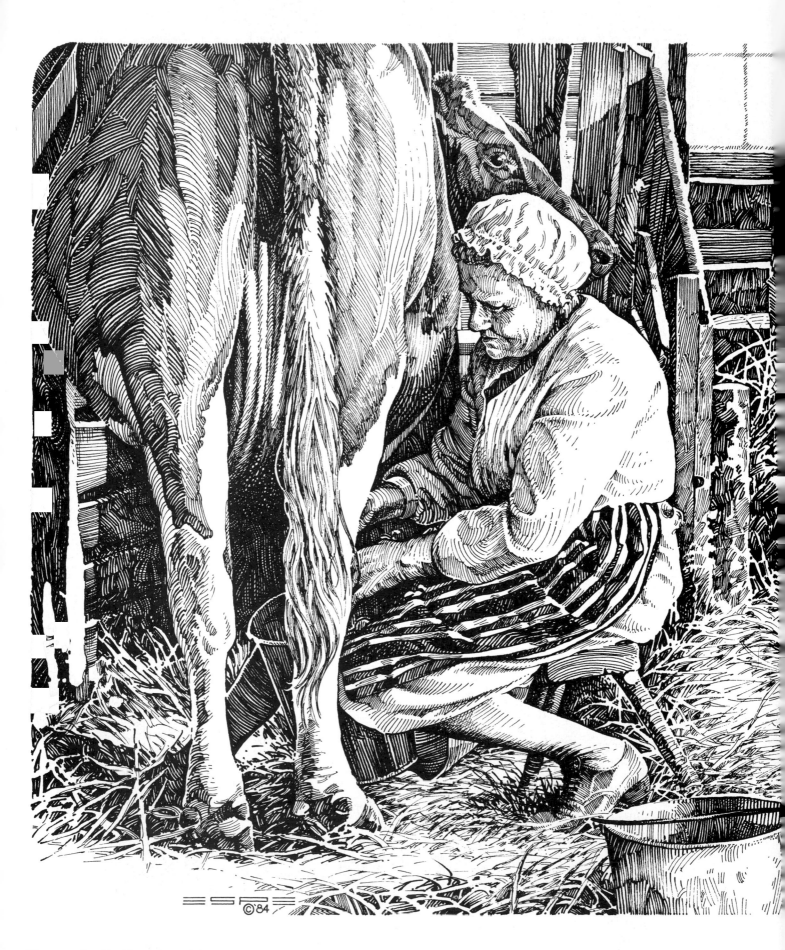

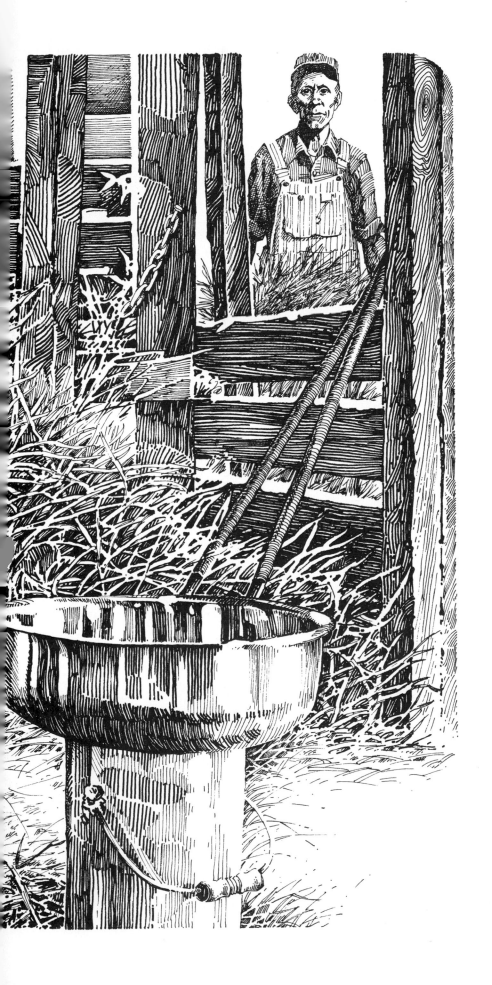

Backdrops for main subjects are not always seen at a great distance. Sometimes they are located just behind the subject, close enough to require some detail work. In such cases, it's doubly important to maintain a degree of contrast between subject and backdrop to keep the illusion of depth in the composition.

In *Milkin' Cows*, Marv Espe has used contrast of line direction and white voids to separate the cow, woman and straw from the barn wall behind them. Note how the white forehead of the cow leads to the white cap and the back of the woman, which in turn leads the eye to the patch of sunlit straw, all of which combine to form a subtle buffer zone between foreground and background areas.

Milkin' Cows, 14×20, by Marv Espe, part of a visual documentary series titled *Man's Hand in the Northland.* (Collection of Citizen's State Bank, Roseau, Minnesota.)

Landscapes

A landscape is a drawing or painting that represents a portion of terrestrial scenery. Well-composed landscapes have one or more points of interest to attract the eye. The points of interest may be natural (a tree, stream, animal, rock formation, etc.) or manufactured (a road, building, fence, etc.). The main points of interest are supported by less-emphasized objects or bits of scenery that recede into the distance, giving the landscape depth.

Not all beautiful bits of scenery will become good, artistic compositions if copied exactly the way they appear in nature. An artist often needs artistic license and some skillful adjustments to enhance what nature offers. This can make all the difference between a "calendar picture" and an art piece.

The farm landscape shown below has potential, but certain changes have to be made to turn it into an artistic composition. Two possibilities are shown at right.

In the top sketch, I removed the silo from the exact center position by offsetting the entire barn to the side. The addition of the old farm equipment provides a foreground point of interest that complements the barn. The trees give vertical lift to the composition.

In the second version, I focused on the left half of the barn, which moved the silo from the center position. Enlarged details add interest throughout the sketch. I lengthened the background evergreen trees to counterbalance the height of the barn. Cloud shapes and sky texture make the backgrounds of both drawings more appealing.

The background and sky lack interest.

The sky, barn and pasture sweep across the picture horizontally. Some vertical lines or shapes need to be added.

A point of interest could be added to wake up the foreground.

The tree is lost in shadow. More contrast is needed to bring it out.

This cluttered area could use simplification.

The silo and the tall background tree need to be moved from the exact center of the composition.

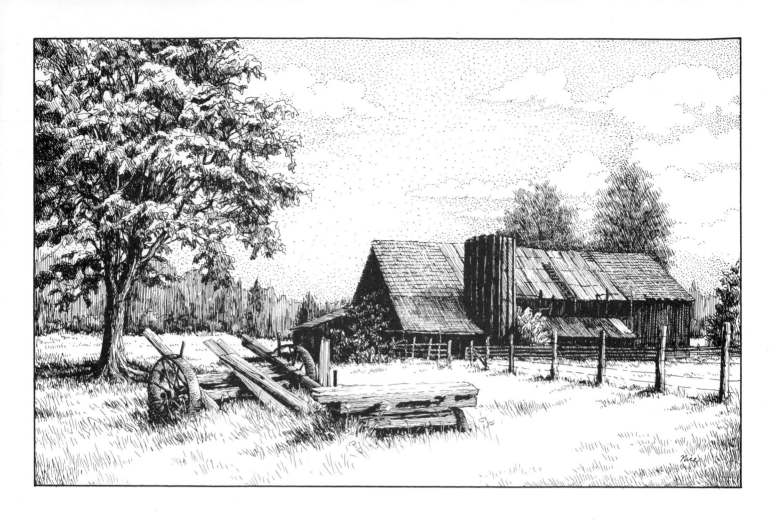

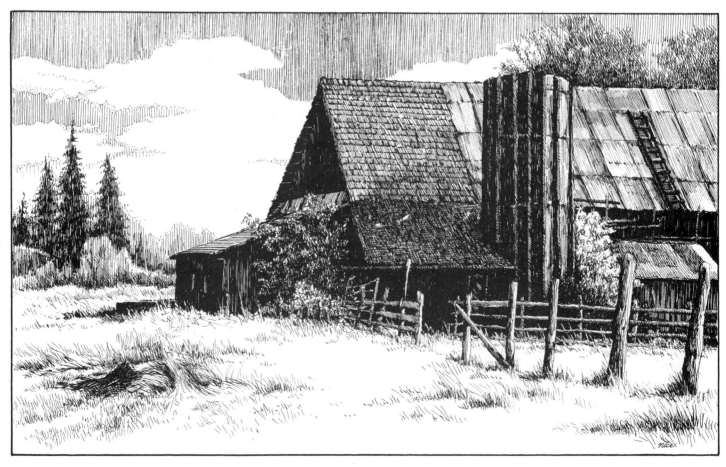

A Place For Vision Quests. I used Rapidograph pen sizes 1, 3×0 and 4×0.

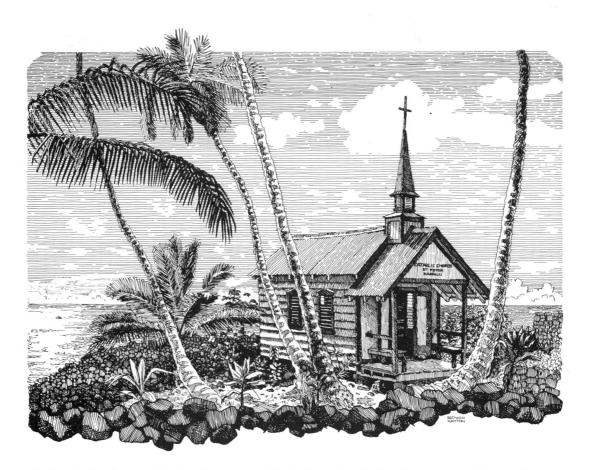

St. Peter's Church, actual size, by Hawaiian artist Edwin Kayton. In this island landscape, the tiny church, reminiscent of the eighteenth-century religious activity in Hawaii, is the center of interest. St. Peter's Church still stands at the shoreline just south of Kailua, Kona, Hawaii. Note how Edwin contrasts the vertical lines of the steeple and palms with horizontal sky lines.

This small country landscape (below) was sketched from my studio window using 3×0 and 4×0 Rapidograph pens.

Chapter Eight

SKETCHING WATER

Water Reflections

To study how light, shadow and reflections are sketched in relation to water, begin with the smallest unit, a drop of water. The area where the light first enters the drop will be a sparkling dot of white. The light spreads out as it travels through the drop, and it exits through a crescent-shaped area that is lighter in value than its surroundings. A shadow will be cast opposite the highlight dot. When strong backlighting is present, it will illuminate the whole upper surface of a water drop. I usually use parallel, contour or light crosshatch lines to depict water drops.

Pools of very still water will reflect like a mirror. Seen close-up, this may be represented as a reverse silhouette or, if the lighting is good, a reverse picture image. I like to use vertical parallel lines to suggest still-water reflections. Their closeness and length are governed by the objects they reflect. Across the reflection lines are placed a few horizontal water surface lines. It is important that these lines be parallel to the horizon line or the water will look tilted.

When the surface of the water is disturbed, water rings or ripples will form. Seen at a distance, rippled reflections can be represented by short contour lines placed horizontally across the surface. Up close, reflections cast upon gently moving water appear to be stretched sideways or broken apart, like puzzle pieces. The more disturbed the water is, the greater this distortion will be, until the reflection is lost altogether.

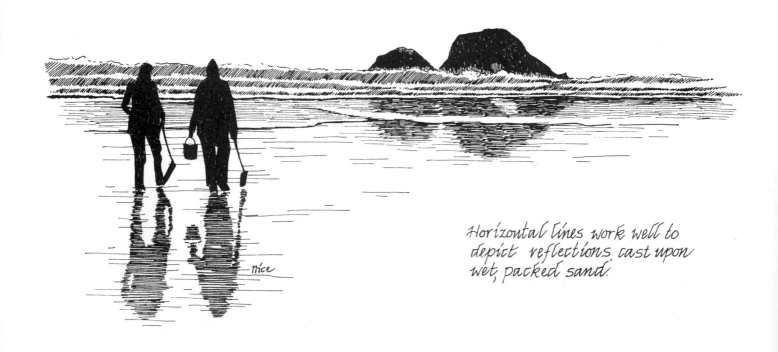

nice

Horizontal lines work well to depict reflections cast upon wet, packed sand.

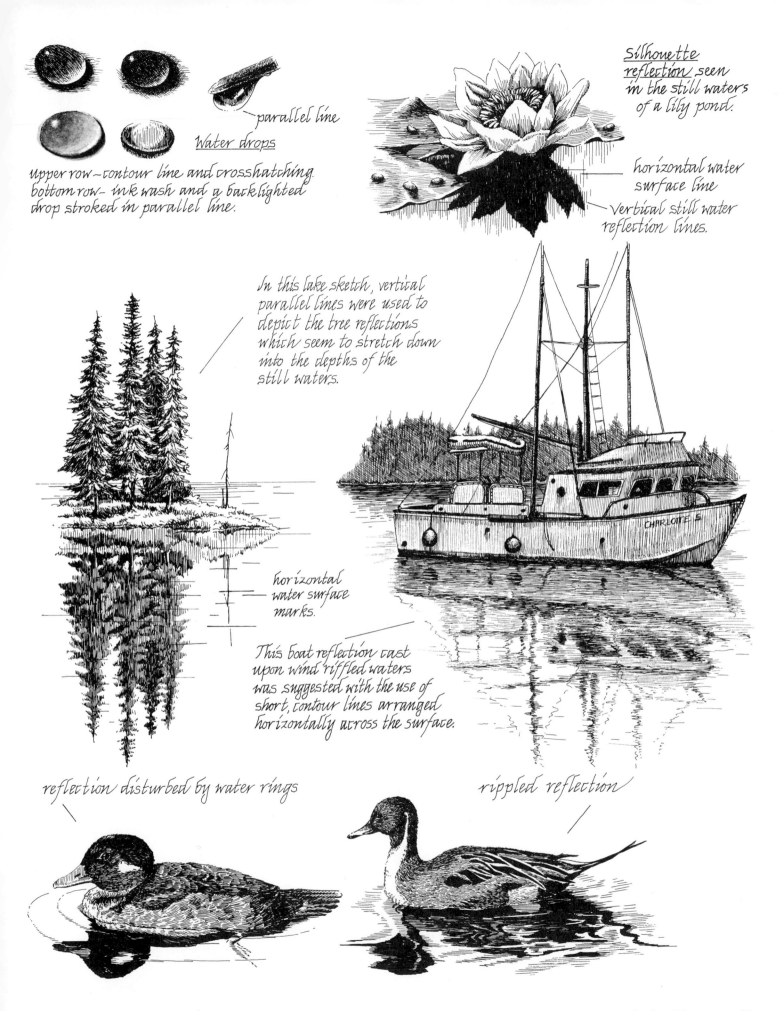

parallel line

Water drops

upper row – contour line and crosshatching. bottom row – ink wash and a backlighted drop stroked in parallel line.

Silhouette reflection seen in the still waters of a lily pond.

horizontal water surface line

vertical still water reflection lines.

In this lake sketch, vertical parallel lines were used to depict the tree reflections which seem to stretch down into the depths of the still waters.

horizontal water surface marks.

This boat reflection cast upon wind riffled waters was suggested with the use of short, contour lines arranged horizontally across the surface.

CHARLOTTE S

reflection disturbed by water rings

rippled reflection

Sketch of river swollen with spring rains.

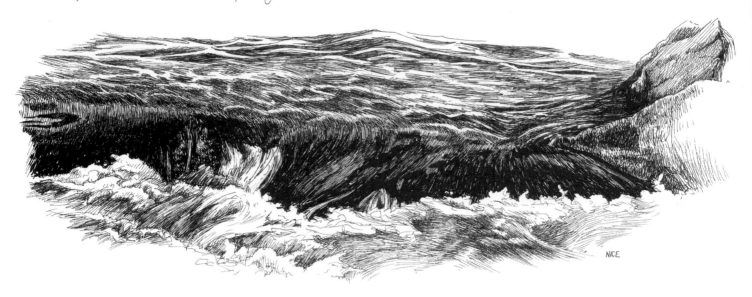

Water in Motion

Contour lines adapt well to the flow of moving water, from gentle ripples to the violent upheavings of white-water rapids. Add the texture of crosshatching, the rhythm of wavy lines, and the freedom of scribble lines, and you have the strokes needed to set water in motion.

Waves sketched with contour line. (4x0)

"Rooster tails" are formed when rocks under the surface force the water to boil up and fall back against itself. Broken scribble lines provide a delicate spray.

A flowing quick-sketch approach to depicting white-water rapids. A 3X0 size Rapidograph was used.

Birches in Reflection, 8 × 10½, pen sizes 4 × 0, 3 × 0 and 1, by the author. Deep, gently flowing water may seem quite calm on the surface, casting picture reflections. But as the current runs up against obstacles such as the protruding grassy bank, the stream will ripple, causing distorted reflections. (Courtesy of Susan Scheewe Publications, Inc.)

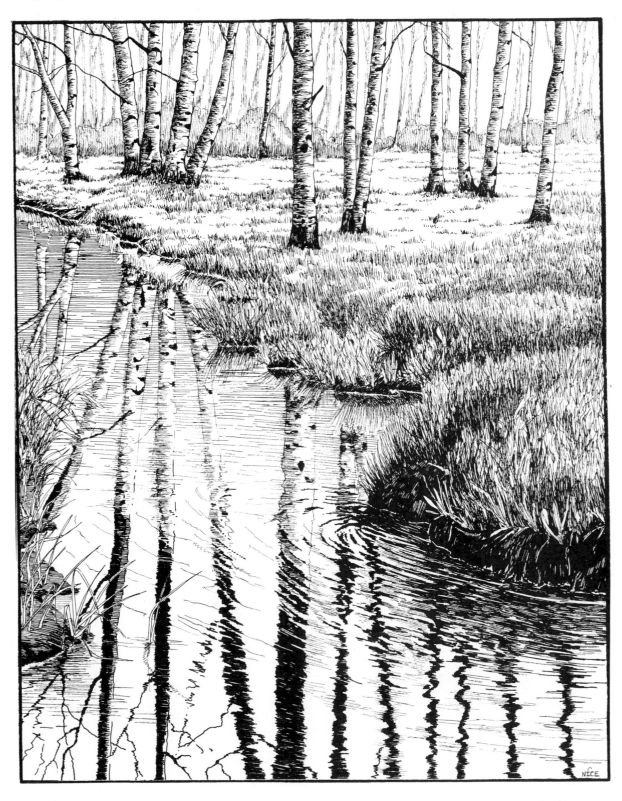

Waterfalls

Contrast is the most important consider-ation in sketching waterfalls: white water and lacy spray against dark bedrock. The goal is to keep the frothy water areas light and delicate, and the surging water areas clean and powerful. To obtain this goal, keep the ink work in the white-water areas to a minimum, using only enough strokes to suggest shape, shadow and flow.

I use contour lines or parallel lines to suggest the movement and shape of the falling water. Shadows or rocks partially hidden behind water are depicted by heavier concentrations of these same lines. Falling water takes on a dirty, flood-water appearance when overworked with ink lines.

Keep foam and water-spray areas sim-ple, with only a light outline of dots or broken scribble lines.

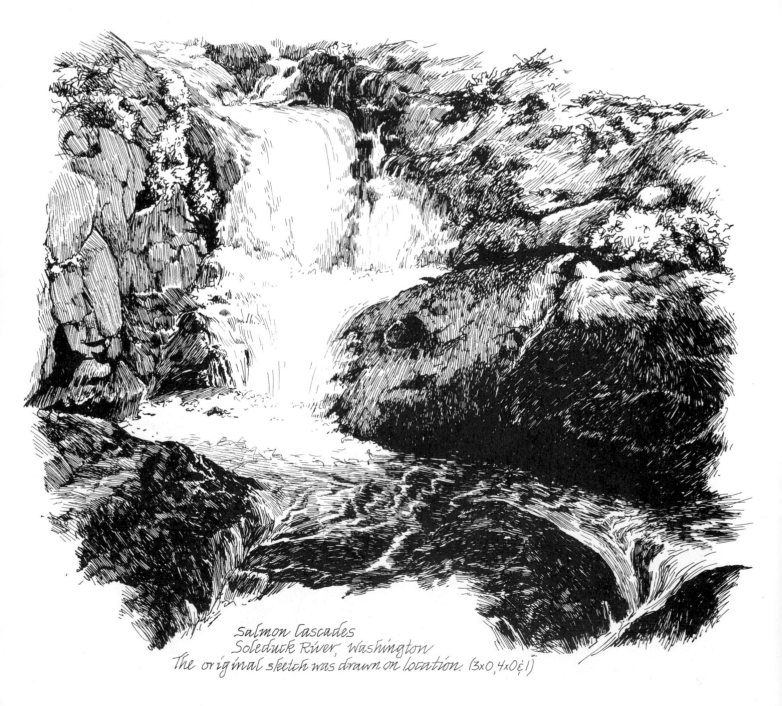

Salmon Cascades
Soleduck River, Washington
The original sketch was drawn on location. (3x0,4x0 & 1)

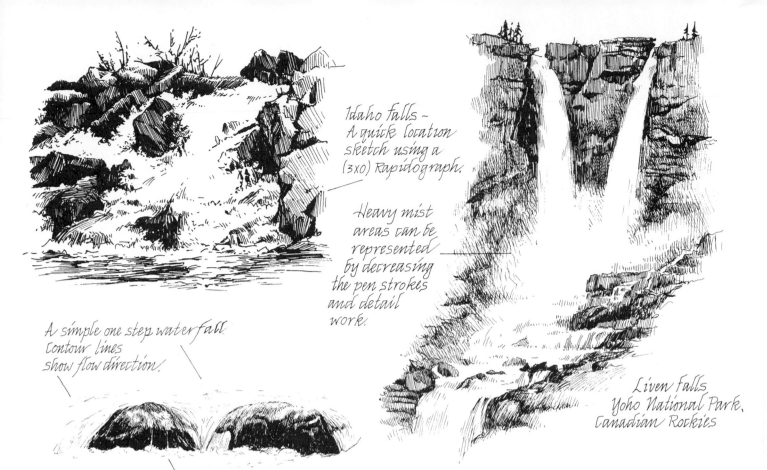

Idaho Falls -
A quick location
sketch using a
(3x0) Rapidograph.

Heavy mist
areas can be
represented
by decreasing
the pen strokes
and detail
work.

A simple one step waterfall.
Contour lines
show flow direction.

Simple broken scribble lines suggest white water.

(Below)- A cascade, stair step type of falls. Note the underlaying rocks.

Liven Falls,
Yoho National Park,
Canadian Rockies

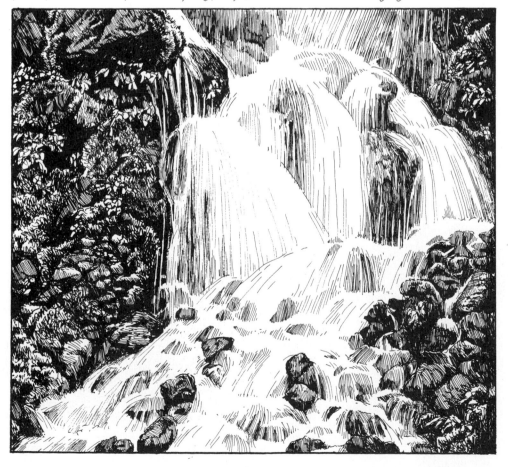

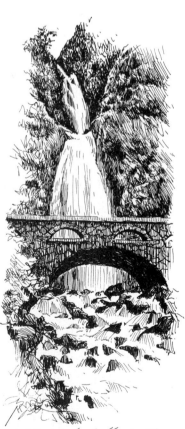

Wahkeenah Falls in the
Columbia River Gorge, Ore.
(3x0 & 4x0).

Surf

Surf, the swell of the sea as it breaks upon the shore, is a combination of wave, white water and waterfall, all stirred together by Mother Nature. The stroking techniques used to depict these various types are used together to sketch surf.

I find it rather difficult to capture a particular wave on location with my pen. Each wave rushes to shore, breaks with individual might and splendor and is gone. No two waves ever look exactly alike. Surf is a subject that requires careful observance, some notes and quick study sketches in the field, and a few rolls of film to unlock its secrets.

Note: When working on hot-press illustration board, use a light coating of masking fluid to protect delicate spray, foam and white-water areas while working background areas.

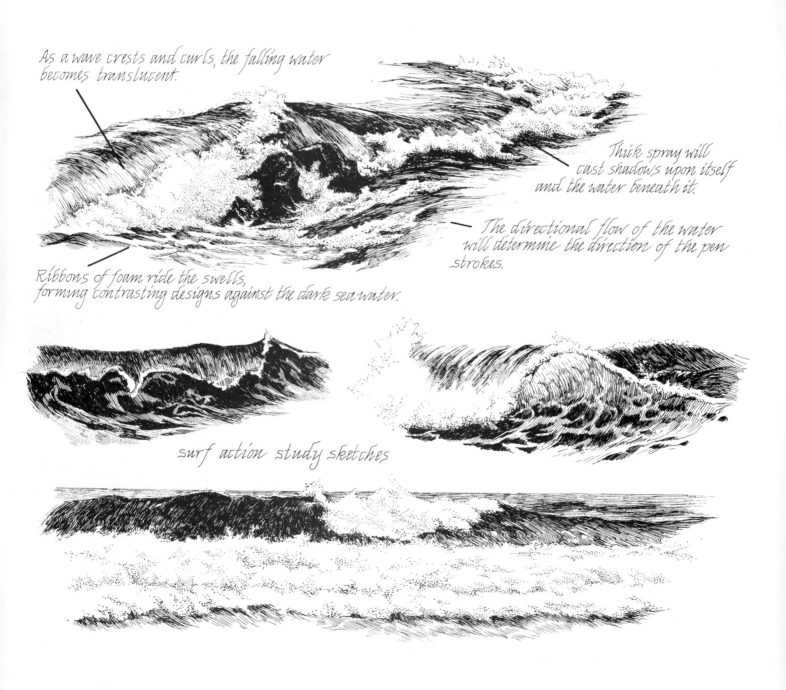

As a wave crests and curls, the falling water becomes translucent.

Thick spray will cast shadows upon itself and the water beneath it.

The directional flow of the water will determine the direction of the pen strokes.

Ribbons of foam ride the swells, forming contrasting designs against the dark sea water.

surf action study sketches

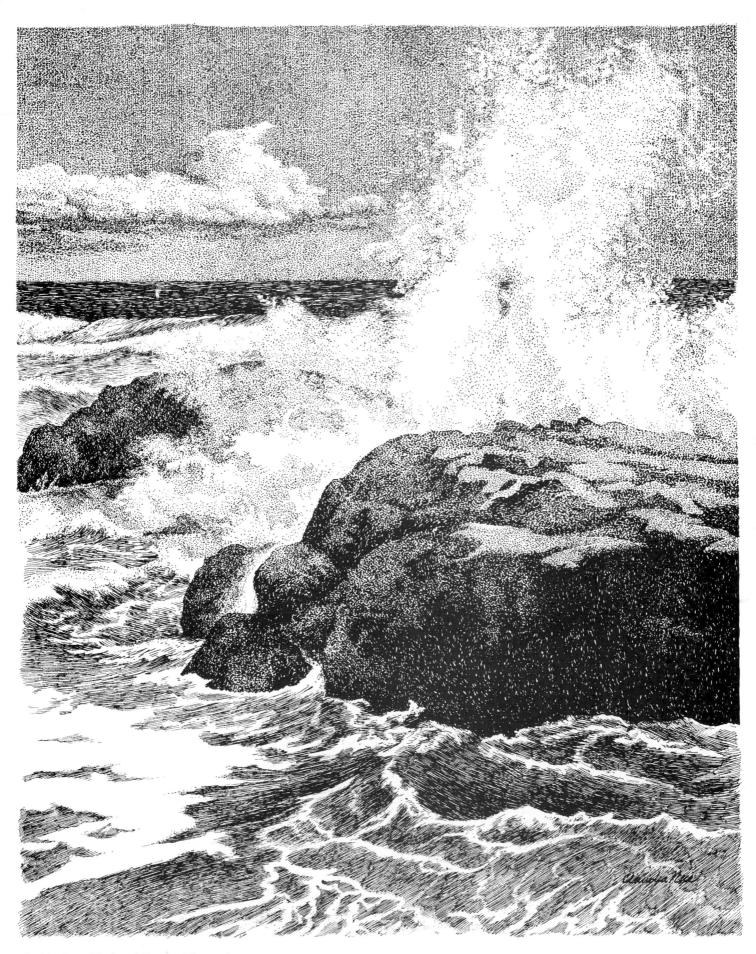

The Meeting of Rock and Sea, 8 × 10, pen sizes
3 × 0 and 0, by the author.

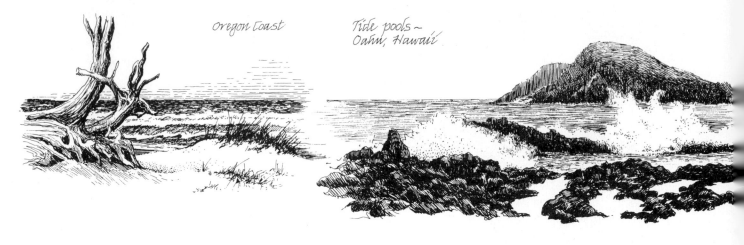

Oregon Coast

Tide pools ~
Oahu, Hawaii

Seascapes

Seascapes provide you the opportunity to bring together land, sea and sky, and combine them into a celebration of contrast and texture. In doing so, you must also strive to obtain unequal balance in the arrangement of subject matter. The ocean alone is horizontal in nature, with rows of waves sweeping across the drawing surface and the crest of the breakers providing the only vertical lift. The artful addition of shapes such as clouds, driftwood, rocks, dunes, beachgrass, people, boats, etc., can lend greater interest as well as artistic balance to the composition.

Glass floats, shells and seaweed gathered along the high tide line, on a west coast beach.

Old Cape Cod

texture studies
(4x0)

Pitted, rusty metal

barnacle incrusted metal

wet sand

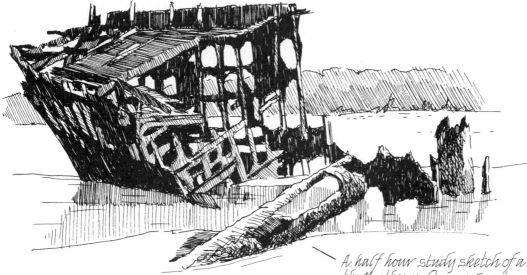

Texture studies and quick, on-location sketches give the artist the opportunity to experiment with pen strokes, lighting and compositional arrangement. The results can then be incorporated into a more detailed drawing.

A half hour study sketch of a shipwreck off the Northern Oregon coast. (3x0 pen size)
Below is a more detailed drawing of the same area.
(3x0 & 4x0)

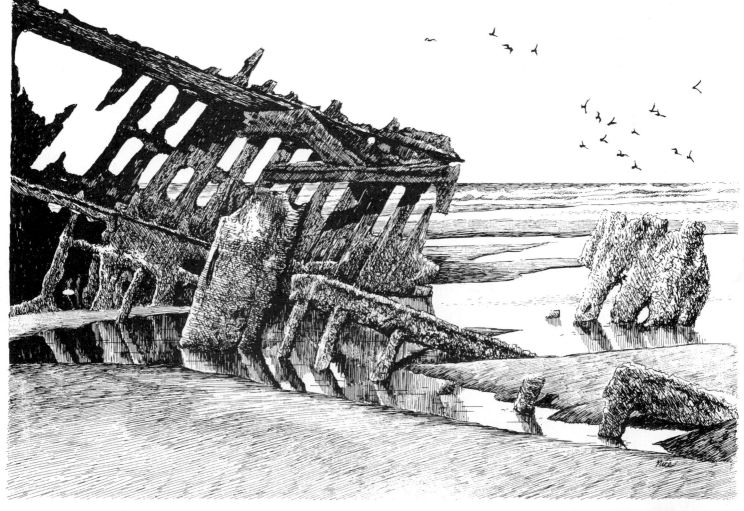

HOUSES & BUILDINGS

The goal of the architectural illustrator is to produce a drawing of a particular structure that is completely accurate in dimension and perspective. The lines of the drawings are geometric and precise, sometimes requiring the use of drafting tools. The completed project often is used commercially to illustrate a proposed building, or document an existing structure.

The freestyle sketcher is more concerned with capturing the *essence* of the structure being drawn, not scale-model precision. To the freestyle sketcher, technique and artistic license are important. However, even in freestyle sketching, you must reflect enough knowledge of form and perspective to make the sketch believable.

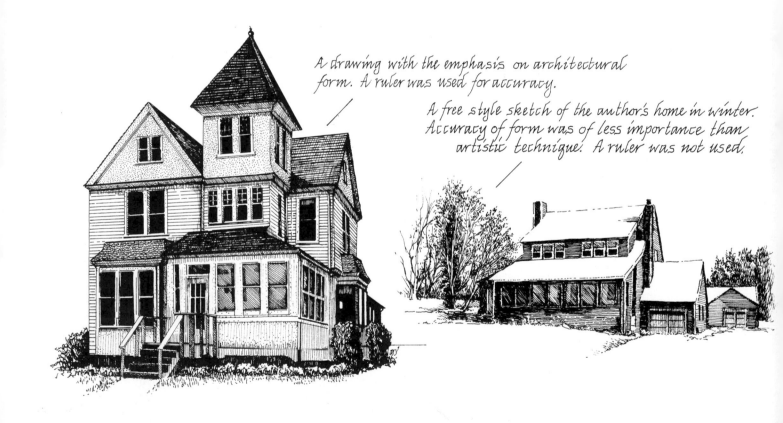

A drawing with the emphasis on architectural form. A ruler was used for accuracy.

A free style sketch of the author's home in winter. Accuracy of form was of less importance than artistic technique. A ruler was not used.

Textures which are useful when sketching houses seen at a distance.

stone work

shingles

wooden shakes

weathered wooden siding

stucco

brick

cement or stone

log construction

Preliminary pencil drawing (reduced), with lines running to the horizon line to check perspective.

horizon line

Below – A free hand sketch of a country home in West Virginia. (3x0 & 4x0)

Victorian Mansion, 8½ × 11, by the author.

The drawing of the Victorian mansion at left is a blending of styles. To achieve precision on some of the intricate detail work, like the masonry, a straight edge was used. Less-exacting parts of the drawing were accomplished freehand. The result is a very solid structure with artistic grace.

The sketch of the abandoned southern mansion below and the shake-sided homestead at right were sketched completely freehand, with little concern about straight lines. This sketchy style adds to the weathered look of both buildings. Indeed the moldering plantation house seems haunted with memories of its elegant past. Style and texture can add greatly to the *mood* of the sketch.

When structures are viewed at close range, details come into sharp focus. Sometimes a small section of a structure provides enough appeal in shape or texture to warrant a complete composition in itself.

When the object of study is glass, like the antique doorknob at left, both the inner and outer shape of the object must be represented, as well as any shapes seen through the glass from behind. Carefully placed highlights, shadows and reflections will give it a transparent appearance, while contour-line work will provide a smooth, glassy quality.

In the stone work composition below, all the strokes but crisscross were used to provide a sketch strong in texture.

(Right) *The Hen House,* 7 × 10, by Dan Puffer. Dan chose to show only part of the building, concentrating on the detail of the weathered wood and tangled vegetation.

THE HEN HOUSE

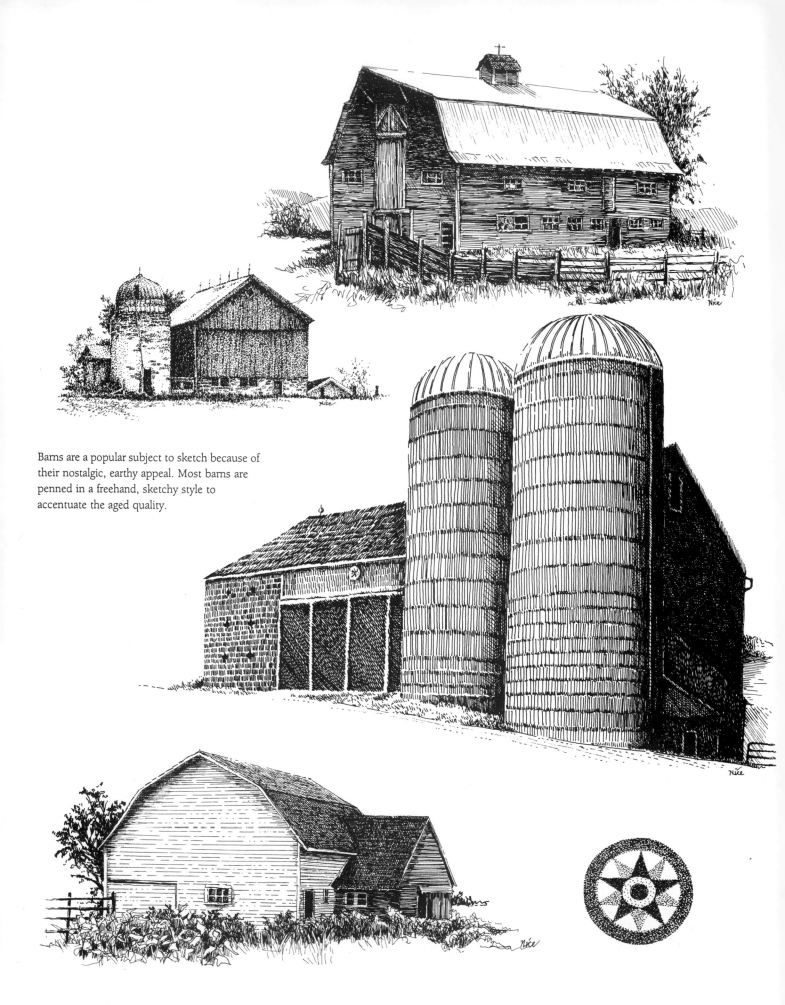

Barns are a popular subject to sketch because of their nostalgic, earthy appeal. Most barns are penned in a freehand, sketchy style to accentuate the aged quality.

The New England farm scene (below) by
Connecticut artist Harold Bellucci is a good
example of how appealing a freestyle sketch can
be. The artist has very successfully combined a
delicate scribble-line technique with a love of
detail to produce a landscape strong in texture,
contrast and nostalgia. The 8½ × 11 drawing is
part of the published "Back Roads of America"
series.

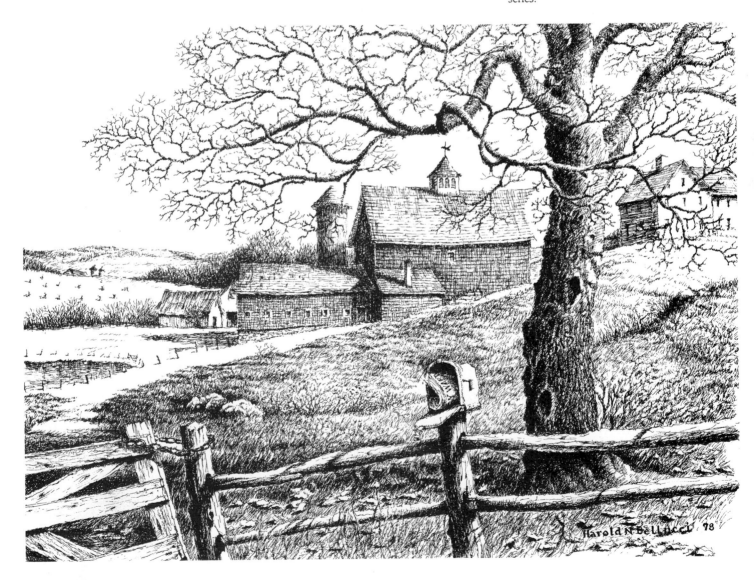

Old Man and Dog and Cabin, 14 × 20, by
Richard DeSpain. DeSpain, with his love of
detail, has managed to capture the rough charm
of this rustic landmark, as well as the feeling of
serenity. He has accomplished a masterful
blending of architectural and freehand styles to
produce realistic renditions of local landmarks
and historic milestones. His work is intricately
detailed, using fine lines and a combination of
all seven stroking techniques. © 1979 by
Richard DeSpain.

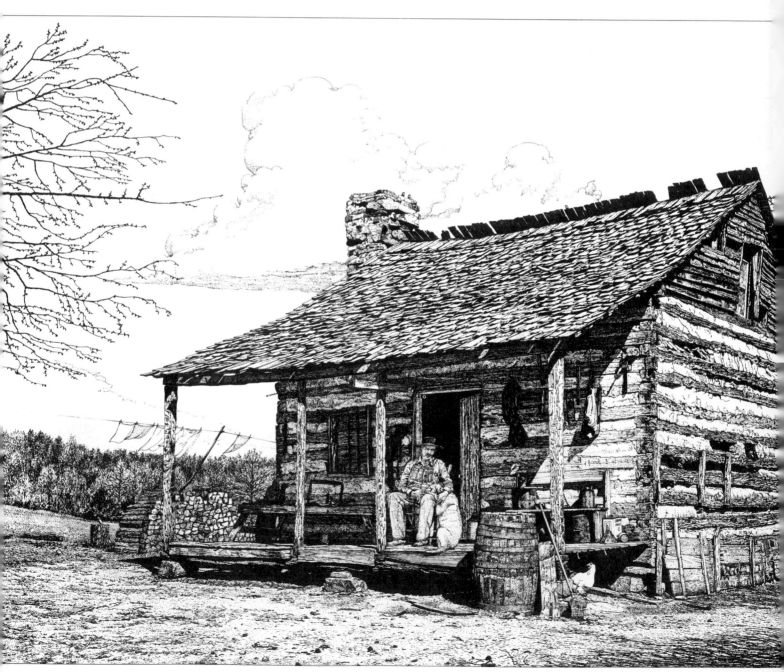

C-B0 Navigator, 20 × 16, by Richard DeSpain. The techniques used to depict architecture also lend themselves well to produce drawings of a mechanical nature. As illustrated by DeSpain's drawing, contrast is important to keep complicated illustrations from becoming confusing. © 1988 by Richard DeSpain.

The Capitol Grounds, 11 × 14, by Richard DeSpain. Precise lines, combined with well-planned use of texture and contrast, give this composition its dramatic impact. © 1982 by Richard DeSpain.

(Right) *Houston,* 20 × 26, by Albert Lorenz. The skillful use of perspective and curved background gives this Texas cityscape the feel of sweeping distance. © 1982 by Albert Lorenz.

(Below) *Chicago,* 19 × 27, by Albert Lorenz, is a cityscape artfully rendered in a combination of precise line work and stippling. Lorenz is a well-known New York architectural illustrator. Showing both imagination and skill, his renderings range from traditional perspectives to the fish-eye lens panoramas shown on this and the adjoining page. © 1982 by Albert Lorenz.

Enlarged detail of *Chicago,* by Albert Lorenz.

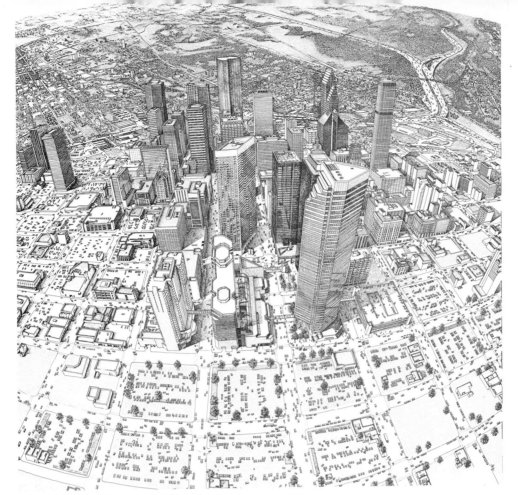

Enlarged detail of *Houston,* by Albert Lorenz.

SKETCHING ANIMALS

As discussed in chapter five, an artist begins drawing an animal by penciling in the main geometric shapes in the subject's conformation. If the animal possesses a long, thick coat of fur, these shapes may be obscured. When you draw the contour of the coat rather than the body beneath, you may lose some definition, and the resulting sketch may take on the appearance of a formless fluff ball.

Body contours are easier to recognize if you have a basic knowledge of how animals are put together. As you can see in the skeletal examples at right, there are certain structural basics that most animals have in common, such as the rib cage, the shoulder bones, the hip bones and the spine. Although leg bones are assembled similarly in most animals, there can be quite a difference in their shape and length. Long-legged grazing animals have the equivalent of the human heel

and wrist near the mid-point of the leg, while the heel of the bear rests on the ground.

The rib cage forms the chest of the animal. Seen from the side, it is oval-shaped. From the front, it looks more rounded and balloons out past the humerus and femur bones.

The scapula and humerus come together at the shoulder, forming a "V" that points to the front of the animal. The pelvic and femur bones form a "V" that points to the rear. These "V"s can be seen beneath the hides of short-haired animals, forming the contours of the shoulder, hip and rump.

Although the curve of the neck and spine are similar in most animals, the length of the bones may vary greatly, resulting in the difference between the long-necked giraffe and the shorter-necked ox.

If you become familiar with the basic animal skeleton, it will be easier to draw the elementary animal shape. Animals vary not so much in the way their bones are arranged, but in the length and shape of each individual bone.

Although you can't see the actual skeleton of each animal subject, the outer mounds and curves formed by the bones can be seen, studied, and used as the basis of each animal drawing.

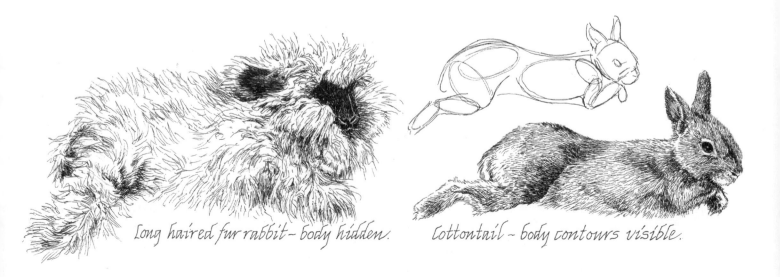

Long haired fur rabbit – body hidden.

Cottontail – body contours visible.

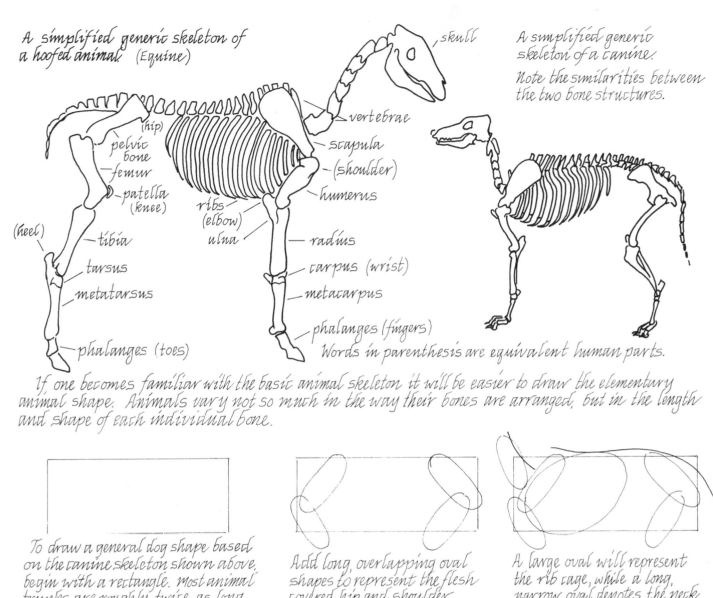

A simplified generic skeleton of a hoofed animal. (Equine)

A simplified generic skeleton of a canine.

Note the similarities between the two bone structures.

skull

vertebrae

scapula

(shoulder)

humerus

(hip)

pelvic bone

femur

patella (knee)

ribs

(elbow)

ulna

radius

(heel)

tibia

carpus (wrist)

tarsus

metacarpus

metatarsus

phalanges (fingers)

phalanges (toes)

Words in parenthesis are equivalent human parts.

If one becomes familiar with the basic animal skeleton it will be easier to draw the elementary animal shape. Animals vary not so much in the way their bones are arranged, but in the length and shape of each individual bone.

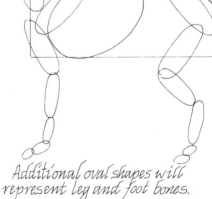

To draw a general dog shape based on the canine skeleton shown above, begin with a rectangle. Most animal trunks are roughly twice as long as they are high.

Add long, overlapping oval shapes to represent the flesh covered hip and shoulder bones.

A large oval will represent the rib cage, while a long, narrow oval denotes the neck. A line will suggest the curve of the spine.

Additional oval shapes will represent leg and foot bones.

The skull narrows towards the nose and can be suggested by two rectangles and a small circle.

Draw a line around these shapes and one has a basic dog body. A change in the size or contour of the shapes would produce a different breed or species.

Although one can not see the actual skeleton of each animal subject, the outer mounds and curves formed by the bones can be seen, studied and used as the basis of each animal drawing.

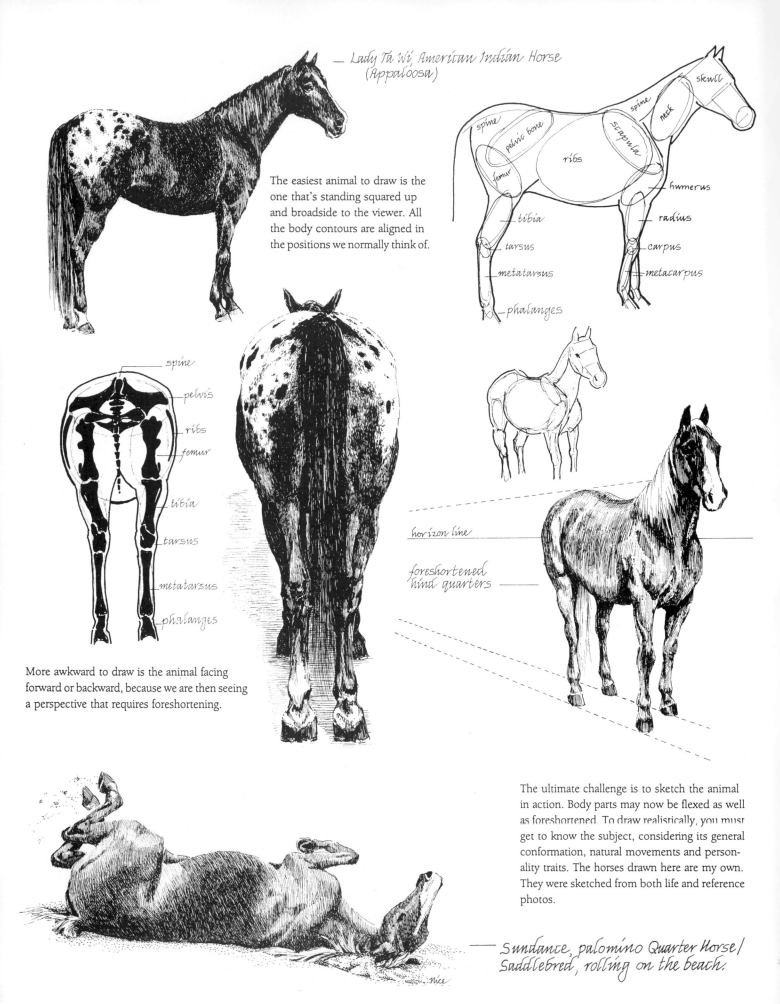

— Lady Ta Wi, American Indian Horse
(Appaloosa)

spine
pelvic bone
spine
neck
skull
scapula
femur
ribs
tibia
humerus
tarsus
radius
metatarsus
carpus
phalanges
metacarpus

The easiest animal to draw is the one that's standing squared up and broadside to the viewer. All the body contours are aligned in the positions we normally think of.

spine
pelvis
ribs
femur
tibia
tarsus
metatarsus
phalanges

More awkward to draw is the animal facing forward or backward, because we are then seeing a perspective that requires foreshortening.

horizon line

foreshortened hind quarters

The ultimate challenge is to sketch the animal in action. Body parts may now be flexed as well as foreshortened. To draw realistically, you must get to know the subject, considering its general conformation, natural movements and personality traits. The horses drawn here are my own. They were sketched from both life and reference photos.

— Sundance, palomino Quarter Horse/
Saddlebred, rolling on the beach.

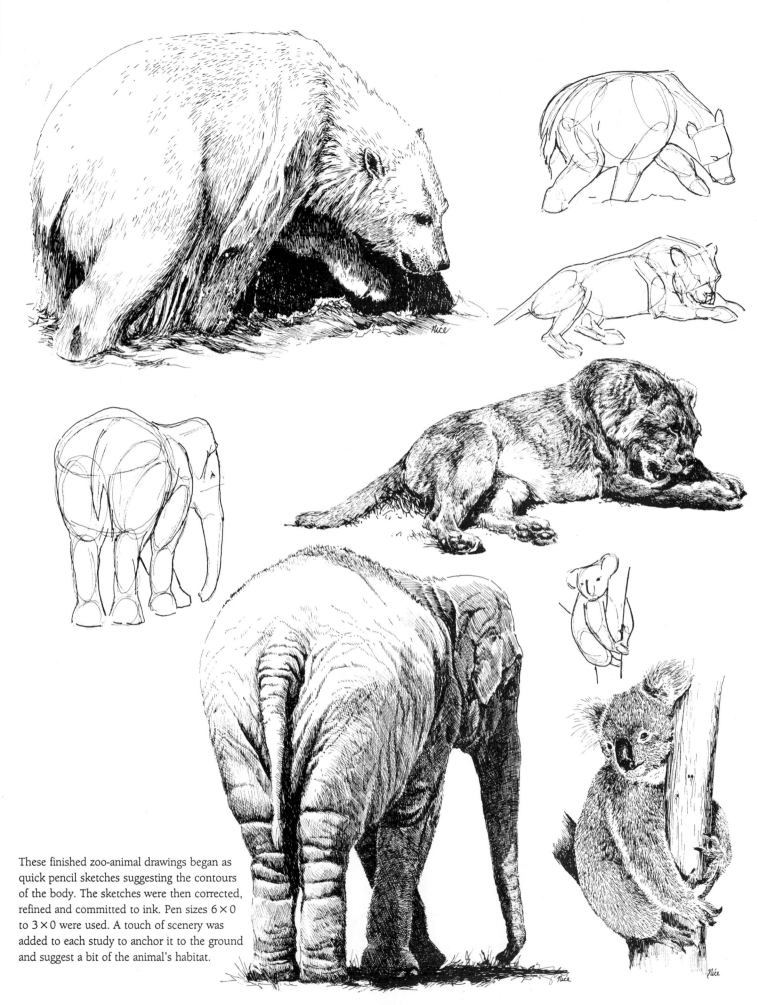

These finished zoo-animal drawings began as
quick pencil sketches suggesting the contours
of the body. The sketches were then corrected,
refined and committed to ink. Pen sizes 6×0
to 3×0 were used. A touch of scenery was
added to each study to anchor it to the ground
and suggest a bit of the animal's habitat.

In these quick sketches of my kittens Tigger and Spook, fur direction, coloration and shadows were indicated by rapid scribble strokes. A 3x0 Rapidograph was used.

Animal Quick Studies

In the quick-sketch technique, the artist is concerned with capturing the essence of the animal's form and motion, in as few strokes as possible. Details and features are merely suggested. You may set down a few pencil guidelines or go directly to ink, allowing the preliminary strokes to become part of the drawing. As in slower, more detailed studies, begin with the contours of the trunk, paying special attention to the curves of the spine. Next add the head. Note its size and angle in relation to the trunk. As you add the legs, consider their length and

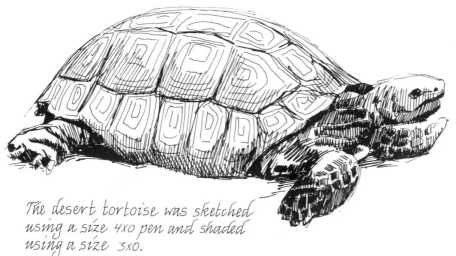

The desert tortoise was sketched using a size 4x0 pen and shaded using a size 3x0.

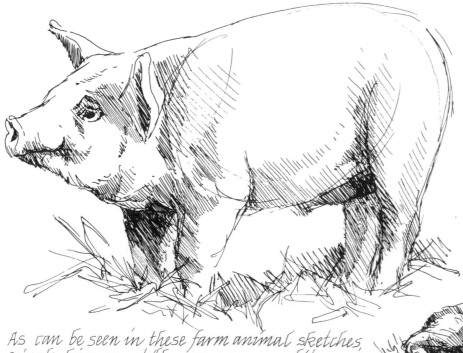

As can be seen in these farm animal sketches, simple lines can still convey personality.

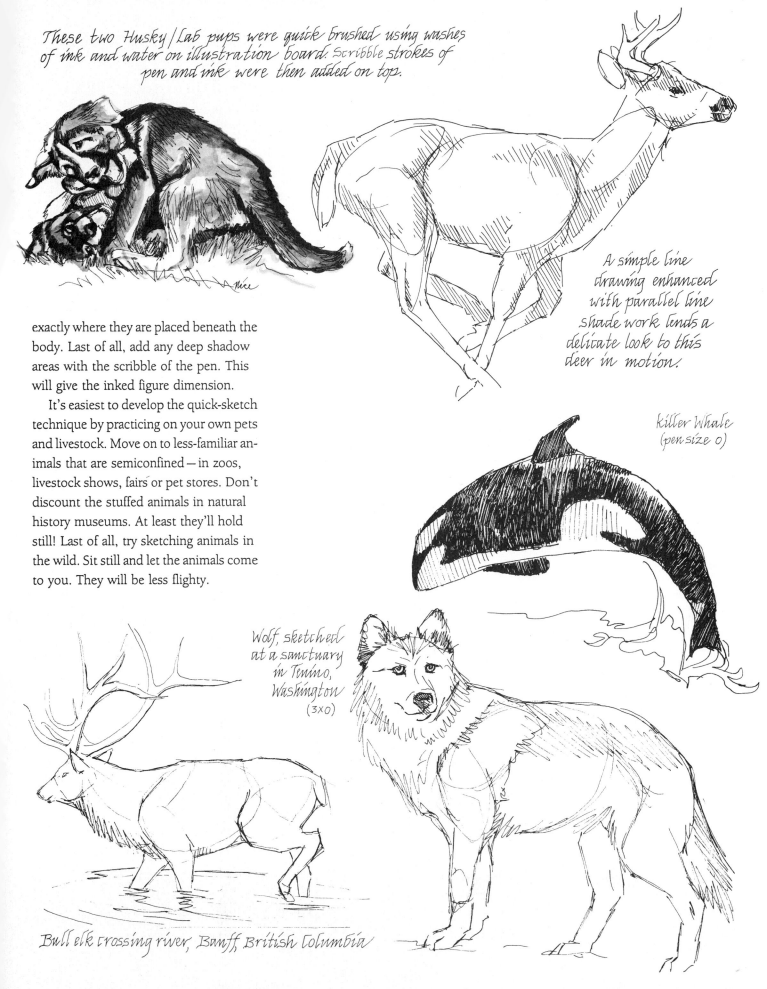

These two Husky/Lab pups were quick brushed using washes of ink and water on illustration board. Scribble strokes of pen and ink were then added on top.

exactly where they are placed beneath the body. Last of all, add any deep shadow areas with the scribble of the pen. This will give the inked figure dimension.

It's easiest to develop the quick-sketch technique by practicing on your own pets and livestock. Move on to less-familiar animals that are semiconfined — in zoos, livestock shows, fairs or pet stores. Don't discount the stuffed animals in natural history museums. At least they'll hold still! Last of all, try sketching animals in the wild. Sit still and let the animals come to you. They will be less flighty.

A simple line drawing enhanced with parallel line shade work lends a delicate look to this deer in motion.

Killer whale (pen size 0)

Wolf, sketched at a sanctuary in Tenino, Washington (3x0)

Bull elk crossing river, Banff, British Columbia

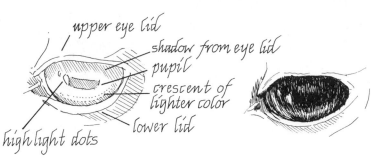

upper eye lid

shadow from eye lid

pupil

crescent of lighter color

lower lid

high light dots

Preliminary drawing.

The eyeball is shaded using contour lines

Deer eye

Light is reflected from the moist rim of the lower lid. Hair is adde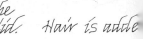

Sketching the Eye

The spark of life is reflected in the eye. I usually begin inking my detailed animal drawings in the eye region. If the finished eye lacks character, staring blankly back at me from the paper, I probably will not proceed with the sketch.

Basically, all eyeballs are orb-shaped. It is the way the eyeball fits into the skull and the way the eyelids fit around it that give each eye its distinctive look. The basic contour of the pupil can vary from round to capsule-shaped, depending on the species. The size of the pupil changes according to lighting conditions — the stronger the light, the smaller the pupil. Eye color often varies from individual to individual. Such is the case with dogs, cats, horses and humans.

The eyeball is shaded much the same as a drop of water. Where the light first strikes the eye, highlights are reflected in one or more small dots or shapes. The light spreads out within the eye, causing illumination. This is represented by a crescent of lighter value along the lower edge of the orb. Eyes that are concealed in shadow will show no highlights and little illumination.

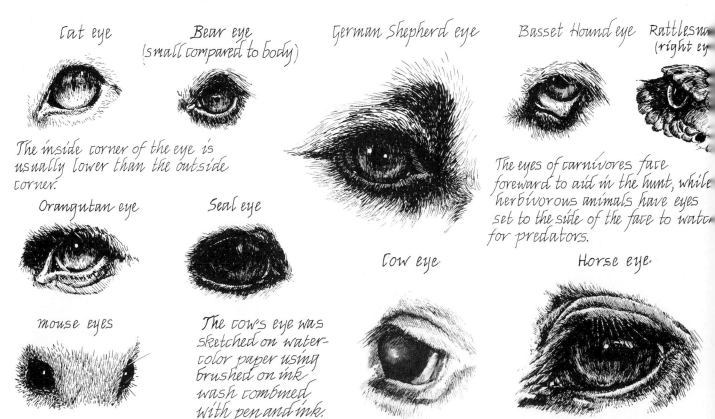

Cat eye

Bear eye (small compared to body)

German Shepherd eye

Basset Hound eye

Rattlesna
(right ey

The inside corner of the eye is usually lower than the outside corner.

Orangutan eye

Seal eye

mouse eyes

The cow's eye was sketched on watercolor paper using brushed on ink wash combined with pen and ink.

The eyes of carnivores face foreward to aid in the hunt, while herbivorous animals have eyes set to the side of the face to watc for predators.

Cow eye.

Horse eye.

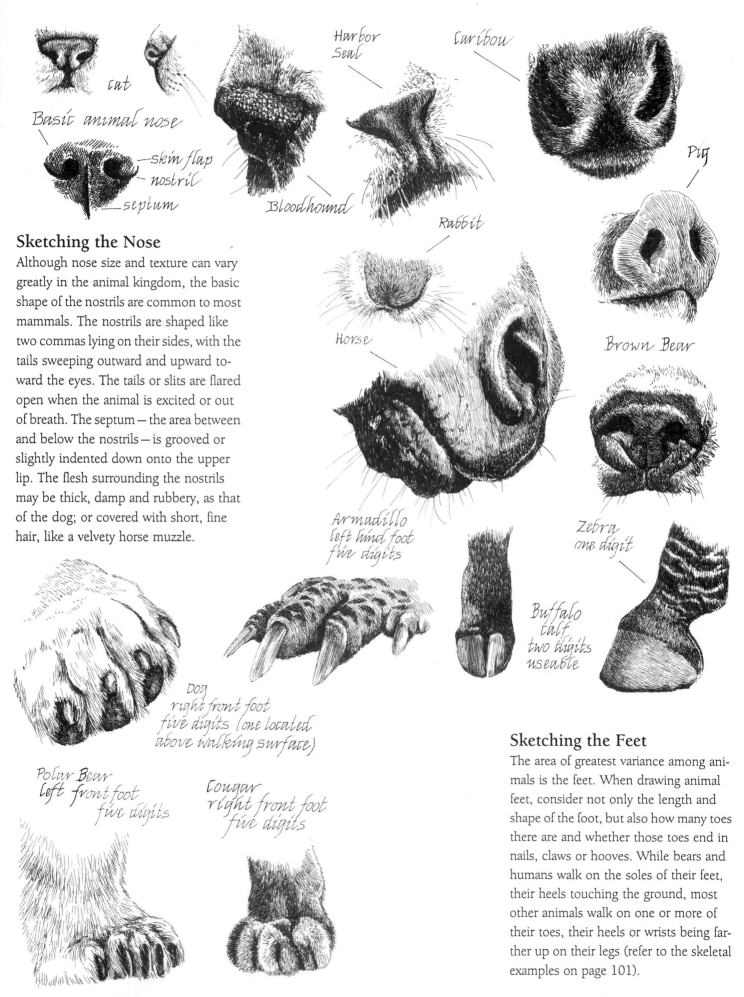

cat

Basic animal nose

— skin flap
— nostril
— septum

Harbor Seal

Caribou

Pig

Bloodhound

Rabbit

Brown Bear

Horse

Zebra one digit.

Sketching the Nose

Although nose size and texture can vary greatly in the animal kingdom, the basic shape of the nostrils are common to most mammals. The nostrils are shaped like two commas lying on their sides, with the tails sweeping outward and upward toward the eyes. The tails or slits are flared open when the animal is excited or out of breath. The septum — the area between and below the nostrils — is grooved or slightly indented down onto the upper lip. The flesh surrounding the nostrils may be thick, damp and rubbery, as that of the dog; or covered with short, fine hair, like a velvety horse muzzle.

Armadillo left hind foot five digits

Dog right front foot five digits (one located above walking surface)

Buffalo calf two digits useable

Polar Bear left front foot five digits

Cougar right front foot five digits

Sketching the Feet

The area of greatest variance among animals is the feet. When drawing animal feet, consider not only the length and shape of the foot, but also how many toes there are and whether those toes end in nails, claws or hooves. While bears and humans walk on the soles of their feet, their heels touching the ground, most other animals walk on one or more of their toes, their heels or wrists being farther up on their legs (refer to the skeletal examples on page 101).

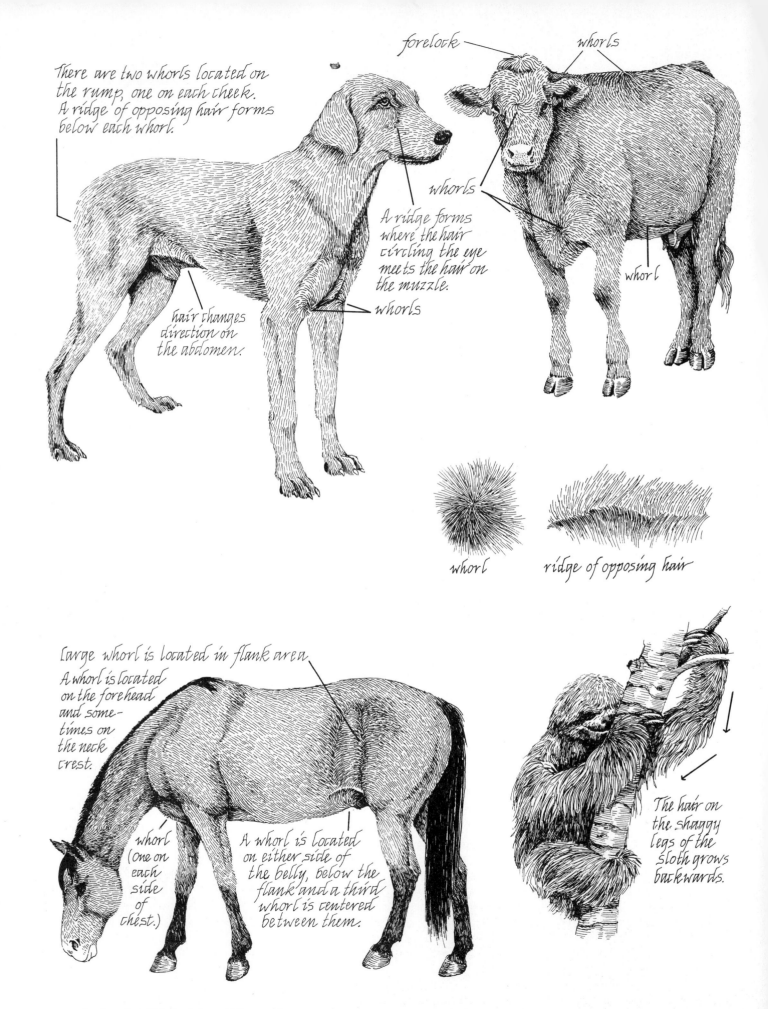

There are two whorls located on the rump, one on each cheek. A ridge of opposing hair forms below each whorl.

hair changes direction on the abdomen.

forelock

whorls

whorls

A ridge forms where the hair circling the eye meets the hair on the muzzle.

whorls

whorl

whorl

ridge of opposing hair

Large whorl is located in flank area

A whorl is located on the forehead and sometimes on the neck crest.

whorl (one on each side of chest.)

A whorl is located on either side of the belly, below the flank and a third whorl is centered between them.

The hair on the shaggy legs of the sloth grows backwards.

Sketching Animal Hair

To pen a realistic coat of hair on an animal, be aware of the direction of hair growth. Basically, the hair grows from the face toward the tail and feet. There are areas where the hair abruptly changes direction, forming a whorl or ridge, then continues on in the normal direction. The location of whorls varies according to the species and individual animal.

Cows and horses begin their hair-growth pattern in a whorl located on the forehead, between the eyes. On most other animals the hair begins its growth pattern just beyond the fleshy part of the nose, radiating outward toward the chin, cheeks and forehead.

The crisscross stroke described in chapter two can lend realism to the coat of a straight-haired animal, seen up close. The pen strokes themselves should be only as long as the hair they represent, and should be fairly straight unless the actual hairs are curved. Spots, stripes, dapples and color changes in the coat are indicated by changing the number of strokes in a given area or changing the nib size of the pen. Sometimes a hair of one color is coarser than a hair of another color, making a change of one nib size appropriate. I can close my eyes and actually tell by touch where my Appaloosa's coat changes from white to black spots. The edge of the coat or the color variations within should never be outlined with a continuous line. Fur areas with an outline will look thin and mangy.

Even when hairs change direction abruptly, they seldom lie across each other in a crosshatch pattern. Crosshatching will make the hair look matted or dirty, unless you use crosshatching for the entire animal.

Scribble lines work well to depict the thick, intertwined coats of sheep, while the curved pattern of wavy lines can represent the texture of a flaxen mane. Dots give the look of velvet to short-haired animals and, with patience, can be used to duplicate all of the other hair types.

Crisscross lines

short hair (4x0)

medium length hair showing change of growth direction (4x0)

long hair ending in a wave (4x0)

dappled coat (4x0)

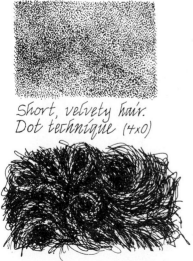

Short, velvety hair. Dot technique (4x0)

Tightly curled scribble line hair (3x0)

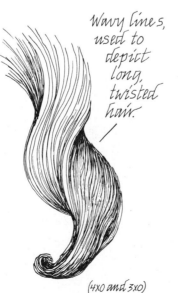

Wavy lines, used to depict long, twisted hair.

(4x0 and 3x0)

multicolored coat (4x0)

Surrounding a dark spot or stripe is an area of value transition where the dark hairs mingle with those of the lighter hue. ⟶

dark stripes on a medium dark coat (4x0 and 3x0)

black spots on white (4x0 and 3x0)

One of the most difficult hair types to represent in pen and ink is the long, shaggy winter coat. Because of its thickness, the hair tends to gather in clumps that stand out from the body. Hair direction changes often as the long hairs intertwine in wavy tufts. A combination of scribble lines, wavy lines and crisscross strokes were used to depict the shaggy coat of the brown bear below.

African Camouflage, 8½ × 11. In the montage of African animals at right, I used variation in hair texture and coloration to provide contrast. The animals, sketched from quick studies and slides taken at the Portland, Oregon, and San Diego zoos, were allowed to overlap as they were drawn. This overlapping quality was carried into the finished ink work, giving a transparent, fantasy look to the composition.

Pen sizes range from 6 × 0 to 0, and the drawing took five days to complete. The animals are (top to bottom) the zebra, lion, black rhinoceros, Mhorr gazelle, Bongo antelope, giraffe, gorilla, oryx, elephant, and a pair of cattle egrets.

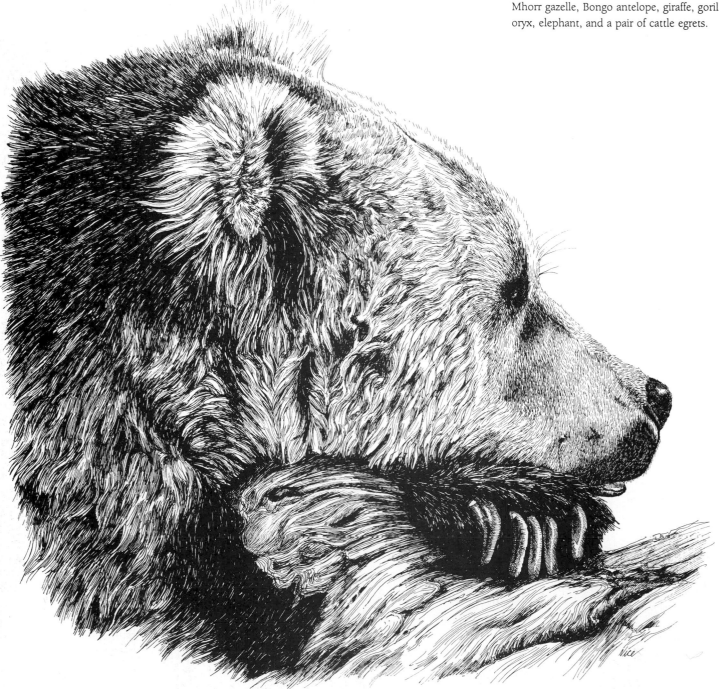

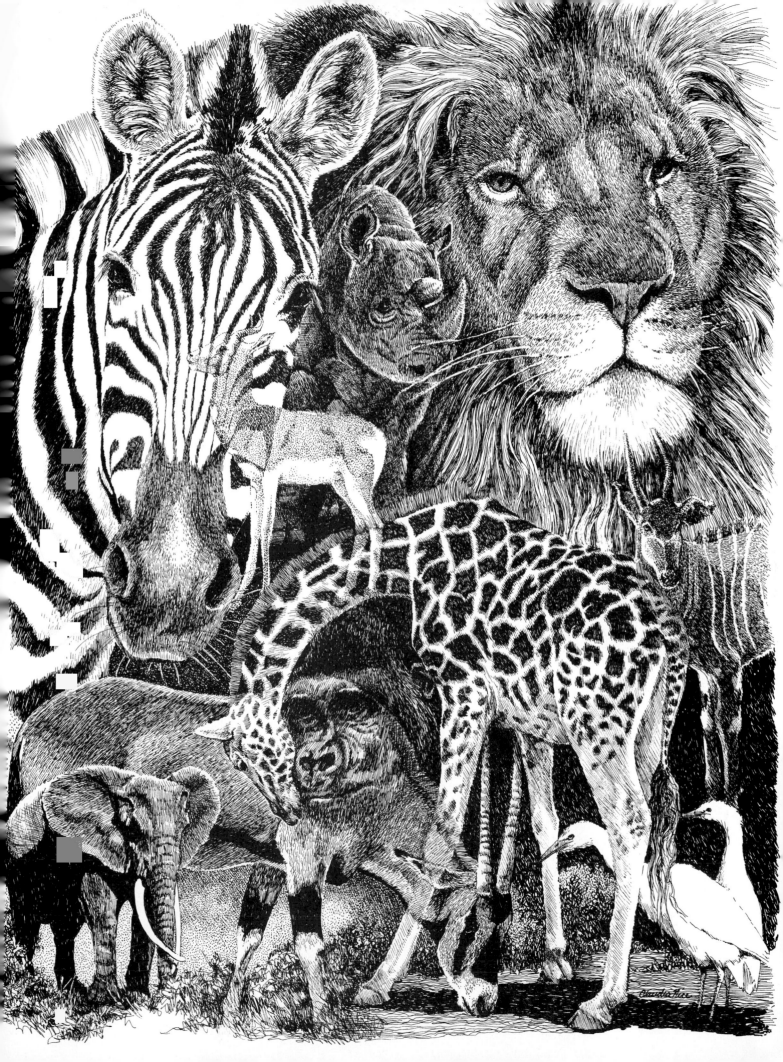

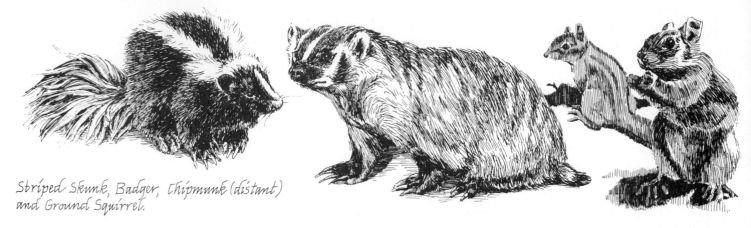

Striped Skunk, Badger, Chipmunk (distant) and Ground Squirrel.

River Otters (6x0, 4x0 and 0)

The river otters (below left) are large enough that each hair of their silky coats can be detailed using short crisscross strokes. The skunk and badger (top left) are seen at a greater distance, where the individual hairs blend together. A combination of crisscross and scribble lines were used to depict them.

The squirrel was inked using contour lines, suggesting that its details are obscured, perhaps by a fine morning mist.

Parallel lines help to place the chipmunk in the background. Animals seen through heavy rain or fog might also have this indistinct appearance.

Lonebull, 16×20, by Willie Preacher. Native American artist Willie Preacher combined several stroking techniques to reproduce the rugged coat of the buffalo. The battle scars and worn places depicted on the hide add a special look of realism to the bison, and suggest an animal of strength who has overcome much to survive.

Ruth C. Daniel

Horses, 22 × 28, by Ruth E. Daniels, part of the Koh-I-Noor Rapidograph Art Collection.

Daniels' masterful use of the stippling technique gives the horses in her drawing the look of velvet. The subtle value changes that can be achieved by arranging tiny dots enabled her to depict each feature with realistic detail. Note the soft contours of the veins beneath the skin. Daniels states that "an artist's work is a biography; a personal interpretation of life expressed through a visual and sensual medium." Her love and knowledge of the horse shines brightly in her work.

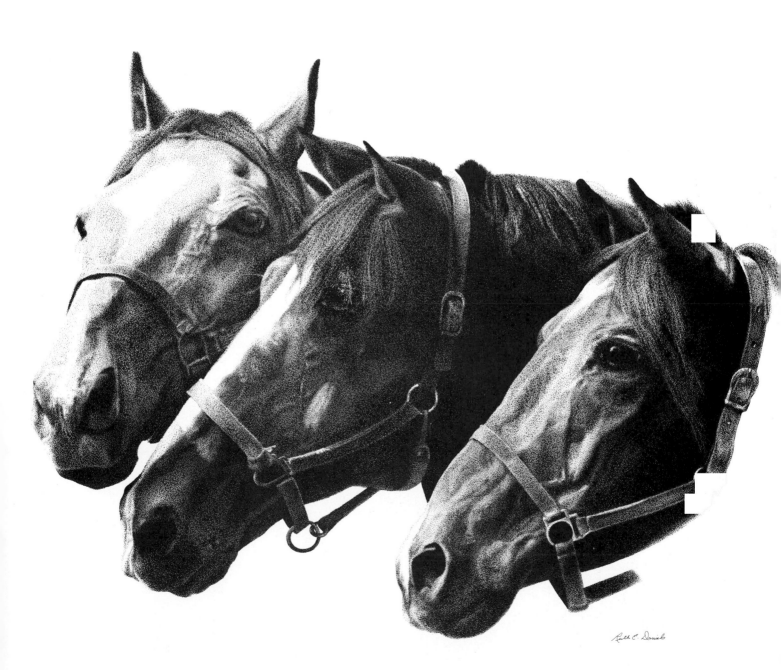

Chapter Eleven

SKETCHING BIRDS

There is great variance of size and form among birds, ranging from the small, stocky hummingbird to the long-necked crane and egret. Yet they all seem to share two basic shapes: The head is oval, sometimes almost round, depending on the angle at which it is viewed; and a large sternum (breast bone) and elongated pelvis give the body an egg shape, the narrow end of the egg pointing toward the tail.

When sketching a bird, the first thing I look for is the size of the body and head in relation to each other and the position of each. Then I look for the length of the neck, for this will determine the placement of the head. Many of the birds have such short necks that the head and body overlap when drawn. After sketching the head and trunk, I pencil in the other features and refine the drawing. Corrections are made and all unnecessary pencil marks are removed. I find it helpful to indicate color changes and shadows lightly in pencil so I know where to make value changes.

I usually begin my ink work by stroking in the bill, eye and head, then work my way back toward the tail. If a wing or foot crosses in front of the body, it should be inked first.

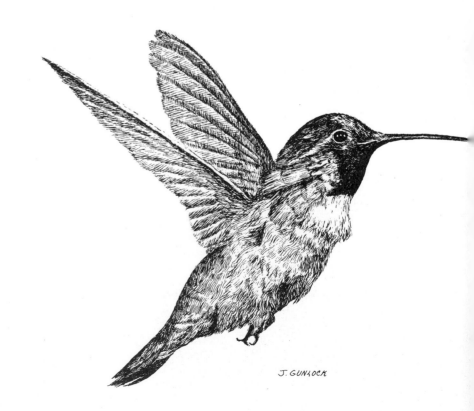

Costa's Hummingbird, © 1986 by Jan Gunlock.

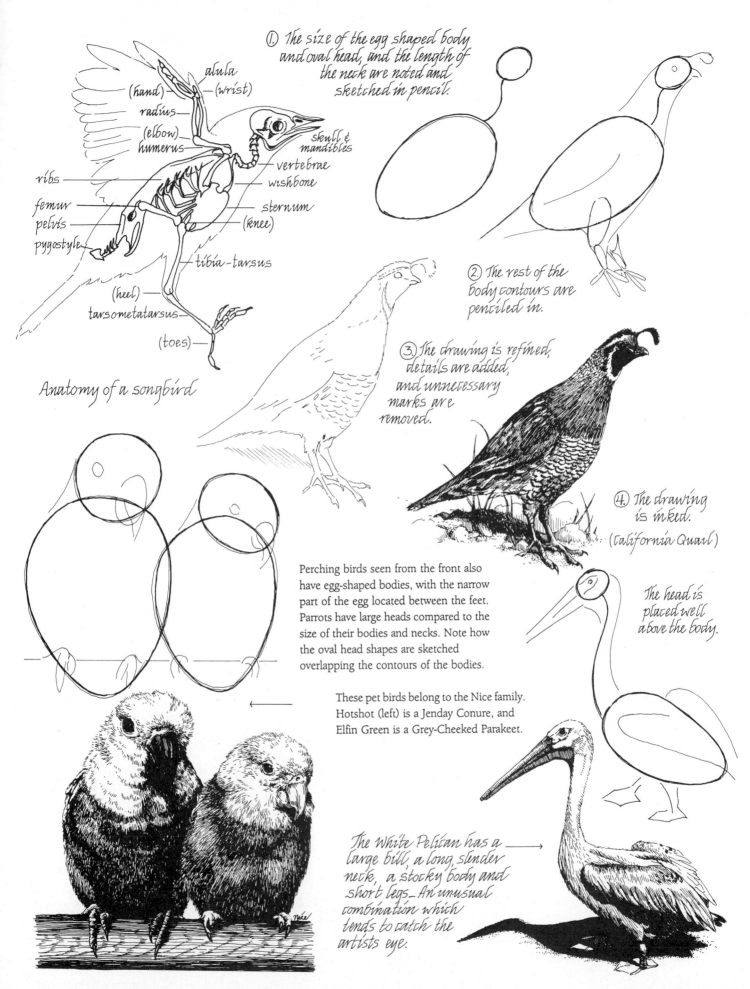

① The size of the egg shaped body and oval head, and the length of the neck are noted and sketched in pencil.

alula (hand)
(wrist)
radius
(elbow)
humerus
skull & mandibles
vertebrae
wishbone
ribs
sternum
femur
pelvis
(knee)
pygostyle
tibia-tarsus
(heel)
tarsometatarsus
(toes)

Anatomy of a songbird

② The rest of the body contours are penciled in.

③ The drawing is refined, details are added, and unnecessary marks are removed.

④ The drawing is inked.
(California Quail)

Perching birds seen from the front also have egg-shaped bodies, with the narrow part of the egg located between the feet. Parrots have large heads compared to the size of their bodies and necks. Note how the oval head shapes are sketched overlapping the contours of the bodies.

These pet birds belong to the Nice family. Hotshot (left) is a Jenday Conure, and Elfin Green is a Grey-Cheeked Parakeet.

The head is placed well above the body.

The White Pelican has a large bill, a long, slender neck, a stocky body and short legs. An unusual combination which tends to catch the artists eye.

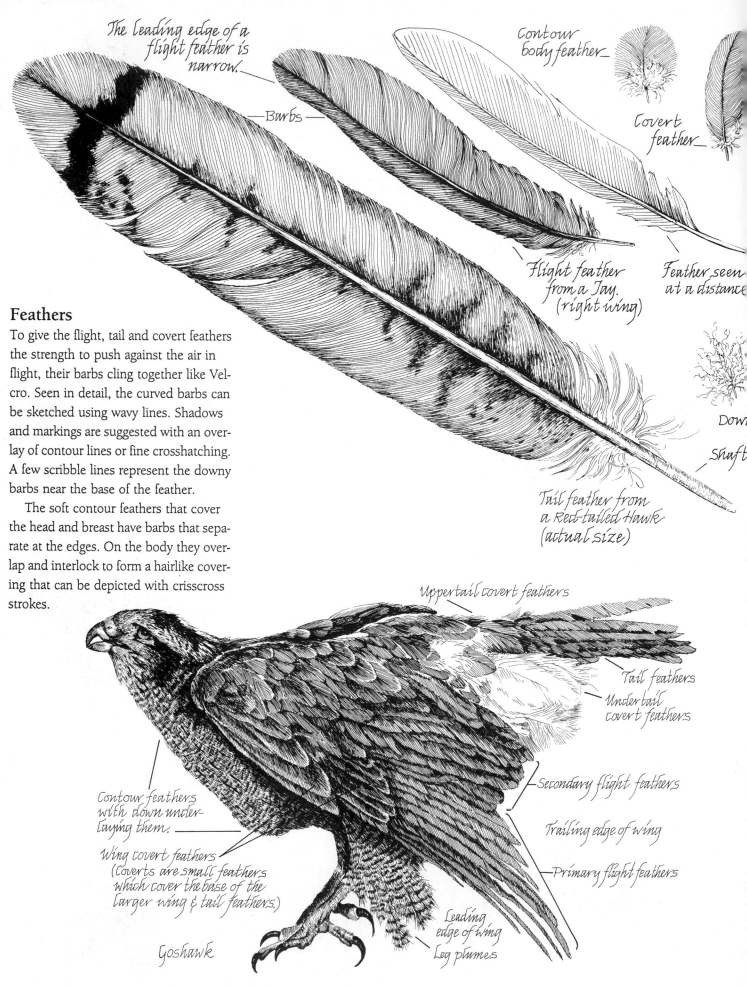

The leading edge of a flight feather is narrow.

—Barbs—

Contour body feather

Covert feather

Flight feather from a Jay. (right wing)

Feather seen at a distance

Dow

Shaft

Tail feather from a Red-tailed Hawk (actual size)

Feathers

To give the flight, tail and covert feathers the strength to push against the air in flight, their barbs cling together like Velcro. Seen in detail, the curved barbs can be sketched using wavy lines. Shadows and markings are suggested with an overlay of contour lines or fine crosshatching. A few scribble lines represent the downy barbs near the base of the feather.

The soft contour feathers that cover the head and breast have barbs that separate at the edges. On the body they overlap and interlock to form a hairlike covering that can be depicted with crisscross strokes.

Uppertail covert feathers

Tail feathers
Undertail covert feathers

Secondary flight feathers

Trailing edge of wing

Primary flight feathers

Contour feathers with down under-laying them.

Wing covert feathers (Coverts are small feathers which cover the base of the larger wing & tail feathers.)

Goshawk

Leading edge of wing
Leg plumes

Feet and Faces

Aside from body size, neck length and plumage, the greatest variance among the birds lies in their feet and bills. These appendages reflect the habitat and diet of each species.

The hard, rounded surface of the bill can best be depicted with contour lines, or a combination of contour lines and light crosshatching for large, detailed drawings.

The feet are scaly in texture. Although I usually use a combination of contour lines and crosshatching to portray them, you might experiment with scribble lines, parallel lines and dots.

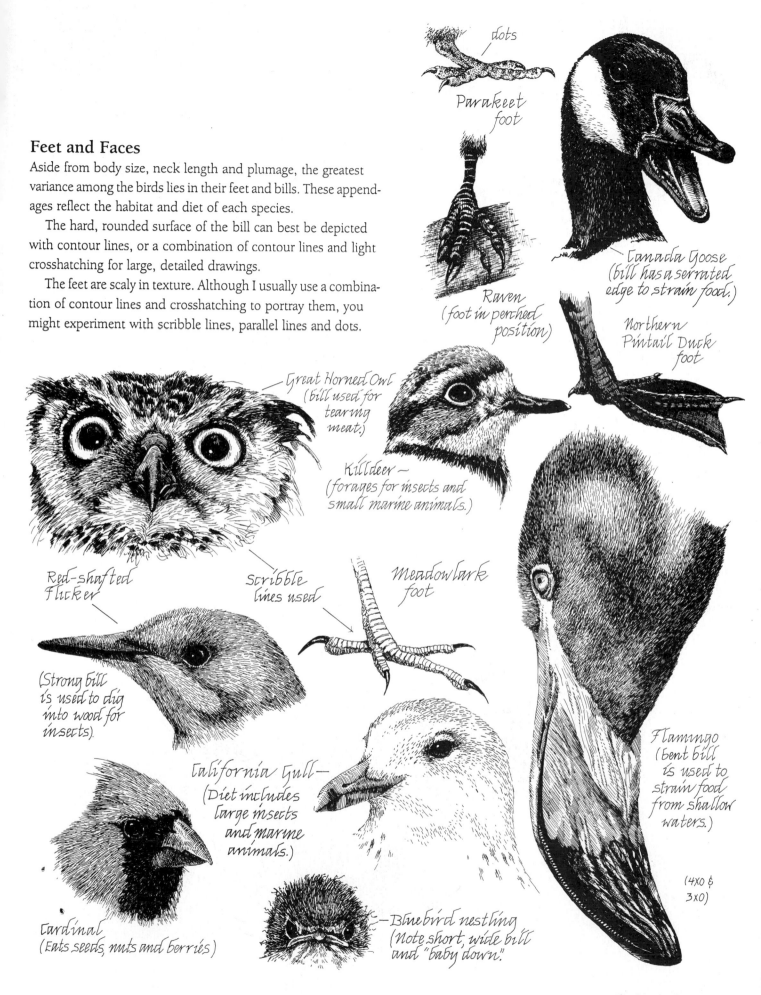

dots

Parakeet foot

Raven (foot in perched position)

Canada Goose (bill has a serrated edge to strain food.)

Northern Pintail Duck foot

Great Horned Owl (bill used for tearing meat.)

Killdeer — (forages for insects and small marine animals.)

Red-shafted Flicker

(Strong bill is used to dig into wood for insects).

scribble lines used

Meadowlark foot

California Gull — (Diet includes large insects and marine animals.)

Flamingo (bent bill is used to strain food from shallow waters.)

(4X0 & 3X0)

Cardinal (Eats seeds, nuts and berries)

Bluebird nestling (Note short, wide bill and "baby down."

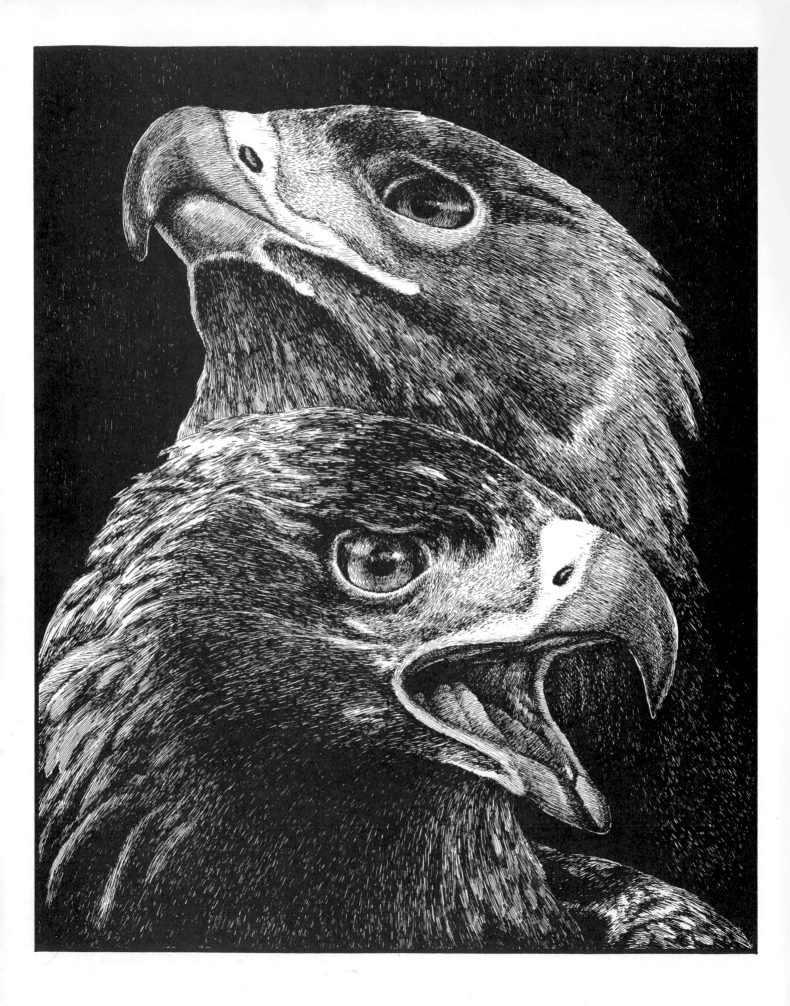

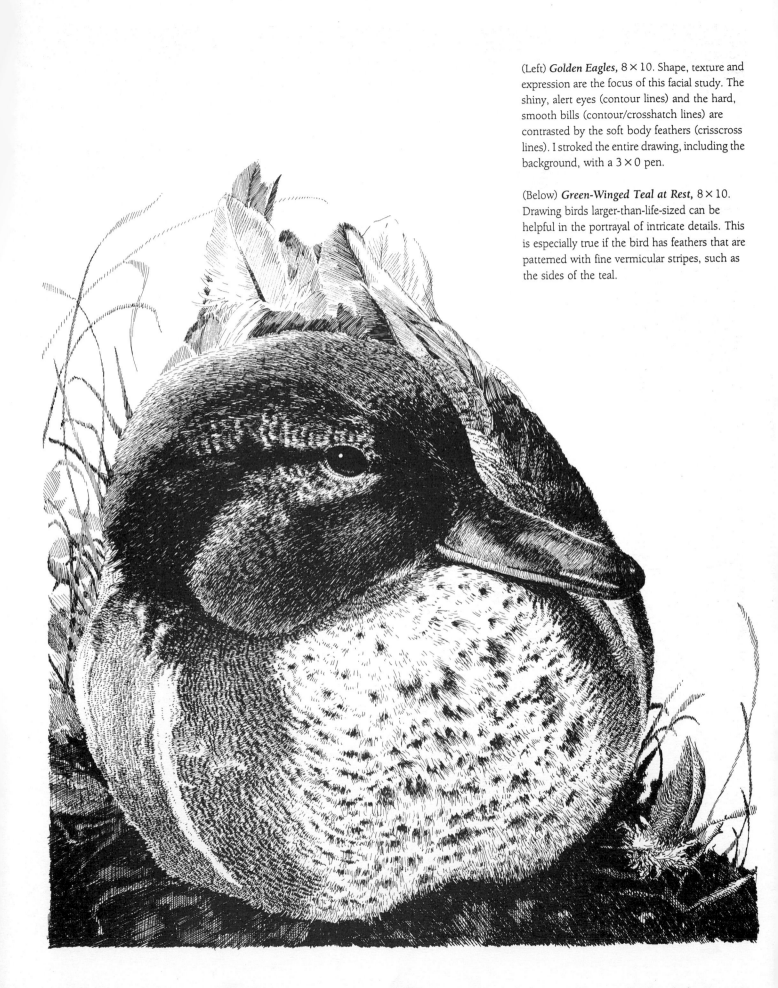

(Left) *Golden Eagles,* 8 × 10. Shape, texture and expression are the focus of this facial study. The shiny, alert eyes (contour lines) and the hard, smooth bills (contour/crosshatch lines) are contrasted by the soft body feathers (crisscross lines). I stroked the entire drawing, including the background, with a 3 × 0 pen.

(Below) *Green-Winged Teal at Rest,* 8 × 10. Drawing birds larger-than-life-sized can be helpful in the portrayal of intricate details. This is especially true if the bird has feathers that are patterned with fine vermicular stripes, such as the sides of the teal.

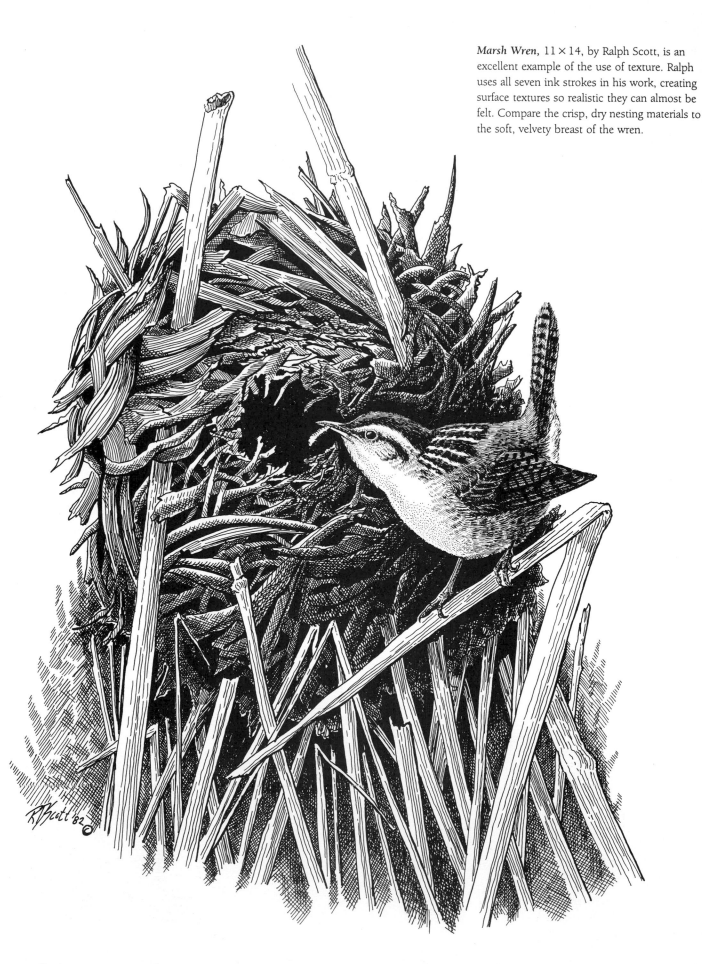

Marsh Wren, 11 × 14, by Ralph Scott, is an excellent example of the use of texture. Ralph uses all seven ink strokes in his work, creating surface textures so realistic they can almost be felt. Compare the crisp, dry nesting materials to the soft, velvety breast of the wren.

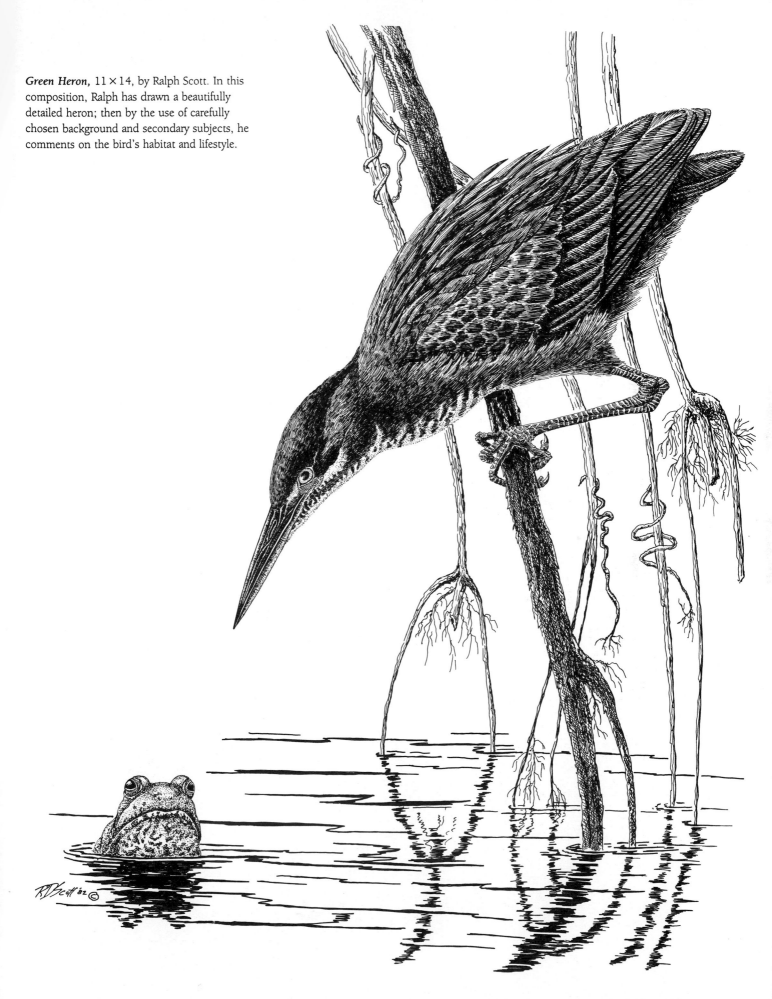

Green Heron, 11 × 14, by Ralph Scott. In this composition, Ralph has drawn a beautifully detailed heron; then by the use of carefully chosen background and secondary subjects, he comments on the bird's habitat and lifestyle.

FACES & FIGURES

Sketching the Face

Although face shapes differ, in my preliminary pencil sketch I usually draw an egg shape to represent the head, the narrow end of the egg over the chin. I find it helpful to dissect this basic head shape with several lines that will assist me in positioning the features. A line stretching from the center of the forehead to the point of the chin will be useful in centering the eyes, nose and mouth. Unless the face is being viewed straight on, the line is drawn with a slight curve, as if it were on a rounded surface. If the head is turned, the line is set off-center, the far side of the face appearing narrower.

A horizontal line drawn across the face about halfway down will aid in the place-ment of the eyes, assuring that they will be even. The lower edge of the nose and the space between the lips are suggested with two short, horizontal pencil lines. Over this basic framework, the face shape and features that are unique to each individual are sketched. The drawing is then refined, perfected and committed to ink.

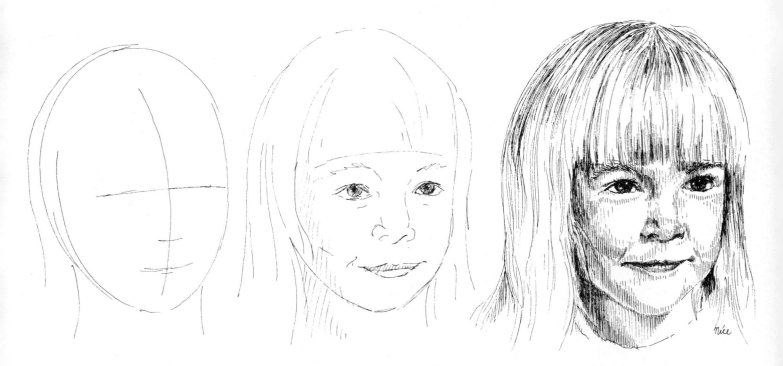

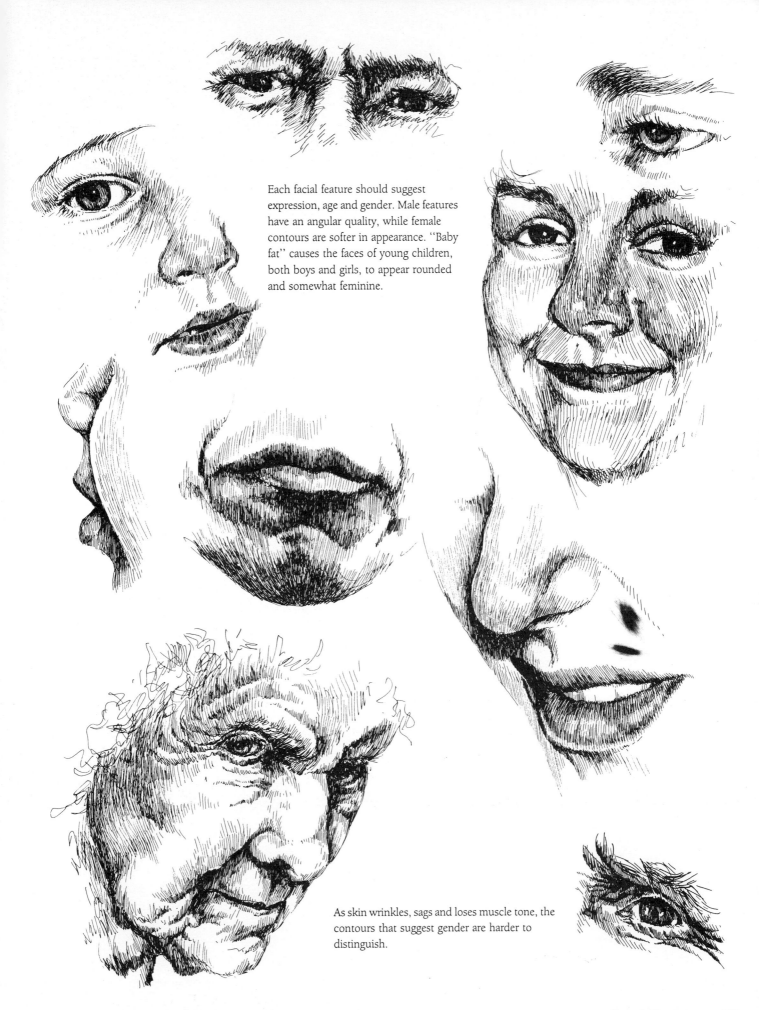

Each facial feature should suggest expression, age and gender. Male features have an angular quality, while female contours are softer in appearance. "Baby fat" causes the faces of young children, both boys and girls, to appear rounded and somewhat feminine.

As skin wrinkles, sags and loses muscle tone, the contours that suggest gender are harder to distinguish.

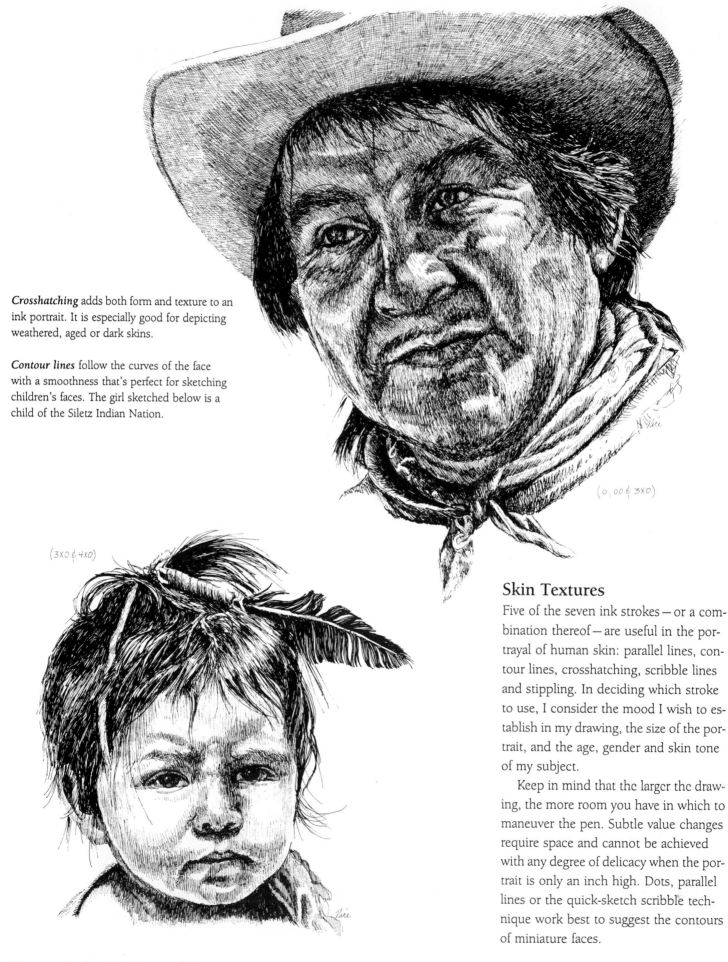

Crosshatching adds both form and texture to an ink portrait. It is especially good for depicting weathered, aged or dark skins.

Contour lines follow the curves of the face with a smoothness that's perfect for sketching children's faces. The girl sketched below is a child of the Siletz Indian Nation.

(3X0 & 4X0)

(0, 00 & 3X0)

Skin Textures

Five of the seven ink strokes—or a combination thereof—are useful in the portrayal of human skin: parallel lines, contour lines, crosshatching, scribble lines and stippling. In deciding which stroke to use, I consider the mood I wish to establish in my drawing, the size of the portrait, and the age, gender and skin tone of my subject.

Keep in mind that the larger the drawing, the more room you have in which to maneuver the pen. Subtle value changes require space and cannot be achieved with any degree of delicacy when the portrait is only an inch high. Dots, parallel lines or the quick-sketch scribble technique work best to suggest the contours of miniature faces.

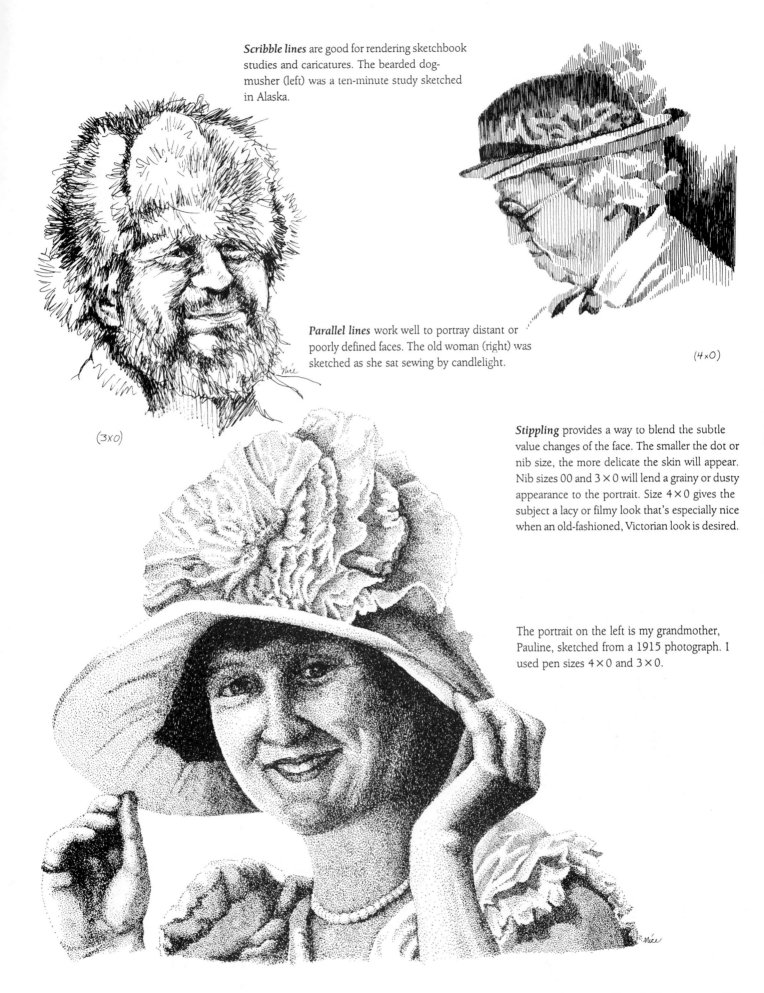

Scribble lines are good for rendering sketchbook studies and caricatures. The bearded dog-musher (left) was a ten-minute study sketched in Alaska.

Parallel lines work well to portray distant or poorly defined faces. The old woman (right) was sketched as she sat sewing by candlelight.

(4×0)

(3×0)

Stippling provides a way to blend the subtle value changes of the face. The smaller the dot or nib size, the more delicate the skin will appear. Nib sizes 00 and 3 × 0 will lend a grainy or dusty appearance to the portrait. Size 4 × 0 gives the subject a lacy or filmy look that's especially nice when an old-fashioned, Victorian look is desired.

The portrait on the left is my grandmother, Pauline, sketched from a 1915 photograph. I used pen sizes 4 × 0 and 3 × 0.

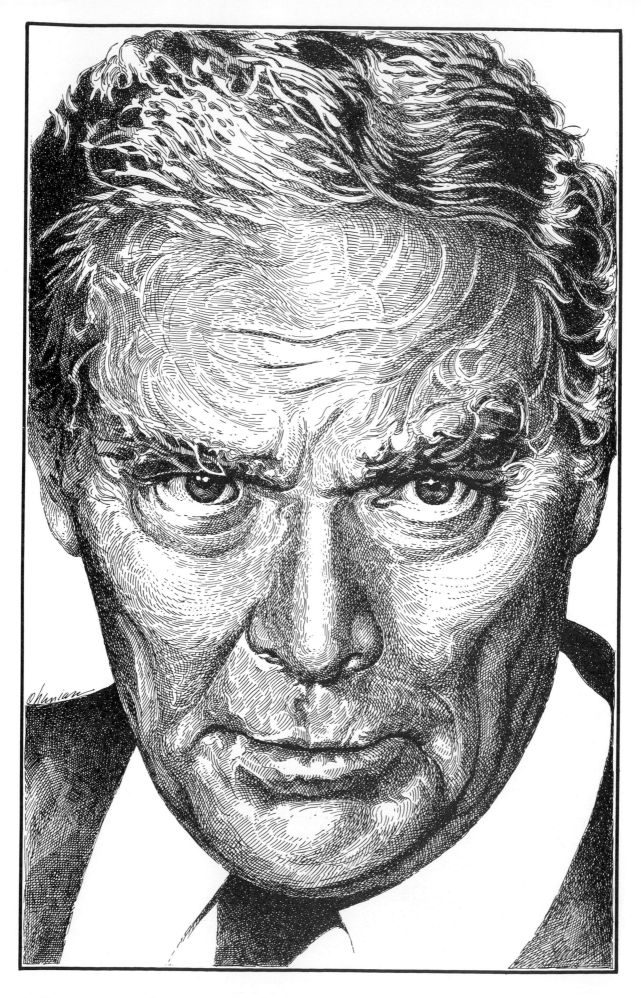

(Left) *Alexander Haig,* 10½ × 6½, by Nancy Ohanian. Nancy uses contour lines and contour crosshatching to texture her portrait. However, her choice of a slightly larger pen size and a bolder style gives the face the look of authority and power. © 1981 by Nancy Ohanian.

She Who Watches the Dance. I sketched this Native American woman with contour lines and contour crosshatching for the skin texture. By using the smaller pen sizes, 4 × 0 and 3 × 0, and gently blending the crosshatched strokes, the tanned face retains a feminine quality.

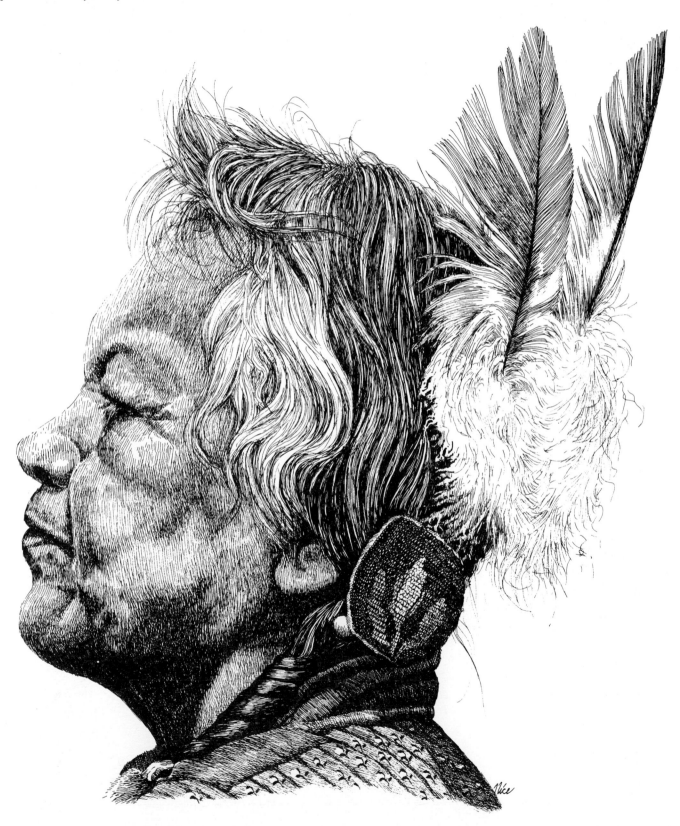

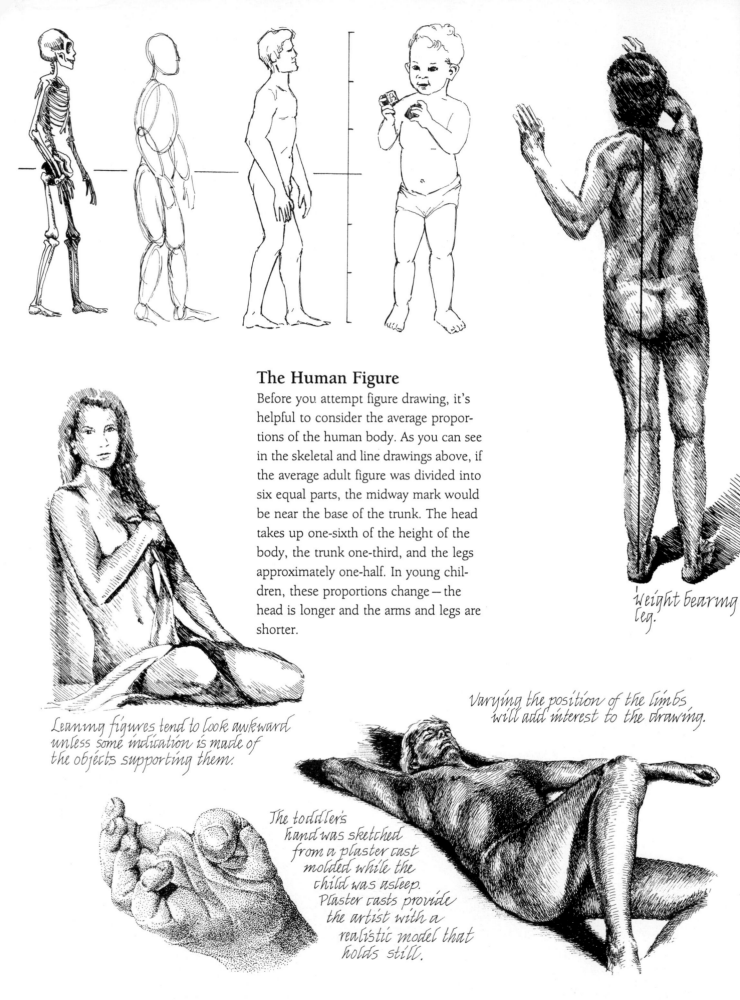

The Human Figure

Before you attempt figure drawing, it's helpful to consider the average proportions of the human body. As you can see in the skeletal and line drawings above, if the average adult figure was divided into six equal parts, the midway mark would be near the base of the trunk. The head takes up one-sixth of the height of the body, the trunk one-third, and the legs approximately one-half. In young children, these proportions change — the head is longer and the arms and legs are shorter.

Weight bearing leg.

Leaning figures tend to look awkward unless some indication is made of the objects supporting them.

Varying the position of the limbs will add interest to the drawing.

The toddler's hand was sketched from a plaster cast molded while the child was asleep. Plaster casts provide the artist with a realistic model that holds still.

As the body is seen in different positions, the effect of perspective and foreshortening may cause body parts to appear larger or smaller than they really are.

The shadows drawn within the contours of the body and surrounding the figure are important in establishing the look of dimension and substance. The figure must appear to have weight to be believable. Darkening the shadows beneath the heaviest area of the body helps indicate its heaviness. In an actual figure, the weight-bearing portion of the body can be identified by running a straight line vertically from the base of the neck, like a plumb line.

When developing the contours of the body, keep in mind that soft flesh tends to conform to the shape of a harder object pressing against it. The greater the pressure, the more compressed the body part will appear. Therefore, the weight-bearing parts of the body should be "spread out" against the objects that support them. Failure to do this will give the figure an unyielding, wooden appearance.

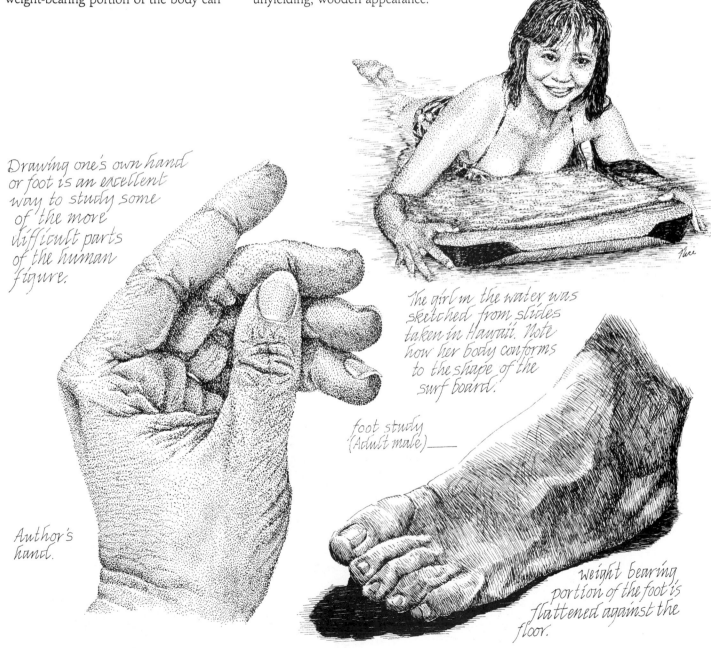

Drawing one's own hand or foot is an excellent way to study some of the more difficult parts of the human figure.

Author's hand.

The girl in the water was sketched from slides taken in Hawaii. Note how her body conforms to the shape of the surf board.

foot study (Adult male)____

weight bearing portion of the foot is flattened against the floor.

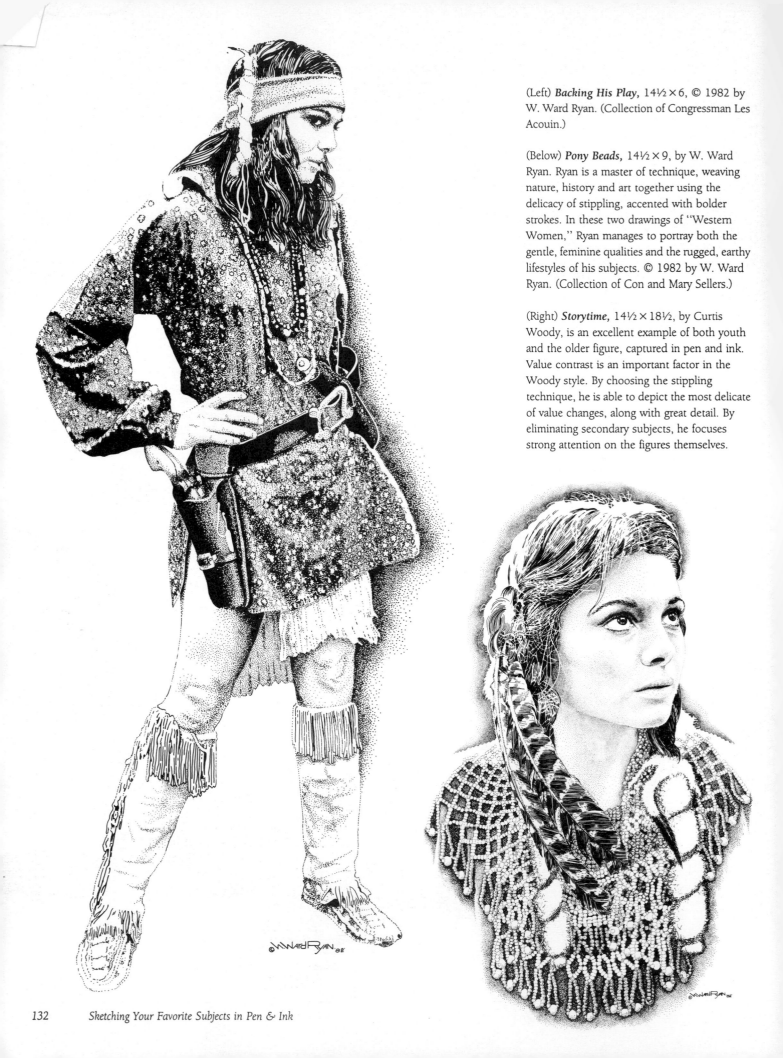

(Left) *Backing His Play*, 14½ × 6, © 1982 by W. Ward Ryan. (Collection of Congressman Les Acouin.)

(Below) *Pony Beads*, 14½ × 9, by W. Ward Ryan. Ryan is a master of technique, weaving nature, history and art together using the delicacy of stippling, accented with bolder strokes. In these two drawings of "Western Women," Ryan manages to portray both the gentle, feminine qualities and the rugged, earthy lifestyles of his subjects. © 1982 by W. Ward Ryan. (Collection of Con and Mary Sellers.)

(Right) *Storytime*, 14½ × 18½, by Curtis Woody, is an excellent example of both youth and the older figure, captured in pen and ink. Value contrast is an important factor in the Woody style. By choosing the stippling technique, he is able to depict the most delicate of value changes, along with great detail. By eliminating secondary subjects, he focuses strong attention on the figures themselves.

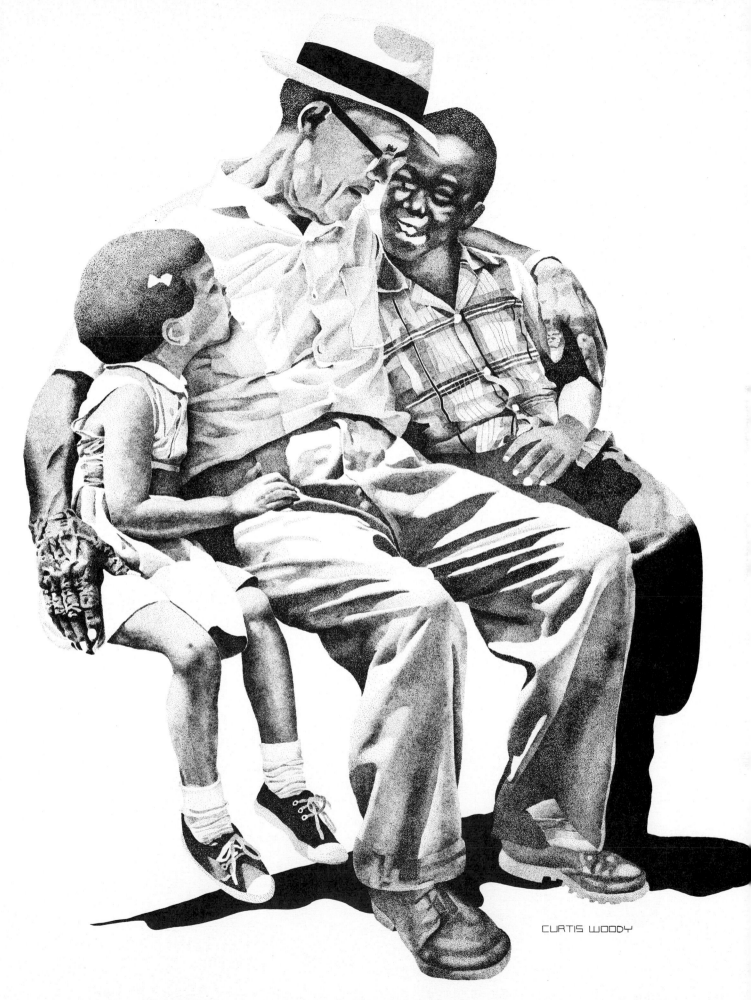

CURTIS WOODY

Harold Bellucci
Waterford, Connecticut
Harold Bellucci began his art career at a very young age, creating a successful, published comic strip in his pre-teen years. He went on to receive a degree in architecture and engineering from North Carolina State University. Mr. Bellucci uses his knowledge of architecture to create successful pen-and-ink drawings centered around country buildings.

Ruth Daniels
Boston, Massachusetts
A graduate of the New England School of Art in Boston, Ruth Daniels has done illustrations for various ads, magazines and greeting cards. Her work has been shown in the juried exhibitions of the Boston Society of Illustrators; The Superbull Western Art Show, Del Rio, Texas; The American Academy of Equine Art; and the New England CCAA (Cape Cod Art Association).

Richard DeSpain
North Little Rock, Arkansas
Richard DeSpain studied drafting at Burdette Vocational School in Blytheville and attributes much of his early artistic training to a local artist, Alice McManus. He is an active member of the Arkansas League of Artists. His accomplishments include a series of commissioned historical drawings and a book on local southern architecture.

Marv Espe
Roseau, Minnesota
Marv Espe received his formal art training in Chicago and Minneapolis. He taught for five years in northern Minnesota and has worked as a design artist in Minneapolis. Espe's work, which is in many publications, galleries and private collections, is known for its great detail and masterful use of texture and white void spaces.

Jan Gunlock
Las Vegas, Nevada
Jan Gunlock is known for her drawings of the unique plant and animal life found in the Southwest desert. She was introduced to pen-and-ink sketching at a recreation center in San Mateo, California, and has gone on to design her own cards and limited-edition prints of desert wildlife.

Robin A. Jess
Edison, New Jersey
Robin Jess, a resident of southern New Jersey, has combined a love of plant life and drawing into a career as a freelance botanical illustrator. Her finely detailed stippling technique produces plant studies reminiscent of eighteenth- and early-nineteenth-century engravings. Robin's work can be found in the collections of the Hunt Institute for Botanical Documentation and the New York Botanical Garden.

Edwin Kayton
Captain Cook, Hawaii
Edwin Kayton is a multimedia artist who depicts the ethnic lore and cultural heritage of the islands with accuracy and great detail. His compositions are exhibited throughout Hawaii and are found in many private and corporate collections.

Albert Lorenz
Floral Park, New York
Albert Lorenz, a well-known New York architectural illustrator, received degrees in architecture from Columbia University and Pratt Institute, and a Ph.D. from Princeton. He has taught at several universities, including Pratt Institute, and has authored several books and numerous magazine articles. His precise, highly detailed work has won Lorenz numerous prestigious awards in design and illustration.

Nancy Ohanian
Beverly Hills, California
Nancy Ohanian majored in drawing, painting and print-making and received her MFA from Pratt Institute in Brooklyn, New York. She has since taught part-time at several universities and has become quite well known for her ink drawings in the editorial sections of newspapers such as the *New York Times,* the *Miami Herald* and the *Los Angeles Times.* Her syndicated illustrations are distributed throughout the United States and Canada.

Willie Preacher
Pocatello, Idaho
Native American artist Willie Preacher, of the Bannock and Shoshone nations, was born on the Fort Hall Reservation. His parents were conscientious instructors of Indian teachings, and he learned early to observe and appreciate the wildlife of Idaho. Carefully researched historical sketches of Native American people in various walks of life are among his favorite subjects. He is a multimedia artist, working in watercolors, oils and scratchboard, as well as pen and ink.

Daniel Puffer
North Andover, Massachusetts
Dan Puffer, from eastern Massachusetts, dramatically interprets the textures in various building materials. Using the smaller nib sizes (6×0 and 4×0), he often takes fifty hours to complete a drawing. Dan, a graduate of MIT and a retired metallurgical engineer, has developed his pen-and-ink skills as a hobby. He is a prize-winning member of both the Rockport and North Shore Art Associations.

W. Ward Ryan
Merlin, Oregon
W. Ward Ryan studied architecture and design at Ohio State University and worked as a professional photographer for NASA and MGM in Hollywood. The wonders of nature and the heritage of America provide the inspiration for much of Ryan's work. His work is owned by notables throughout the world.

Ralph Scott
Pueblo, Colorado
Ralph Scott received his BFA from Ohio University and furthered his art studies at the Massachusetts College of Art and Howard University's Museum of Comparative Zoology. This led Ralph to a career as an artist/naturalist at various museums and conservation organizations, including the Massachusetts Audubon Society. Now retired, Ralph resides in Pueblo, Colorado, where he produces pen-and-ink renderings of wildlife, Native Americans and cowboys. His drawings have won awards in national, regional and local exhibits.

Gary Simmons
Hot Springs, Arkansas
Gary Simmons is a self-taught artist who learned the skills of pen-and-ink drawing to fulfill a job requirement. He received a doctorate in educational media from Indiana University and is presently teaching on the art faculty of Henderson State University in Arkansas. Gary is well known for his portrait montages, where he combines several different views of his subject with other people and with physical items important to the subject's life. The Simmons style relies on the strong use of value content for drama and emphasis.

Curtis Woody
Upper Marlboro, Maryland
After earning an associate's degree in commercial art from Thomas Nelson Community College, Curtis has had great success as a professional illustrator — from working as a technical illustrator with NASA, to art director of NPC Associates, to the present national recognition of his drawings. His career is characterized by a continuing allegiance to his black cultural heritage, sketching ordinary people in their struggle to survive the joy and sadness of day-to-day life.

INDEX

A complete catalog of North Light Books is available FREE by writing to the address shown below, or by calling toll-free 1-800-289-0963. To order additional copies of this book, send in retail price of the book plus $3.00 postage and handling for one book, and $1.00 for each additional book. Ohio residents add 5½% sales tax. Allow 30 days for delivery.

North Light Books
1507 Dana Avenue
Cincinnati, Ohio 45207

Stock is limited on some titles; prices subject to change without notice.

Write to the above address for information on North Light Book Club, Graphic Artist's Book Club, The Artist Magazine, Decorative Artist's Workbook, HOW magazine, and North Light Art School.